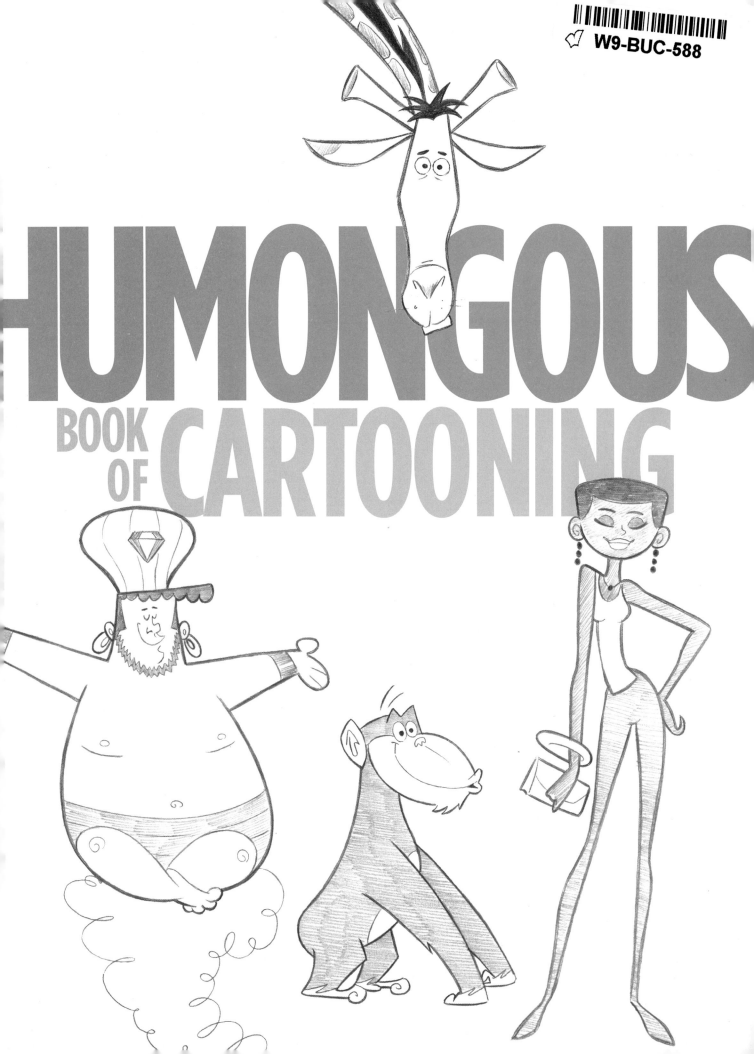

HUMONGOUS
BOOK OF CARTOONING
BOOK OF

CHRISTOPHER HART

HUMO

BOOK OF

WATSON-GUPTILL PUBLICATIONS
NEW YORK

SPECIAL THANKS TO

Lauren Shakely
Candace Raney
Victoria Craven
James Waller
Brian Phair
Autumn Kindelspire
And, of course,
YOU, THE READER!

—Chris

Published in the United States by Watson-Guptill Publications, an imprint
of the Crown Publishing Group, a division of Random House, Inc., New York.
www.crownpublishing.com l www.watsonguptill.com

WATSON-GUPTILL is a registered trademark and the WG and Horse
designs are trademarks of Random House, Inc.

Library of Congress Cataloging-in-Publication data: 2009927070

ISBN-13: 978-0-8230-5036-9

Designer: Dominika Dmytrowski

First printing 2009
Printed in China

5 6 7 8 9 / 17 16 15 14 13 12

FROM THE AUTHOR

Do you enjoy drawing, but are frustrated that you aren't getting to the next level? Would you like to improve your drawing skills? That's exactly what this book is designed to help you do. It will give you practical insights into cartooning that you can apply immediately to your drawings, so that you can see results right away.

Humongous Book of Cartooning is more than your average tutorial. It's like having a personal mentor by your side while you draw. In this book, I cover professional techniques that I have personally distilled over my years in cartooning into easy-to-grasp lessons. I have filled the book from beginning to end with scores of tips, which will give you a clear understanding of the techniques I use. As a result, you'll find that you can begin drawing with a professional flair from the very first chapter. What a thrill it will be to see your cartoons spring to life and surpass even your own expectations! I think you'll get a real kick out of it.

There's a great deal value in being able to successfully recreate the images in this book. After all, many cartoonists make a handsome living drawing characters that have been designed by other people. Whether they work on comic books, animated TV shows, or animated films, virtually all cartoonists begin their professional careers by drawing other people's characters. If, however, your goal is to create something totally original, learning to draw the characters in this book will teach you all the principles you need to get started on the right track.

This book covers the widest spectrum of subjects, from cartoon people to cartoon animals, funny robots, costumes, layout, backgrounds, fantasy creatures, expressions, drawing action, and more.

Everyone needs a little encouragement. I got it when I was still a high school student, by attending some life drawing classes taught by animators at the Cartoonist's Union in North Hollywood, California. I was well situated, living in the film capital of the world, but I was also ambitious. I sought out mentors in the form of animation directors and producers who looked over my portfolio and gave me advice along the way. You may not live in Los Angeles or have any contacts in the cartooning and animation world. Not to worry—because we're about to level the playing field, or actually tilt it in your favor. In these pages, you'll get all the information that I had when I was starting out—and more. It's my way of giving something back, and I'm grateful to have had the opportunity to do so.

I'm delighted to have you on board.

Onward!

CHRIS

Drawing Cartoon Characters' Heads

The basis for drawing a cartoon character's head isn't the eyes, or the mouth, or any particular facial feature. It's the shape of the head itself—the outline. A circle is the most basic head shape, but it's only one of many. The head can be stretched, adjusted, or cut off to create funny forms. That's why cartoonists begin by drawing the basic head shape first. It dictates where the features should go.

Give the head shape some thought. Put as much creative juice into drawing the shape of the head as you would, for instance, into drawing of the character's eyes. Too often, beginning artists focus exclusively on the features. This is a mistake—but not one that you're going to make!

NINE BASIC HEAD SHAPES

By using and modifying nine simple shapes, you can draw just about any type of cartoon character's head. We're going to see how each shape can be turned into a lively character in only a few steps. Here are the nine basic shapes.

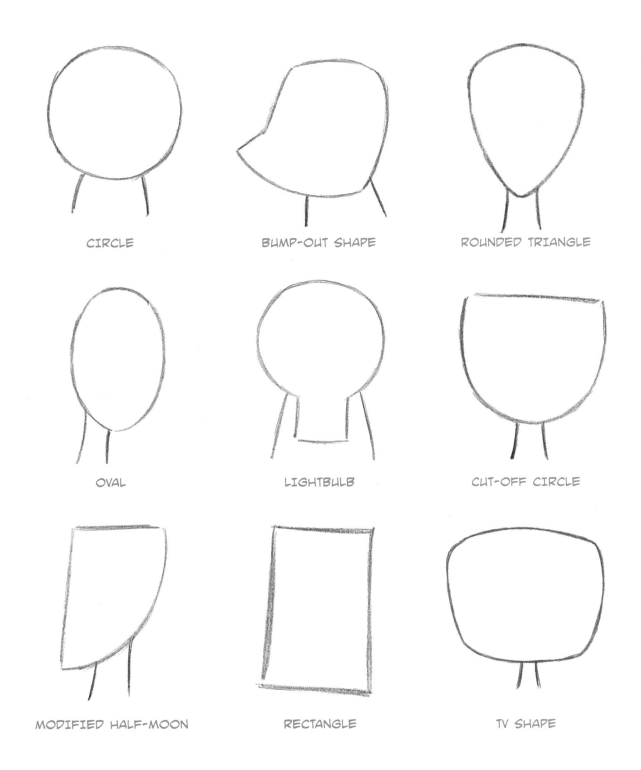

CIRCLE

BUMP-OUT SHAPE

ROUNDED TRIANGLE

OVAL

LIGHTBULB

CUT-OFF CIRCLE

MODIFIED HALF-MOON

RECTANGLE

TV SHAPE

Circle (Squirrel)

Circles work equally well for people and animals, but notice how a round shape makes a character—human or animal—look young, cute, or retro (or a combination of all three). Place the features on a circular face symmetrically. The lower you move the features on the circle, the cuter the character will be. (A tiny muzzle is necessary for "cuteness.")

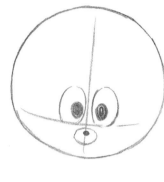

Bump-out Shape (Bear Cub)

The bump-out shape greatly exaggerates the prominence of the cheek and can therefore make a cute character even cuter. It also widens the face, giving the character greater presence. It's mainly used for human characters but can also be applied to animals, as with this bear cub. The bump-out should always appear low on the face, and it always occurs on the cheek c the far side of the face.

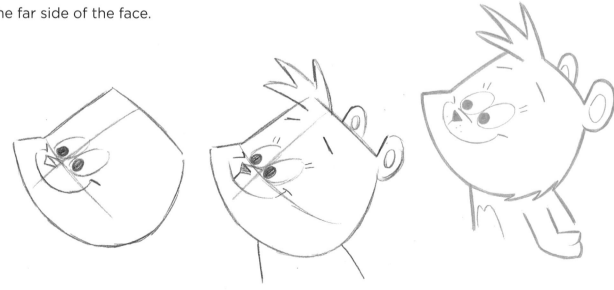

Rounded Triangle (Teenage Guy)

This idealized head shape, wide at the top and narrow at the chin, works mainly for teenage characters: Hanging the ears low on the head is a sign of youth. Most of his hairdo is drawn *within* the outline of his head. Sweep the hair to one side, which makes for a more dramatic look.

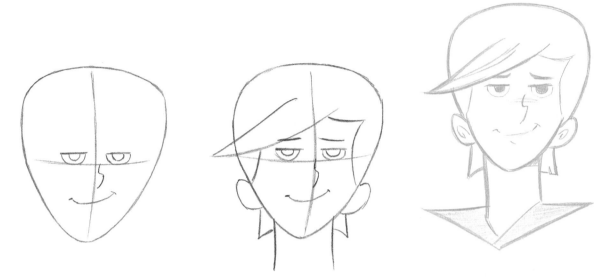

Oval (Teenage Girl)

The oval head shape is a particularly good look for female characters. You can make the head even more feminine by tapering the chin to a softened point. A long, thin neck is a nice complement to an oval-shaped head. Since this character has a lot of hair, I've left room for it by giving her an extra-big forehead.

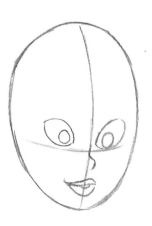
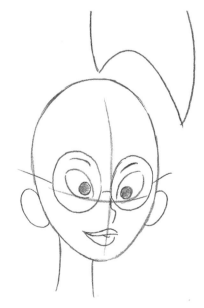

Lightbulb (Mad-Scientist Villain)

This kind of character is a favorite of mine. He's not just evil—he's funny-evil. The lightbulb shape is perfect for mad scientists: They typically have big craniums, in which they store their maniacal plans to take over the world. But the rest of the face is skinny, reflecting the cartoon stereotype that casts scientists as physically meek. (And notice the sunken cheeks—they're a sure sign of *evil*.)

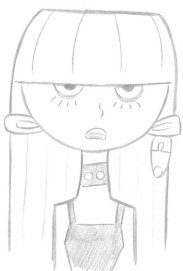

Cut-off Circle (Goth Girl)

The cut-off circle gives a severe, stylized look, so you need to use it for severe, stylized characters. Notice how this goth girl's bangs chop off the tops of her eyes, repeating the way the top of her head is chopped off. The cut-off look should be very abrupt. Don't soften the edges of the head.

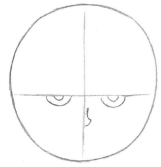

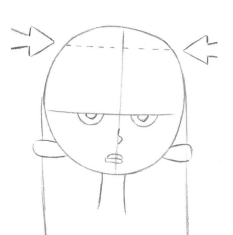

Modified Half-Moon (Cartoon Dad)

This is the quintessential head construction for the "retro" dad—that not-so-handy Sunday afternoon barbecue king. Keep the features well up on the head so that there is plenty of chin—stereotypical dads always have sizable chins. And don't give him a cheek-bump-out. That would make him too "cute"—not lean enough. Dad always has well-groomed hair and a fairly thick neck.

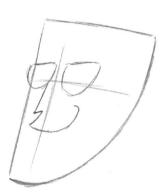
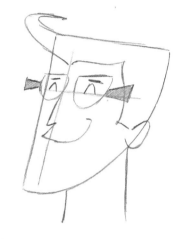
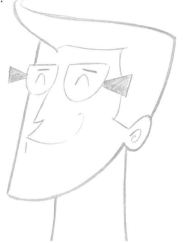

Rectangle (Fox)

Some shapes, like this rectangle, are so strong that they can be used for the entire character—not just the head. This fox's snout breaks the outline, but other than that he's just one big vertical box. Notice that there's no break whatsoever between the head and the body. It's a highly stylized look—and as far from a real fox as you can get without the character becoming unrecognizable. It's mainly his markings, bushy tail, pointy ears, and snout that give him away.

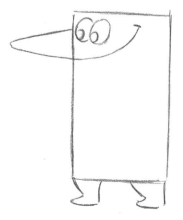

A CAST OF CHARACTERS

Now we're going to develop a whole cast of appealing cartoon characters, keeping in mind the need to draw the basic head shape first. We'll do some animals and some people, since both are essential in cartooning. By following the steps, you'll be able to isolate the areas that present you with challenges and, even more important, recognize where your strengths lie.

By the way, I don't agree with the point of view that says you should focus your energy on correcting weak points before moving on. Doing so is bound to be draining and frustrating, and it won't bring you to a higher overall skill level.

To raise your artistic skills, push yourself in those areas where you show signs of strength, where you excel, or where you are most inspired and driven. Work on improving your weaknesses as the need arises. But don't slow your progress to a grinding halt simply because you have weaknesses. Keep pressing your boundaries. See where your talent leads you.

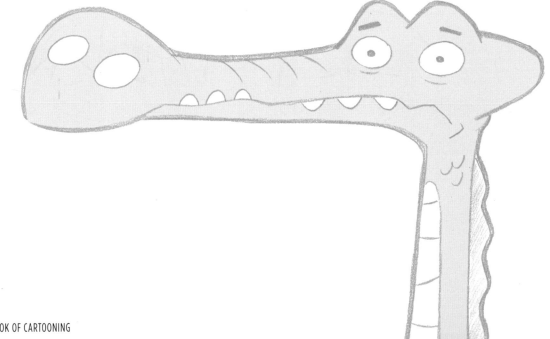

Sketch Guidelines

Animators always use sketch guidelines—a center line and an eye line—to position the facial features correctly. You can do the same whether you draw animation or still cartoons. When you use sketch guidelines to map out where the features go, you'll always put them in the right place.

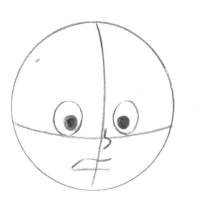

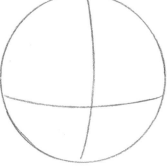

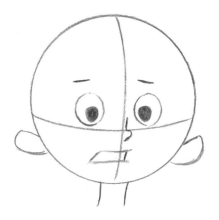

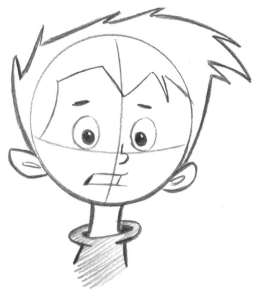

Pipsqueak Pup

This droll pup has a TV-shaped head. The face looks very wide because all the features are scrunched together in the middle. The neck has to be slender, or the doggy will appear to be a little tough guy, which is not the look we're after. Keep the features fairly low on the face, as we're drawing a cute young character.

Notice that here and in the drawings that follow, my last step is to add a super-thick line around the character's head. This is a very popular look—you see it a lot on today's animated TV shows. Inside that thick outline, however, the interior features should remain thin-lined. More intricate and detailed aspects of the drawing have to be done in a thin line, or the drawing will look muddy. Current animated styles lean toward this thick-lined approach, and I always like to show the latest thing.

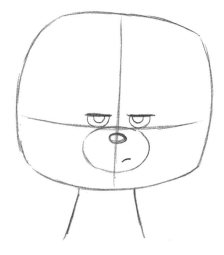

THE BASIC HEAD SHAPE IS THAT OF AN OLD-FASHIONED TV.

DRAW THE EYE LINE AND CENTER LINE SO THAT THEY INTERSECT FAIRLY LOW IN THE FACE.

THE MUZZLE SHAPE IS A SLIGHTLY FLAT-TENED CIRCLE.

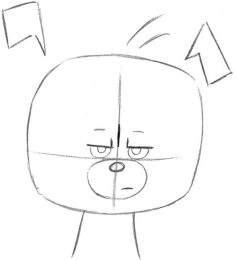

I LIKE THE EARS TO BE VERY ANGULAR, WHICH MAKES THEM HUMOROUS.

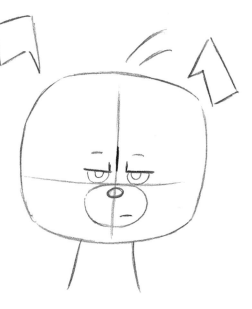

PUT SOME EXPRESSION LINES OVER THE EYE-BROWS AND SOME HAIR ON TOP OF THE HEAD.

HERE I'VE OUTLINED THE HEAD WITH A THICK PENCIL LINE.

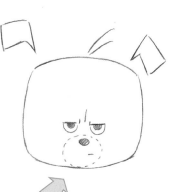

Tips and Options

Here's an alternative way to draw the head. Indent the basic outline at the sides, which makes the cheeks look wider.

Make sure the muzzle stays well within the outline of the face. Don't allow it to touch the bottom edge.

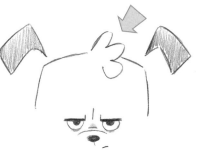

If you like, you can give Pipsqueak Pup curls instead of straight shafts of hair on top of his head.

Typical Teen (Boy)

Younger teenagers are among the easiest characters to draw because they have simple head shapes, with bright, open features. Go for simplicity with your teen and preteen characters: Big eyes, a small nose, and a big head of hair do the trick. A long, thin neck suggests a lanky teenage body. Note that the head shape is not a perfect circle but tapers just a bit at the chin.

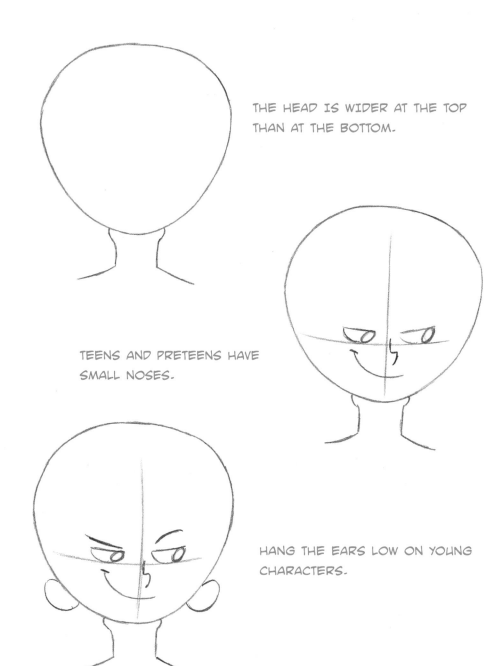

THE HEAD IS WIDER AT THE TOP THAN AT THE BOTTOM.

TEENS AND PRETEENS HAVE SMALL NOSES.

HANG THE EARS LOW ON YOUNG CHARACTERS.

A YOUNG TEENAGER'S NECK IS LONG.
(THE TURTLENECK GIVES HIM A COOL
LOOK.) SHAG THE HAIR AS IT ZIGZAGS
ACROSS THE FOREHEAD.

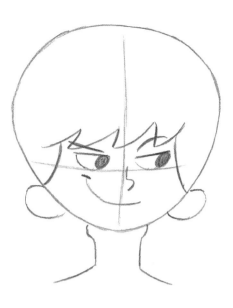

NOTE HOW THE THICK OUTLINE REALLY
MAKES THE IMAGE POP!

Tips and Options

The hair can comfortably fall over
the eyes, for a carefree look.

The eye on the same side as the grin will
always be slightly "crushed" by the eyebrow.
(It's a good idea to commit this principle
to memory.) The other side of the face will
open up as a result.

Typical Teen (Girl)

It's easy to draw teenage girls if you give them a round, moon-shaped face. This almost guarantees that the character will look appealing and feminine. Her eyelashes should be drawn with a darker, thicker line than the rest of her features, to make them stand out. If she's meant to be an attractive character, it's essential to give her full lips. If you want her to be goofy, you can draw the mouth as a simple line instead of giving her full lips.

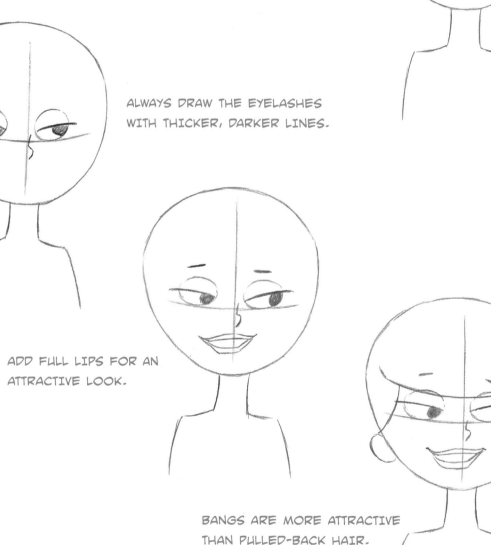

A MOON-SHAPED HEAD IS A SAFE BET WHEN DRAWING ATTRACTIVE FEMALE TEENS.

ALWAYS DRAW THE EYELASHES WITH THICKER, DARKER LINES.

ADD FULL LIPS FOR AN ATTRACTIVE LOOK.

BANGS ARE MORE ATTRACTIVE THAN PULLED-BACK HAIR.

Note the two-toned "colors" of the eyeball (iris and pupil) and the thickness of the eyelash line.

thick line

thick line

You can draw the top lip with a little indentation in the middle and a "bump" on either side or make a smooth line that rises slightly in the middle (which is a more contemporary look).

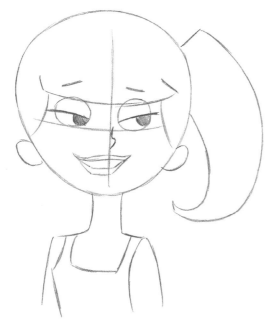

THE PONYTAIL ALSO HELPS GIVE HER A YOUTHFUL LOOK.

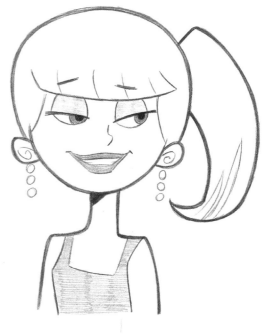

NOTE THE DIFFERENCES IN SHADING IN THIS FINISHED DRAWING: THE EYEBALLS ARE "TWO-TONED" (DARKER FOR THE PUPIL, LIGHTER FOR THE IRIS), THE EYELIDS ARE LIGHTLY SHADED, AND THE LIPS ARE A MEDIUM TONE.

Classic Bad Guy

You know how your mom always warned you not to run around with sharp objects, or you could poke an eye out? Well, this guy never listened—and see what happened? The eye patch is a must-have for many popular bad guys. I've also given him a crooked nose (which only a bad guy would have!) and tucked his chin inside his jaw area. But this is just one kind of classic bad guy. Other types include organized-crime figures and greedy capitalist titans of industry.

GIVE THIS BAD GUY A VERY CLEAN, SYMMETRICAL HEAD SHAPE, WITH A SMALL CRANIUM AND WIDE JAW.

HIS FEATURES SHOULD BE CENTERED IN THE MIDDLE OF THE HEAD SHAPE, NOT TOO HIGH OR TOO LOW.

HE DOESN'T HAVE A NECK—HIS SHOULDERS SEEM TO ATTACH DIRECTLY TO HIS HEAD.

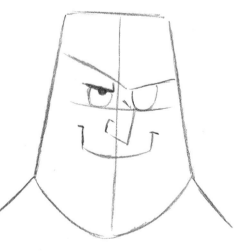

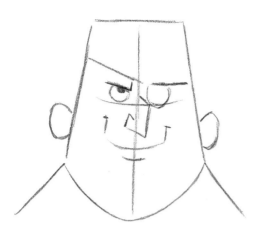

HIS CHIN APPEARS WITHIN THE OUTLINE OF THE JAW AREA. THE BOW TIE IS AN INCONGRUOUS BIT OF SARTORIAL SPLENDOR—A THINLY VEILED ATTEMPT TO CIVILIZE THIS THUG! PUT A SMALL TUFT OF THINNING HAIR ON TOP (LEAVE THE SIDES OF THE HEAD HAIRLESS).

PLACE A SCAR UNDER THE EYE—PARTLY HIDDEN BEHIND THE EYE PATCH.

Get the
Details Right

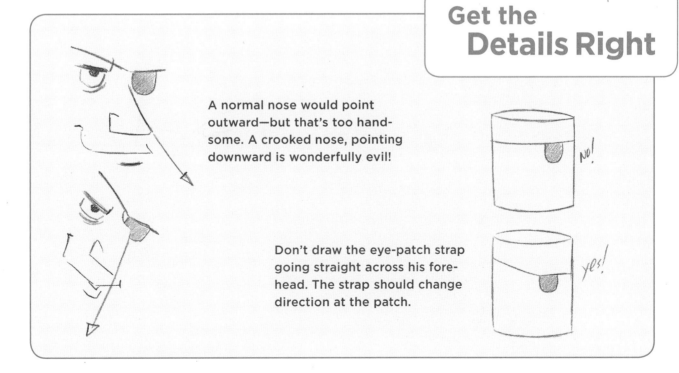

A normal nose would point outward—but that's too handsome. A crooked nose, pointing downward is wonderfully evil!

Don't draw the eye-patch strap going straight across his forehead. The strap should change direction at the patch.

NO!

yes!

Goofy Giraffe

Some animals—giraffes and horses, for instance—have such oddly shaped heads that it's just not possible to use off-the-shelf head shapes such as a circle or an oval. In these cases, you have to simplify the complex head shapes, distilling them down to their basic forms. With this giraffe, notice how symmetrical the final head shape is, and yet how totally suited it is to this animal's unique look.

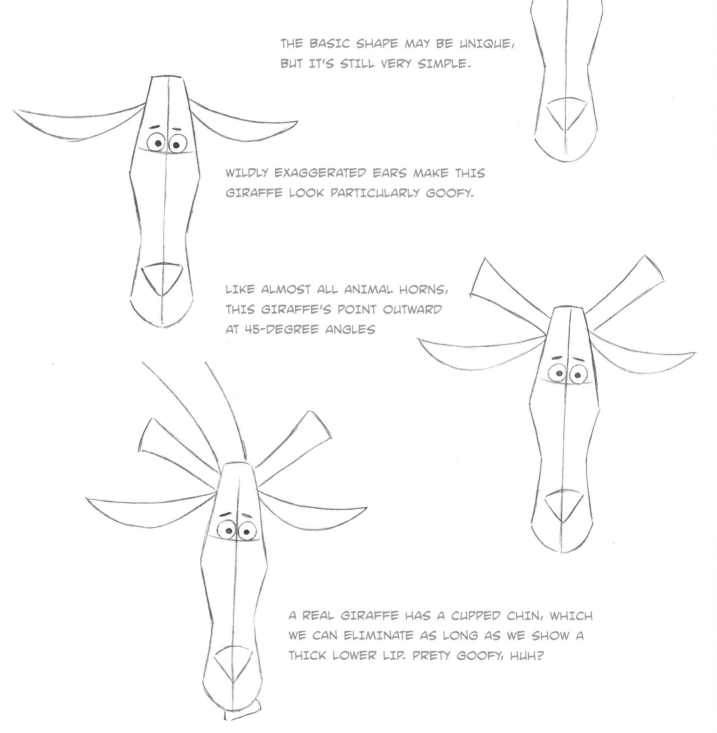

THE BASIC SHAPE MAY BE UNIQUE, BUT IT'S STILL VERY SIMPLE.

WILDLY EXAGGERATED EARS MAKE THIS GIRAFFE LOOK PARTICULARLY GOOFY.

LIKE ALMOST ALL ANIMAL HORNS, THIS GIRAFFE'S POINT OUTWARD AT 45-DEGREE ANGLES

A REAL GIRAFFE HAS A CUPPED CHIN, WHICH WE CAN ELIMINATE AS LONG AS WE SHOW A THICK LOWER LIP. PRETTY GOOFY, HUH?

When finishing up the drawing, add some details: Show the interior of the ears. Lightly draw in the bridge of the nose. If you prefer, draw a cup-shaped chin rather than a lower lip. And draw the front of the mane as if it were bangs flopping down on the giraffe's forehead.

When you do the shading, vary the darkness: The spots should be more lightly shaded, the mane more darkly shaded.

SHOW THE MANE'S TEXTURE BY GIVING IT A RUFFLED, ZIGZAG LOOK.

ADD SPOTS—BUT NOTICE THE SPECIFIC PATTERN. A GIRAFFE'S SPOTS ARE CLOSE TO ONE ANOTHER, WITH VERY NARROW BLANK GUTTERS BETWEEN.

TURNING A CHARACTER'S HEAD

Trying to turn a character's head in different directions while maintaining the character's recognizability can raise a beginning cartoonist's anxiety level. But it's not as challenging as you might fear. Don't change the expression as you turn the head—at least not at first. Keeping the expression the same makes it easier to recreate the character at different angles.

Also, the more basic the head shape, the easier it is to recreate the character. So let's start off with a really simple character: Mr. Rectangle.

Mr. Rectangle

Because his head is just a rectangle, the sketch guidelines run straight across his face, side to side and vertically. Because they don't curve, it's easy to turn him.

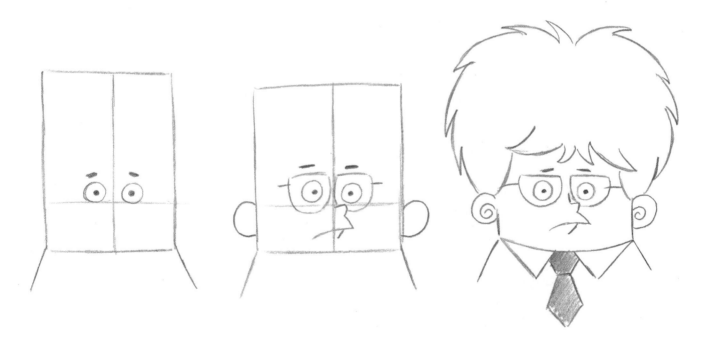

HERE'S THE STRAIGHT-ON, FRONT VIEW.

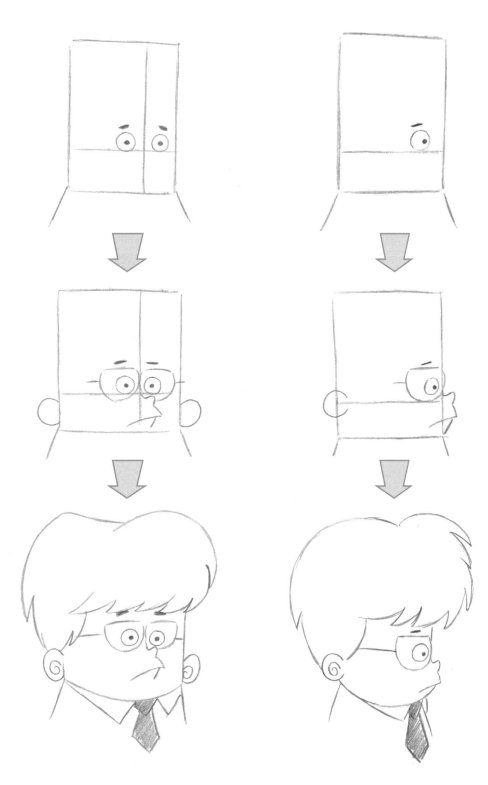

AS YOU CAN SEE, ALL WE DO WHEN TURNING HIM FROM A FRONT VIEW TO A THREE-QUARTERS VIEW IS TO SHIFT THE VERTICAL SKETCH GUIDELINES OVER TO THE RIGHT A BIT, AND THEN DRAW THE FEATURES WHERE THE EYE LINE AND CENTER LINE INTERSECT.

TO DRAW THE CHARACTER IN PROFILE, WE SHIFT THE FEATURES ALL THE WAY TO THE SIDE OF THE FACE—BUT THE HEAD SHAPE REMAINS EXACTLY THE SAME! ONLY THE FEATURES AND THE HAIR CHANGE.

The Profile

So what happened to that center line in the profile view? It suddenly seemed to disappear. Where did it go? Well, it became the *front of the face*.

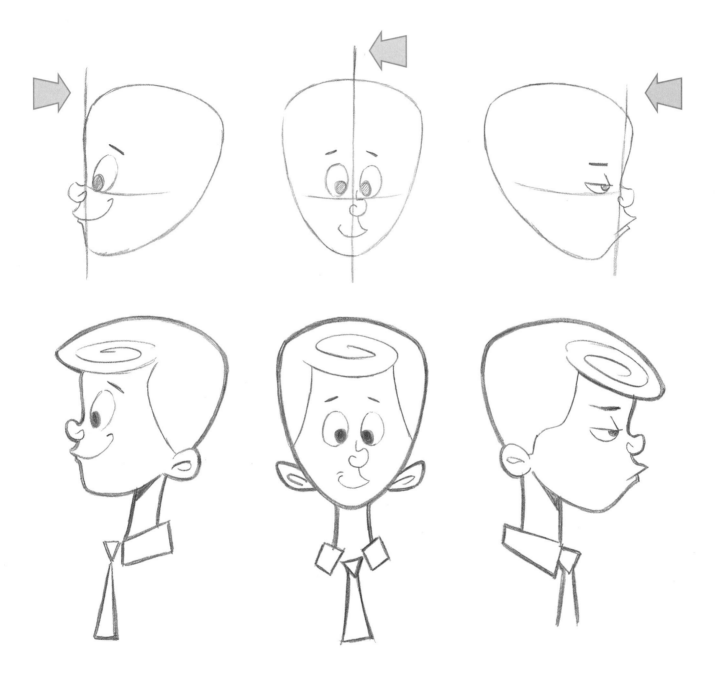

TAKE A LOOK AT THESE DRAWINGS OF A YOUNG MAN—THE INITIAL SKETCHES AND THE FINISHED DRAWINGS. YOU CAN SEE THAT THE CENTER LINE STILL EXISTS, BUT IN THE PROFILE IT BECOMES THE FACEPLATE.

Turning an Oval or Circular Head

The front view is a flat view. The profile view is also a flat view.
But a three-quarters view shows roundness. Shall we give it a try?
If we take it step by step, I have every confidence you can do it!

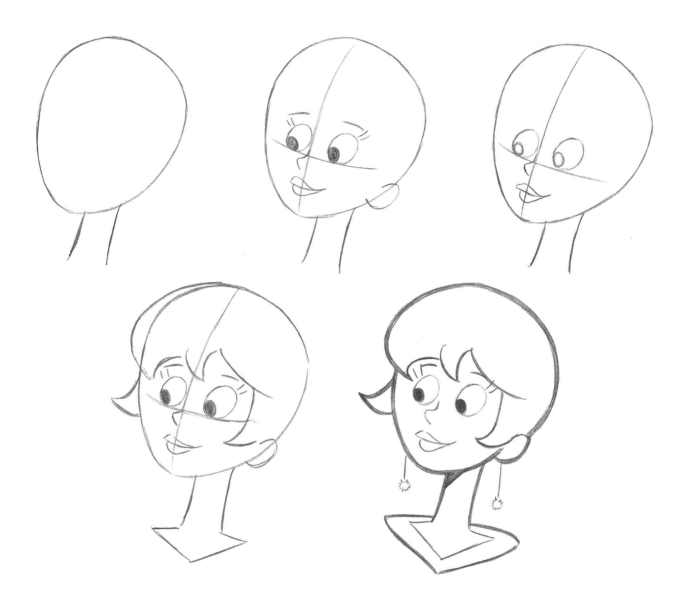

DRAWING A THREE-QUARTERS VIEW IS SLIGHTLY TRICKIER
WHEN YOUR CHARACTER'S HEAD IS OVAL OR ROUND. THE
SKETCH GUIDELINES HAVE TO BE DRAWN AS IF THEY WERE
WRAPPING AROUND A ROUNDED SURFACE. BUT BECAUSE
WE'RE STICKING TO SIMPLE SHAPES LIKE THE OVAL USED
FOR THIS YOUNG WOMAN'S HEAD, THE TURN REMAINS SIMPLE
AND PREDICTABLE.

Drawing the Facial Features

All the facial features are important, but the eyes are the *most* important—second only to the basic head shape. That's why I always begin with the eyes when drawing the features. If the eyes don't come out exactly right, I often start the drawing over.

THE EYES

It's not just the *shape* of the eyes that creates emotional impact—it's also their *placement* on the face. Where do you want them to be? High on the face? In the middle? Low down? Drawing is decision making. The more good decisions you make when drawing your character, the funnier the result will be.

EYES PLACED HIGH ON THE FACE

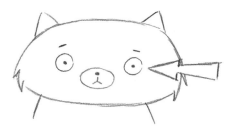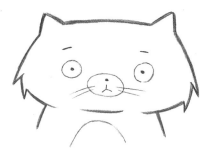

EYES IN THE MIDDLE OF THE FACE

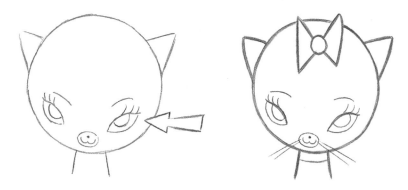

EYES PLACED LOW ON THE FACE

Classic Cartoon Eyes—Animals

Eyes are malleable. They can be simple circles or stretched into ovals. You can tug them left or right. The pupils can be drawn close together, or they can wander apart. Here are a few winning eye styles you'll want to use for your animal characters. They can be used with any species or breed.

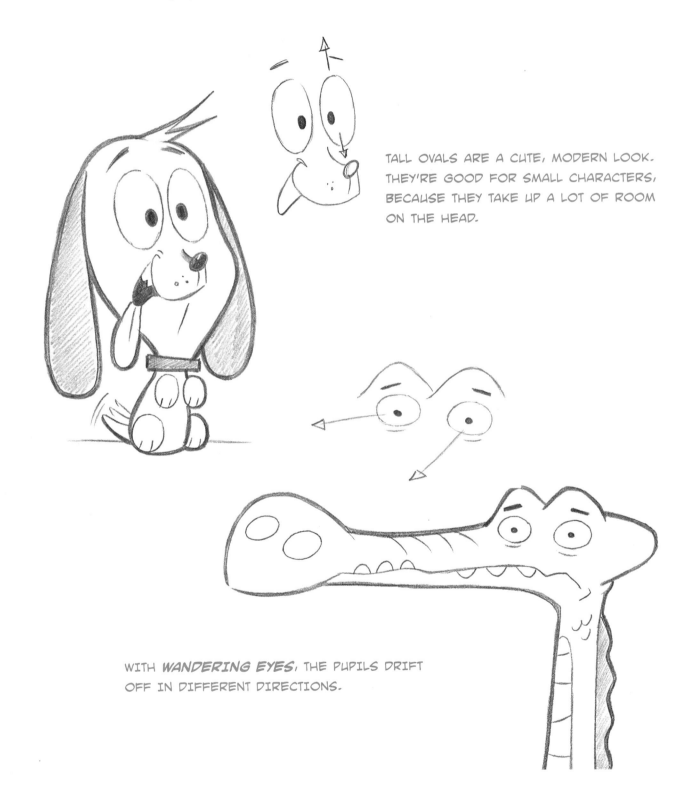

TALL OVALS ARE A CUTE, MODERN LOOK. THEY'RE GOOD FOR SMALL CHARACTERS, BECAUSE THEY TAKE UP A LOT OF ROOM ON THE HEAD.

WITH *WANDERING EYES,* THE PUPILS DRIFT OFF IN DIFFERENT DIRECTIONS.

THIS BUNNY'S EYES ARE *ASYMMETRICAL*:
ONE EYELID PRESSES UP, WHILE THE OTHER
EYE LOOKS NORMAL. A VERY FUNNY LOOK.

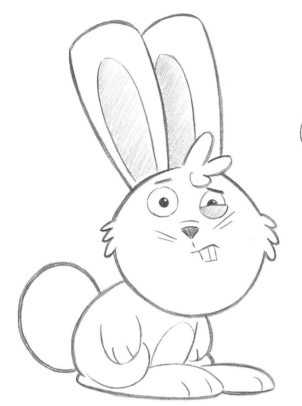

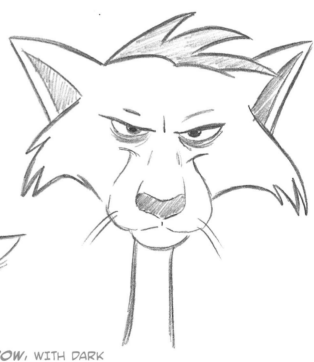

THIS FOX'S EYES ARE *NARROW*, WITH DARK
CIRCLES UNDERNEATH. IT'S A GREAT LOOK
FOR VILLAINOUS ANIMALS.

Classic Cartoon Eyes
—Male Characters

Here are some of my favorite eye types for men, male teenagers, and boys. Note that you don't have to limit your use of a certain eye type to a particular kind of character. For example, you might sometimes want to use "sneaky eyes" on characters who aren't really sneaky. Even a hero can have a sneaky thought now and then!

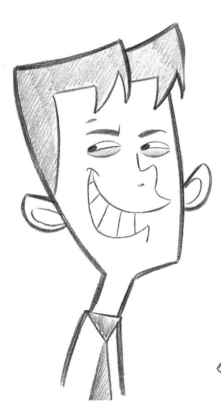

FOR **SNEAKY EYES,** LIGHTLY SHADE THE LOWER EYELIDS.

TO DRAW **GOOFY EYES,** GIVE THE EYES THE SHAPE OF A PAIR OF EGGS PUSHED TOGETHER. THIS IS A VERY POPULAR CARTOON LOOK.

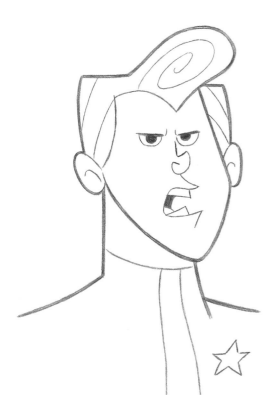

HERO EYES ARE ALSO GOOD FOR DETERMINED EXPRESSIONS ON ANY CHARACTER.

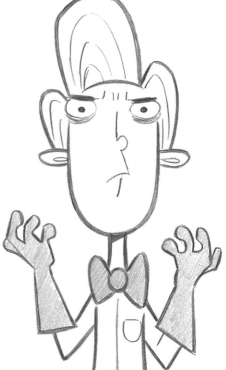

GRAVE EYES ARE GREAT FOR MOMENTOUS, DECISION-MAKING MOMENTS—AND FOR CRAZY CHARACTERS!

THESE *TWO-TONED, ALMOND-SHAPED EYES* HAVE DARK PUPILS INSIDE LIGHTER-TONED IRISES. THIS TYPE WORKS BETTER FOR PEOPLE THAN FOR ANIMALS—ESPECIALLY FOR HONEST, DECENT, GOOD-GUY CHARACTERS.

Classic Cartoon Eyes—
Female Characters

Female eyes aren't just male eyes with eyelashes added.
The eye shape itself has to be feminized.

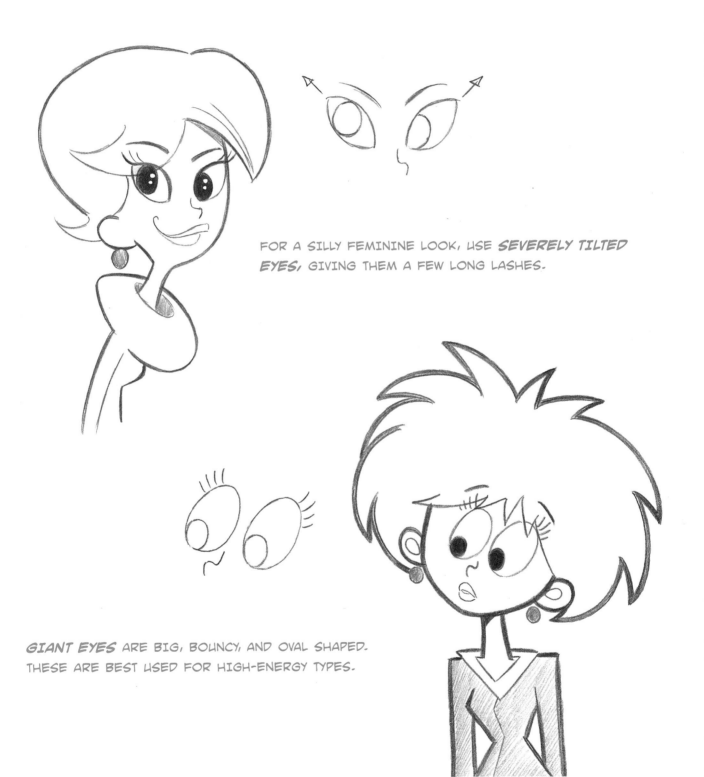

FOR A SILLY FEMININE LOOK, USE *SEVERELY TILTED EYES,* GIVING THEM A FEW LONG LASHES.

GIANT EYES ARE BIG, BOUNCY, AND OVAL SHAPED.
THESE ARE BEST USED FOR HIGH-ENERGY TYPES.

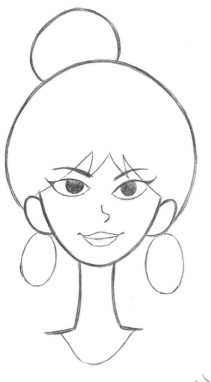

HORIZONTAL EYES HAVE A VERY PRETTY SHAPE—A STANDARD FOR ATTRACTIVE CHARACTERS. IF YOU PREFER, YOU CAN ALSO LIFT THEM SLIGHTLY AT THE ENDS SO THEY TILT A BIT.

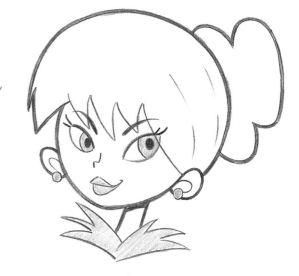

ON THESE ULTRA-FEMININE EYES, NOTE THE CURVED UPPER EYELID AND FEATHERED LASHES.

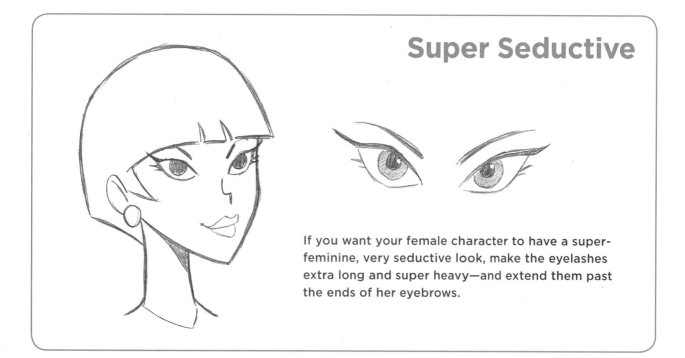

Super Seductive

If you want your female character to have a super-feminine, very seductive look, make the eyelashes extra long and super heavy—and extend them past the ends of her eyebrows.

THE NOSE

Here come the honkers! Noses are fun to draw because you can be as subtle or as over the top as you want.

Male Noses

This "menu" of male noses is by no means complete, but it's a good selection of popular styles and provides you with some good starting points. But feel free to add some nose designs of your own!

YOUNG KID

WIDE

CURLED, WITH NOSTRIL

SUPER BIG!

RETRO

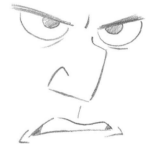

HEAVY BRIDGE

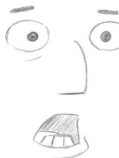

BEAK TYPE

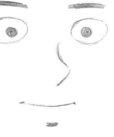

SUBTLE (SOFT CURVE)

Female Noses

As a general rule, don't make female noses as broad as male noses—unless your female character is very large or weird (like a witch or a kook). Attractive cartoon women are always drawn with subtle noses. Note how the eye types match the nose types—for example, if the nose is upturned and snobby, the eyes are disdainful, too.

SNOBBY

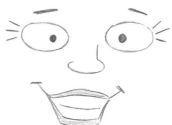

OVAL

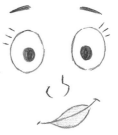

AVERAGE

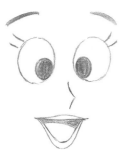

MANGA

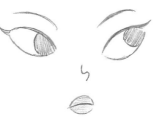

PETITE

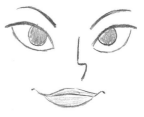

RETRO

BIG

EXTENDED

THE EARS

When drawing cartoon characters' ears, don't aim for anatomical accuracy. Think of the ear as a design, and choose a design that complements your character or suits your own taste. There are two aspects of ear design: the outline (or exterior shape) and the interior design.

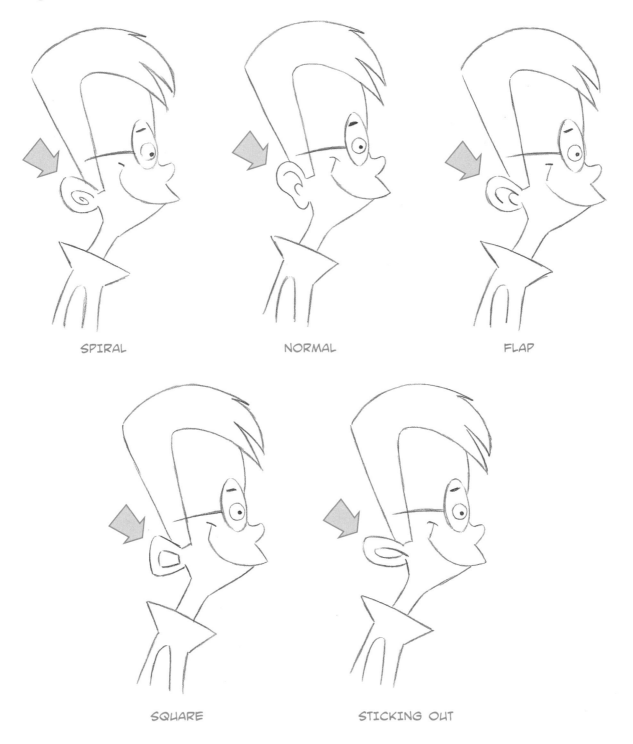

SPIRAL

NORMAL

FLAP

SQUARE

STICKING OUT

Cartoon Earrings

Large jewelry is a must for female cartoon characters. It's flashy, trendy, and cheap. Hey, you can use as much jewelry as you want and never have to pay for it. Here are some basic earring designs.

TRIANGLE

DEMON

LIGHTNING BOLT

STAR

DIAMOND SHAPE

DANGLING BEADS
OR PEARLS

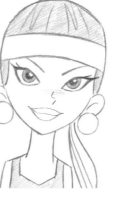

OVERSIZED OVALS

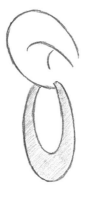

HOOP

THE MOUTH

Cartoon mouths are where we really have some fun. They run from big and extreme to dainty and demur. Mouths don't necessarily have to mirror the expressions of the eyes. For example, a "surprised" look will always feature wide eyes with small pupils. But the mouth that accompanies a surprised look can be drawn small, with a stunned look. Or it can be drawn super wide, in amazement. The mouth is freed up from the rest of the expression to do as it pleases.

CLASSIC CARTOON-CHARACTER EXPRESSIONS

Too often, books on drawing describe facial expressions with simple adjectives like *happy* and *sad.* Such nondescript labels tell you very little about what a character is thinking or feeling. Although I draw many cheerful characters, I would rarely describe them as "happy," because that's just not specific enough. But I might well describe a character's expression as "perky" or "jubilant." The more specific you can get in your description of the emotion, the more personality you infuse into the image.

In this image of a dog, I was going for "perky," because I wanted to show how alert and eager this pup is. Another character's "happy" expression might look quite different—more calm and serene, for example.

Now, we're going to create some very specific expressions, always going for the edge of the emotion. And we'll keep using man's best friend as our model. But it doesn't really matter whether you're drawing a person or an animal—the same principles apply. Get as specific as you can with the emotion you want your character to convey.

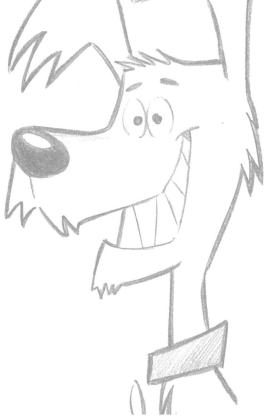

Our doggie model has a fairly straightforward head construction. Before you try your hand at any of the specific expressions, have a good look at the drawings below, which show how this cartoon canine is drawn from a few different angles.

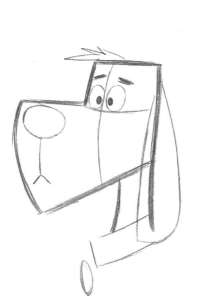
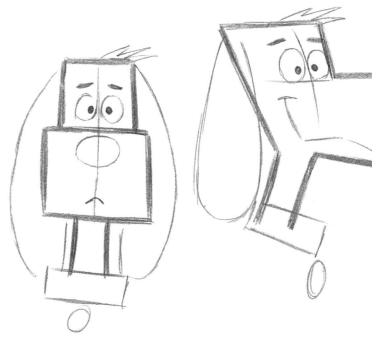

THE FAMOUS "LIP QUIVER"

Puppy dog eyes are not enough to garner sympathy—you've also got to get the lip into the act. A big, pouty bottom lip, tugged to one side, turbocharges the expression. Big, wet eyes and a pouting lip are an irresistible combo!

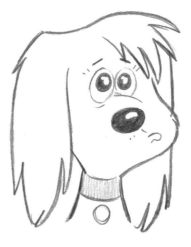

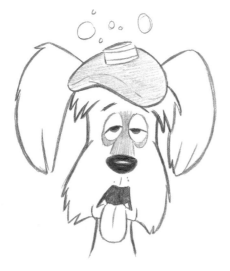

SICK AS A DOG

Feeling under the weather? Not as bad as this guy. Note the "sickness bubbles" dancing over his head. The ears droop and the eyes are sunken, with eyelids at half-mast. Make sure the lower lip curves up in the middle, so that it doesn't form a smile.

SNEAK-A-PEAK

He's almost sleeping, but still keeping one eye on the lookout. The sleeping eye is shut; the "awake" eye is three-fourths closed. (If the "awake" eye were all the way open, he would look startled.) Note the eyebrow action. And blow a little whistle through his lips, to make it seem like he's snoring.

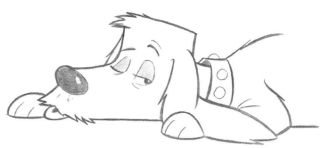

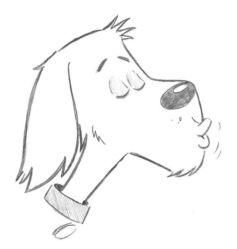

SMOOCHIE POOCHIE

Our Casanova is puckering up for a kiss. Adding tiny motion lines near the lips make the expression funnier. Close the eyes and lift both eyebrows. Lean him forward and put a little strain in his neck.

SO SELF-CONFIDENT!

That single tooth poking up from the lower jaw gives his grin an extra degree of self-assuredness. But the real statement is made with those half-closed eyes, with the eye-balls tucked under heavy eyelids.

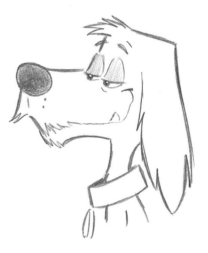

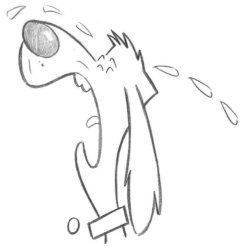

BOO HOO!

Despair never looked so funny! Do you know which part of this drawing makes the image work so well? All the elements are impor-tant, but one is most important—the way the lower lip curls back as it rises up into the mouth.

DAYDREAMER

His eyes are half-closed, but even more important is the way they look off into the distance. A long, goofy grin accompanies the expression.

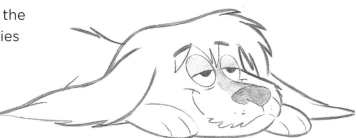

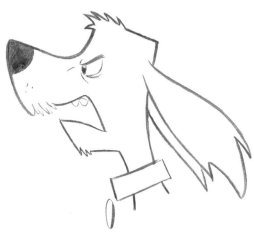

RRRRUFF!

Angry eyes and a voluble mouth show that he's mad about something! For an expression like this, pull the mouth down sharply at the corner and swing the ears to show the head's movement.

GRUMPS

This is a "take" in which the character looks at the reader for a beat. It's a funny pause in the action. The eyebrows go straight across both eyes.

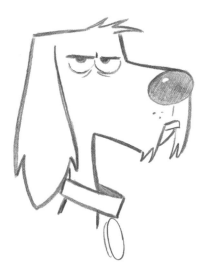

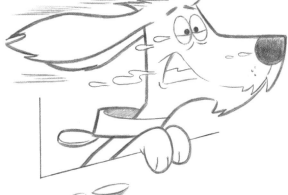

EXTREME STRESS

Let's have some liberal use of eye, mouth, and nose drool, if you please. Yuck!

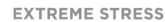

DOUBLETHINK

Point the head in one direction, but have him suddenly look back in the other direction. Both ears perk up well over the head, showing alertness.

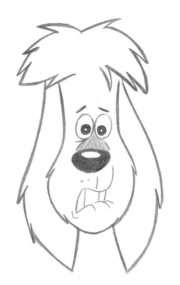

YUM!

Keep the bone in the front of the mouth, held by the front teeth. Curl the mouth and widen the cheeks to accommodate the smile. Remember to make the bone large—it's the focus of the image.

OH NO!

A sudden bad thought! A few of the top teeth bite down on the lower lip. The lower lip creases, and the eyebrows show concern.

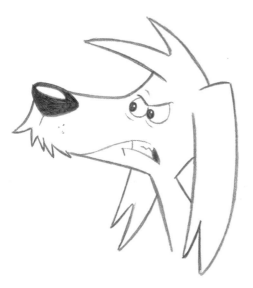

ANNOYANCE

Grit the teeth and ruffle the fur on the front of the lip. Make the eyebrows press down.

Drawing the Entire Figure

Now we move on to drawing the entire figure: head and body together. Remember that they work as a unit. To make it funny, we caricature the body just as we caricatured the face. Do you remember how we created cartoon characters' heads by first drawing basic shapes? Well, that's also how we create cartoon bodies. When you think of the torso as a basic shape, it becomes easier to draw.

In this chapter, we're going to focus on the age categories to which most cartoon characters belong—the specific ages that are most popular among comic book readers and the audiences for animated TV programs. If you flip on the TV and have a look at the popular animated shows, you'll see what I mean: There aren't very many shows starring senior citizens, babies, or toddlers, but there are lots of kids, teens, moms, and dads. If you want to develop your own original comic strip, comic book, or animated show, you'll have the best chance of success if you stick with characters in these age groups.

SMART KIDS

Let's start with the kids who are generally smarter than their parents and wise beyond their years. Each is a "type": the Genius, the Psycho, the Social Outcast, the Gossip, the Tattletale, and so on. Typically, they're between eight and twelve years old. But if you think that characters like this are only for kids' shows, you're wrong. Many TV shows with cutting-edge humor—and some of the best writing on television—star kid characters. And, in fact, most of the kids' shows are written on two levels so that they can be enjoyed by children but also by older audiences who get the more sophisticated humor that is always included. This is equally true of the design of the characters and backgrounds: It's very witty and can be enjoyed at a simple level or appreciated with a more nuanced eye.

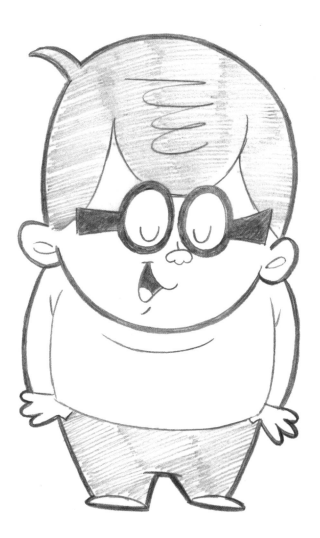

The Know-It-All Type

He's smug. His hand pops up every time the teacher asks a tough question no one else can answer. We often give smart characters prominent eyeglasses and well-groomed hair.
We also make them physically unassuming, or downright out of shape. We also make them look like mini-grownups: This guy is only one and a half heads tall, which is an impossibly short proportion! At that height, this character is truncated all over, which gives him plump, chunky proportions—a humorous look.

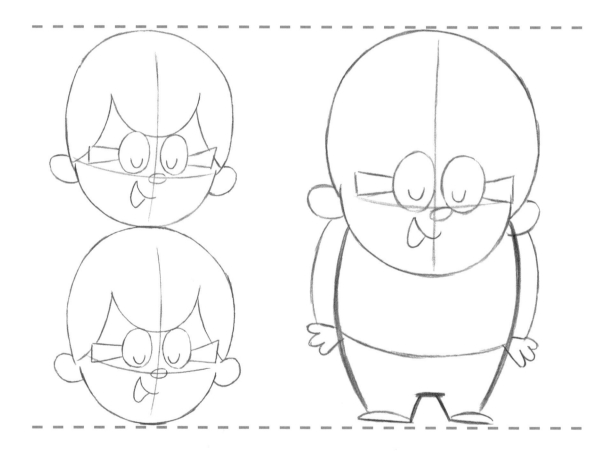

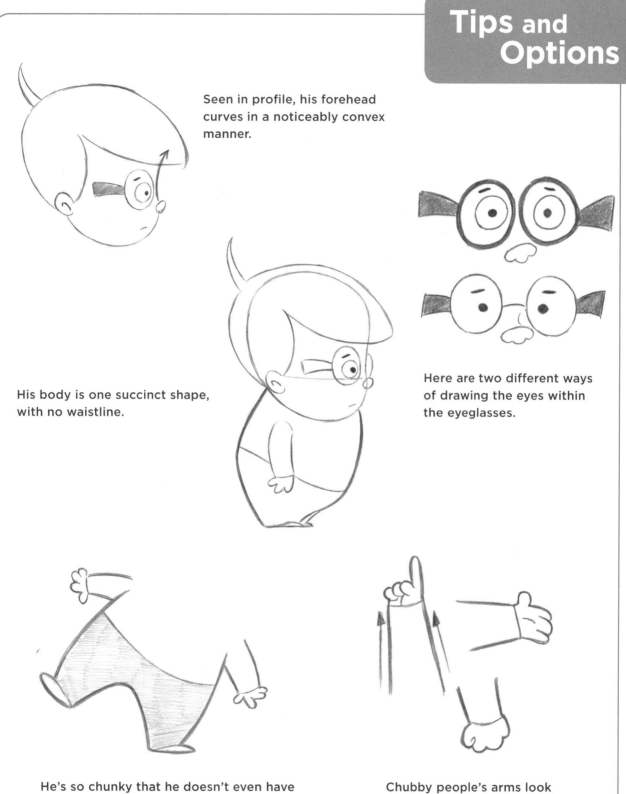

Seen in profile, his forehead curves in a noticeably convex manner.

His body is one succinct shape, with no waistline.

Here are two different ways of drawing the eyes within the eyeglasses.

He's so chunky that he doesn't even have knees to bend or a waistline to crease, so he has to lean his entire body and waddle to move a leg forward.

Chubby people's arms look funnier if you draw them tapering from fat to thin.

Typical Schoolgirl

Schoolgirls usually fall into one of two categories: sadistic or perky. Here is the affable type. (The sadistic type has been done to death.)

She usually has a wiry build, and she's usually taller than boys her age, as girls mature younger and faster. She looks a little like a matchstick—a big head on a small frame. Don't dress her in anything too fashionable. She's a young teen—just before fashion and shopping mania take hold of her and her father's wallet! (The skirt and knee socks make for a good schoolgirl look.)

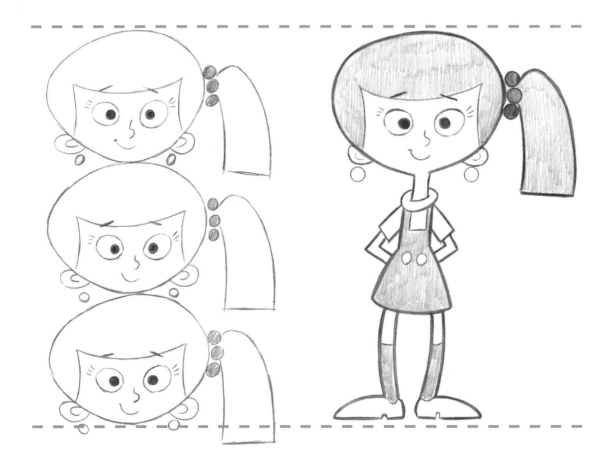

AS YOU CAN SEE, SIS IS THREE HEADS TALL.

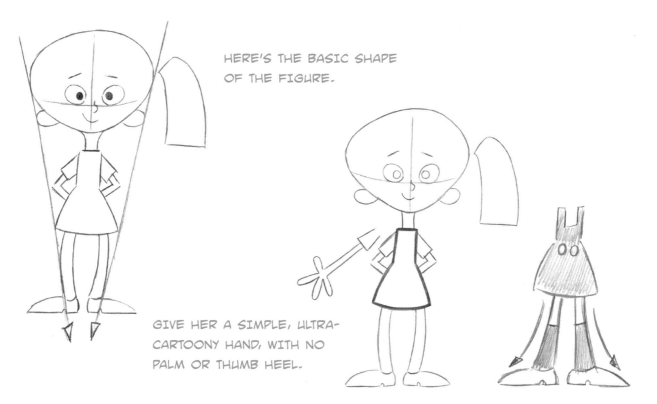

HERE'S THE BASIC SHAPE OF THE FIGURE.

GIVE HER A SIMPLE, ULTRA-CARTOONY HAND, WITH NO PALM OR THUMB HEEL.

SHE'S FUNNIER BOWLEGGED THAN KNOCK-KNEED.

Tips and Options

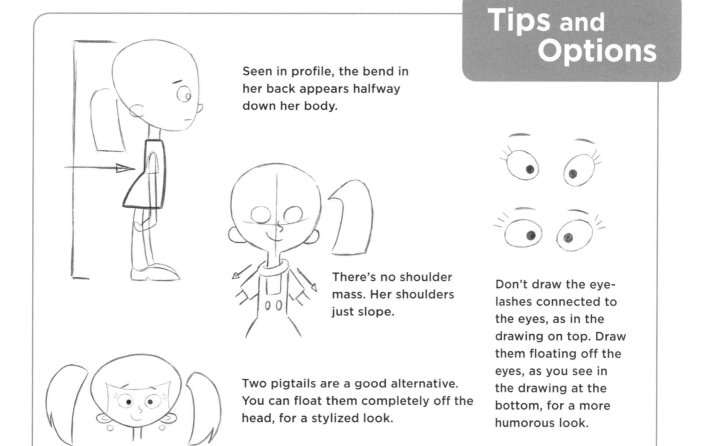

Seen in profile, the bend in her back appears halfway down her body.

There's no shoulder mass. Her shoulders just slope.

Two pigtails are a good alternative. You can float them completely off the head, for a stylized look.

Don't draw the eyelashes connected to the eyes, as in the drawing on top. Draw them floating off the eyes, as you see in the drawing at the bottom, for a more humorous look.

TEENAGERS

Teens frequently star in animated comedy-adventures, where they have humorous faces but athletic bodies that can quickly leap into action. Other teen characters—nerds, slobs, goths—may not be so adventurous, but they are nonetheless entertaining.

Teenage Boy: The Cool Nerd

This character is a funny combination of hip and goofy, sort of a cool nerd. Unless they're bullies or jocks, teenage guys have skinny, slight physical frames. Long arms and legs are key to their proportions. This older boy is many heads taller than the younger boy character we drew earlier—five and a half heads instead of just two.

KEEP A TEEN CHARACTER'S HEIGHT IN THE FOUR- TO SIX-HEADS RANGE. THIS GUY IS FIVE AND A HALF HEADS TALL.

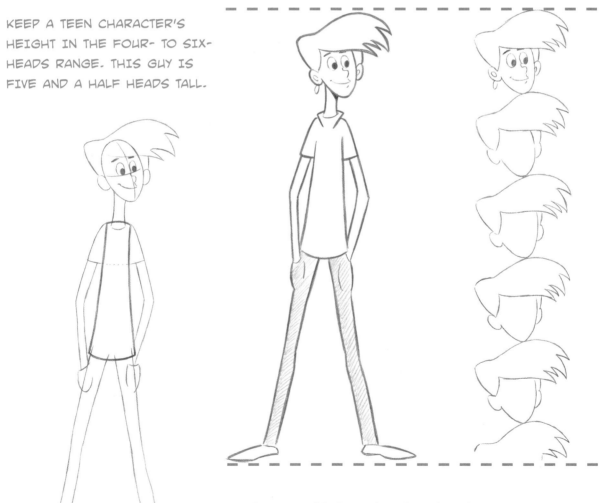

THE DARKER OUTLINE SHOWS THE BASIC SHAPE OF THE TORSO. IT EMPHASIZES HIS NARROW SHOULDERS.

Don't make his legs perfectly straight, as on the left. It gets boring for the eye to follow a long straight line. Instead, add a little jag in the middle of the leg—something subtle, but just enough so add some life.

The collar—in this case, a turtleneck—is not drawn straight across, but is rounded, encircling the neck.

This side view of our teen guy shows how he leans back—a posture that emphasizes a concave chest wall. Pull his hair far forward for a cartoony style. And pop that collar for a preppy look!

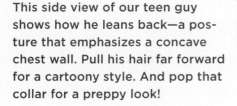

On lanky cartoon characters, exaggerate the length of the arms so that the tips of the fingers reach to just a few inches above the knees. (On a real person, the fingertips would fall midway between the hips and the knees.)

Pretty Teenage Girl

The teen girl has an attractive figure, featuring a short torso and long legs. Keep the hips wide but the waist narrow. And look at her face: a simple, perfect oval, which makes a pretty character and is easy to draw, too. Don't overcomplicate it. Her extra-long hair is a teenage thing.

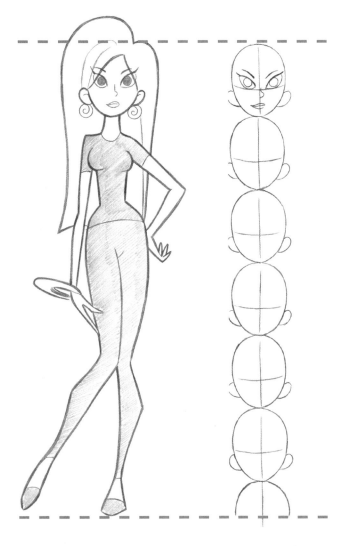

SHE'S SIX AND A HALF HEADS TALL—CLOSE TO A FEMALE MODEL'S PROPORTIONS. A SMALLER PERCENTAGE OF HER OVERALL HEIGHT IS TAKEN UP BY HER HEAD AS COMPARED TO THE TEENAGE BOY CHARACTER.

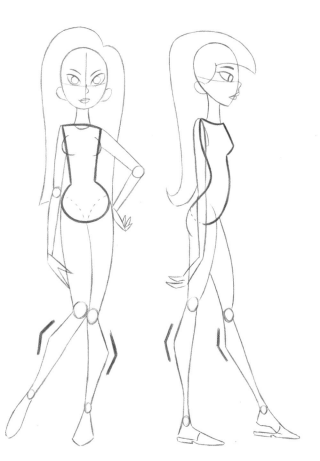

HER TORSO IS A VERY SIMPLE SHAPE: AN UPSIDE-DOWN KEYHOLE. BUMP OUT HER CALF MUSCLES—BRINGING THEM ALMOST TO A POINT. THE SHARPER THE ANGLES (NOTE THE SHOULDERS, TOO), THE MORE STYLIZED THE CHARACTER WILL LOOK.

HERE'S A SIDE VIEW OF THE CHARACTER. NOTICE THAT HER TORSO ISN'T STIFF, BUT VERY PLIABLE AND ELASTIC.

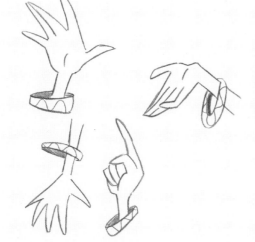

Draw female hands differently from male hands. Fingernails are not necessary (unless she's a witchy old character), but the fingers must taper. The knuckles should not be apparent.

The height of the hair and the length of her neck are the same.

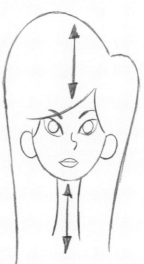

To give the stance some movement, draw one foot poised on its toe, the other flat on the ground (and foreshortened).

Note how the hips bump out quite suddenly. Don't soften the angle.

PARENTS

In cartoonland, parents are generally portrayed as happy idiots, blissfully unaware that their kids are in the basement working with their science kit and hatching a diabolical plot to take over the world.

Clueless Dad

The cartoon dad is a nice guy, but he's generally clueless, which is why he's so often drawn with his eyes closed or hidden behind big, thick glasses. The refrain, "How was school today, Butch?" could be answered with, "I set the teacher on fire," and the response from Dad would still be, "Well that sounds fine. Come in for dinner. Mom made your favorite: crunchy liver casserole!"

 With kooky characters like this, we can have fun stretching out the basic shape, posture, and proportions. Note Dad's simple head shape and how it melds into the neck without making a distinct break. That's because he's a "weak-chinned" character. Weak-chinned characters are, by definition, funny. Let's have a look.

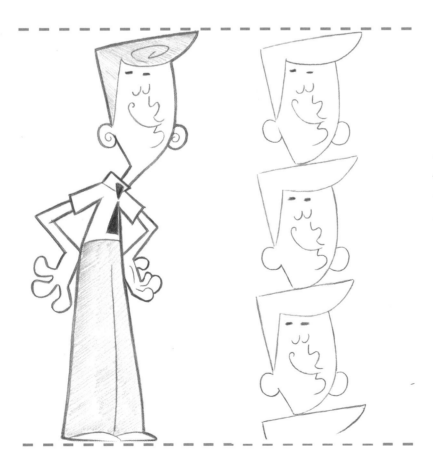

THE CARTOON DAD IS ABOUT THREE HEADS TALL. MAKE HIM TALLER THAN THAT—AS MEASURED BY HEADS—AND YOU'RE IN DANGER OF GIVING HIM "REAL" PROPORTIONS. YOU WANT THE HEAD TO REMAIN OVERLARGE AS COMPARED TO THE BODY, TO KEEP HIM CARTOONY AND WACKY.

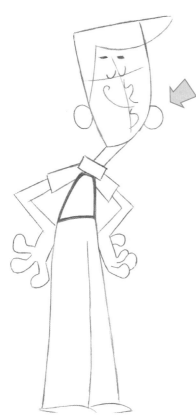

DAD'S TINY UPPER BODY IS CUT OFF BY A HUMOR-OUSLY HIGH BELT LINE. SHOW HIS EAR POPPING OUT ON THE FAR SIDE OF HIS HEAD, FOR A GOOFY LOOK. THE OVERSIZED HANDS CONTRIBUTE TO HIS OVERALL CARTOONY APPEARANCE.

THE BACKWARD BEND IN THE NECK READS AS FUNNY.

Get the
Details Right

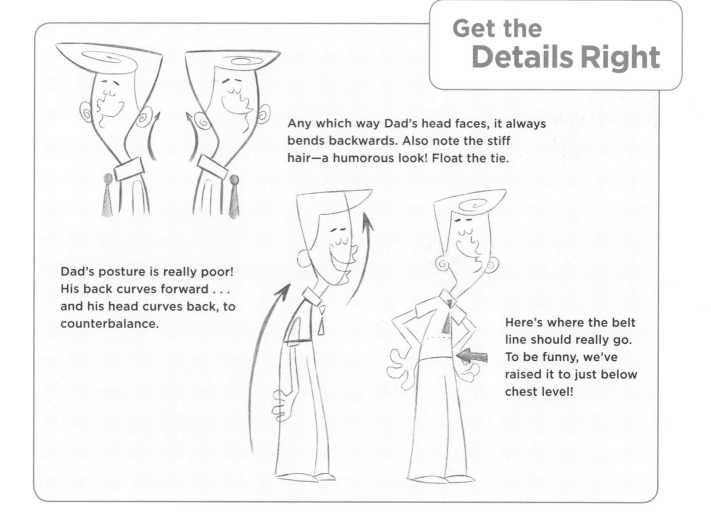

Any which way Dad's head faces, it always bends backwards. Also note the stiff hair—a humorous look! Float the tie.

Dad's posture is really poor! His back curves forward . . . and his head curves back, to counterbalance.

Here's where the belt line should really go. To be funny, we've raised it to just below chest level!

"With It" Mom

Like the cartoon Dad, the cartoon mom has a chipper personality. But she's much more "with it"—or at least she tries to be. But that's not necessarily a good thing. Listening to your mom use the latest teenage slang is enough to make you want to barf.

Having children, getting older, and the effects of gravity have done a lot to alter her physique over the past sixteen years—in ways that going to aerobics classes twice a week can't fix. She's grown a bit of a tummy and put on a few pounds in the caboose, too. But, despite it all, she remains bright eyed.

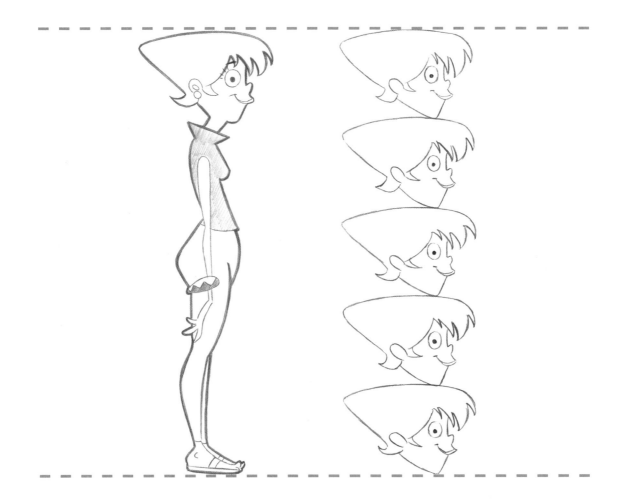

CARTOON MOMS ARE USUALLY ABOUT FOUR TO FIVE HEADS TALL. THERE'S A LITTLE PROTRUSION AT THE TUMMY AND—UH-OH!—A LITTLE TOO MUCH PADDING IN THE REAR END.

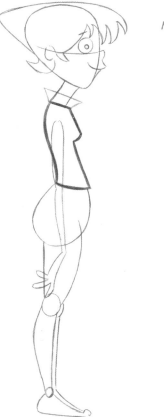

MOM'S UPPER BODY REMAINS THIN.

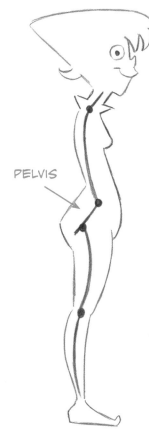

PELVIS

THIS STICK-FIGURE SKELETON SHOWS THE BASIC ANGLES OF MOM'S BODY. NOTICE THAT ALL THE LINES (EXCEPT THE ONE REPRESENTING THE PELVIS) ARE CURVED.

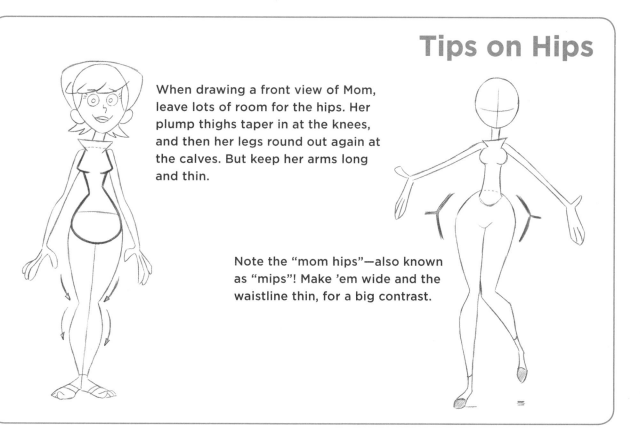

Tips on Hips

When drawing a front view of Mom, leave lots of room for the hips. Her plump thighs taper in at the knees, and then her legs round out again at the calves. But keep her arms long and thin.

Note the "mom hips"—also known as "mips"! Make 'em wide and the waistline thin, for a big contrast.

Designing a Character

Head shapes? Check. Eyes, nose, ears? Check, check, check. Bodies and proportions? Check, check. Okay. Now that we're armed with a solid background in cartooning basics, we sally forth into the really fun area of coming up with our own original characters. This is where we put it all together. Each character we create will have a different age, family role, occupation, or personality. As we go, take note of how we exaggerate specific physical traits to highlight those differences.

As we build our characters, we'll continue to take gradual, easy-as-you-go steps. And I'll include lots of tips and options along the way. If you get stuck at any point, slow down and try to isolate the problem. But don't get bogged down. It doesn't have to be perfect.

That said, these steps have been designed to be simple and concise, so that none of them should be beyond your ability.

Little Toughie

Bullies are fun characters to draw, and popular foils on animated TV shows. Football is just his excuse for being able to get away with crushing his classmates on the field. We can tell his attitude by a few simple characteristics: the upturned, punky nose; the heavy eyebrows; and the blockhead with the razor-cut hairdo. A bully character's body is mostly torso, with very small legs. I've also given him long arms, to make him look a little apelike.

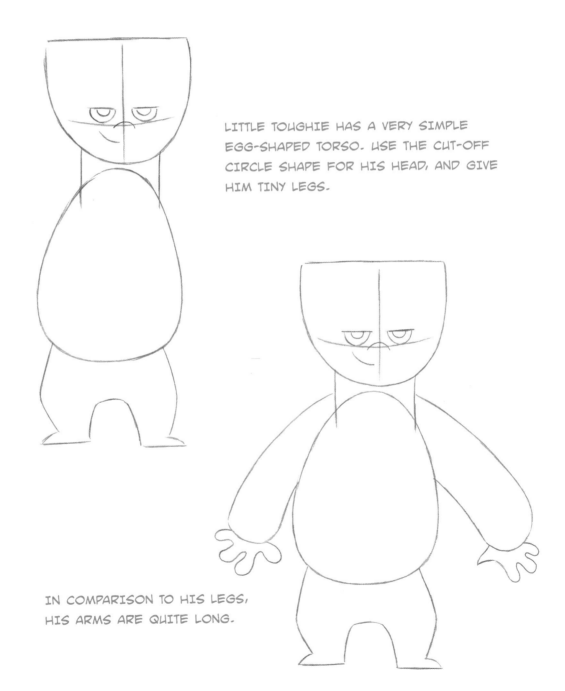

LITTLE TOUGHIE HAS A VERY SIMPLE EGG-SHAPED TORSO. USE THE CUT-OFF CIRCLE SHAPE FOR HIS HEAD, AND GIVE HIM TINY LEGS.

IN COMPARISON TO HIS LEGS, HIS ARMS ARE QUITE LONG.

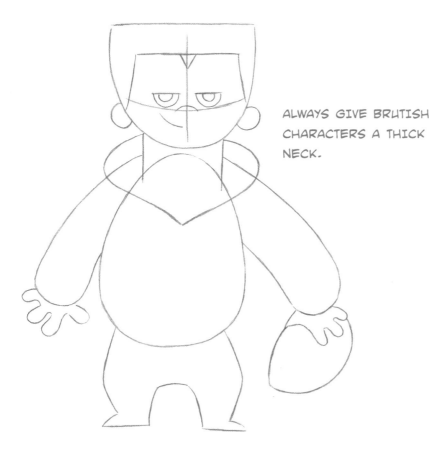

ALWAYS GIVE BRUTISH CHARACTERS A THICK NECK.

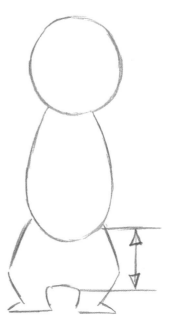

A LOW INSEAM MAKES HIM LOOK LESS MOBILE, THEREFORE FUNNIER.

BEFORE

DURING

AFTER

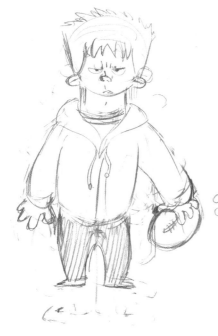

As you can see from this series of drawings—which go from the initial sketch, through an intermediary stage, to the final version—Little Toughie looked a little different when I was first playing around with the character. Often, characters require a few tweaks and adjustments along the way to their finished form.

Pajama Girl

If you want to elicit that synchronized "Awwww!" response in your audience, simply draw a little girl in a pair of pajamas and stick a teddy bear in her arm.

Very young, very cute characters like our Pajama Girl always look more coy with long hair. Most of her features—the small mouth and nose—are petite, but the eyes must be large. They're the focus of the face. And make sure you place the features low on the face.

WHO SAYS A CIRCLE CAN'T MAKE AN INTERESTING CHARACTER? IT'S A CLEAN, SIMPLE LOOK. HER P.J.'S SHOULD GO ALL THE WAY DOWN TO HER SKINNY LITTLE ANKLES—AND MAKE HER NECK SKINNY AND DELICATE, TOO.

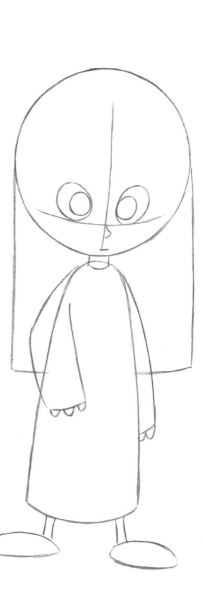

WHEN DRAWING THE HANDS, SHOW ONLY HER FINGERTIPS. NOTE THAT HER HAIR FALLS MIDWAY DOWN HER BACK.

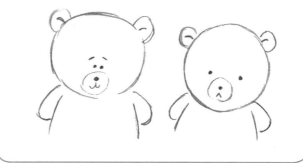

Bears vs. Teddy Bears

Cartoon-character bears' eyes are close together, but teddy bears' eyes are drawn wide apart—which indicates that they are dolls and not "living" animals.

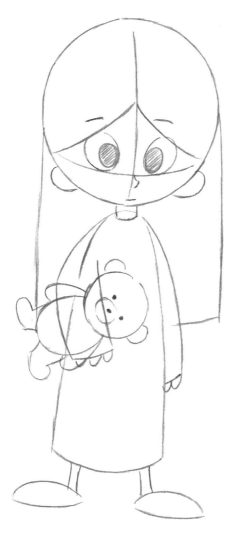

DRAW THE TEDDY BEAR AT A DIAGONAL.

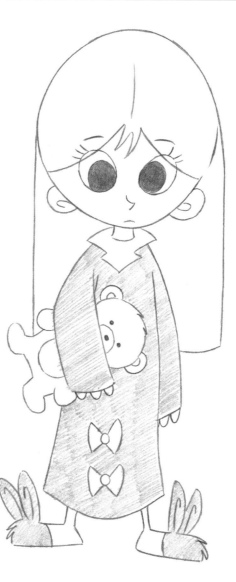

Stylish Woman

There's nice body-action going on in this pose. The simplicity of the body construction—just two circles connected by two lines—helps us to draw what would otherwise be a challenging pose. Like most stylish female characters, she's long legged and lanky. She's just a wisp of a gal, which makes her body easy to stretch in any direction.

HER BODY IS BASED ON SIMPLE CIRCLES. ALTHOUGH HER LEGS ARE THIN, THEY'RE WELL SHAPED.

EVEN SKINNY ARMS HAVE SOME MUSCLE DEFINITION—JUST NOT TOO MUCH.

The exterior lines of the legs are rounded, but the interior lines are straight—a stylish effect.

For a dynamic pose, tilt the shoulder plane and the hip plane in opposite directions.

Beach Bum

Here's a self-styled ladies' man: the seaside crooner. You can find him serenading the ladies near the boardwalk. And you can see the ladies leaving in droves! With his Elvis-wanna-be hairdo, he thinks he's irresistible. Give him a tank top, ragged cut-off shorts, and sandals. (These are his formal clothes!)

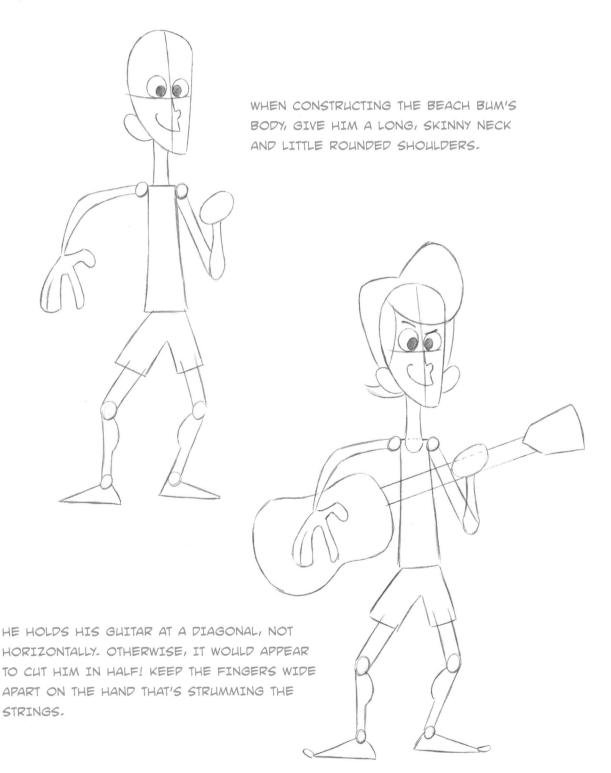

WHEN CONSTRUCTING THE BEACH BUM'S BODY, GIVE HIM A LONG, SKINNY NECK AND LITTLE ROUNDED SHOULDERS.

HE HOLDS HIS GUITAR AT A DIAGONAL, NOT HORIZONTALLY. OTHERWISE, IT WOULD APPEAR TO CUT HIM IN HALF! KEEP THE FINGERS WIDE APART ON THE HAND THAT'S STRUMMING THE STRINGS.

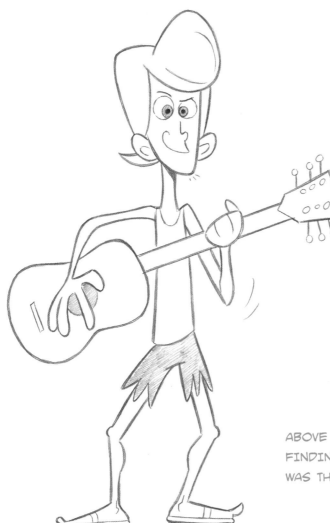

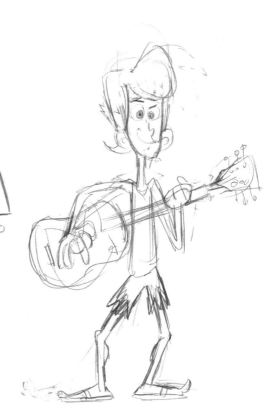

ABOVE IS MY INITIAL SKETCH FOR THE BEACH BUM.
FINDING THE CORRECT PLACEMENT OF THE ELBOWS
WAS THE KEY TO GETTING THIS POSE RIGHT.

Tips and Options

The sole of his foot can be arched, as in the previous drawing, or flat footed, as shown here.

The Beach Bum's knee bumps out, like a little cup, for a humorous effect. Show his calf muscle—but no other muscles.

Evil Henchman

Creating a character using an extreme graphic style like this is fun, and it's a different kind of exercise in cartooning—almost like arranging shapes rather than drawing. But that's the fun of it—trying to keep that extreme two-dimensional look. For this kind of figure, a super-thick pencil line is a must. It flattens out the entire form.

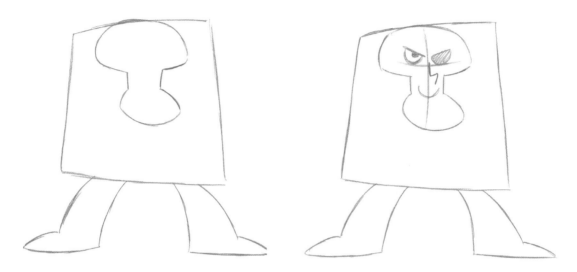

THE HENCHMAN'S HEAD IS A SIMPLE UPSIDE-DOWN KEYHOLE SHAPE. NOTE THE WIDE SKULL, THE SUNKEN CHEEKS, AND THE WIDE JAW (SLIGHTLY NARROWER THAN THE SKULL). DON'T HIDE THE FACT THAT THE BODY IS A RECTANGLE; EMPHASIZE IT, BY MAKING SURE THAT THE LEGS *DO NOT* GRADUALLY BLEND INTO THE UPPER BODY. (I KNOW, IT'S COUNTERINTUITIVE, BUT IT *WORKS!*)

THE SHOULDERS AND ARMS ARE DRAWN ALONG A SINGLE LINE. THE HENCHMAN'S SKINNY ARMS MAKE A FUNNY-LOOKING CONTRAST TO THE BIG SLEEVES AND THICK TORSO.

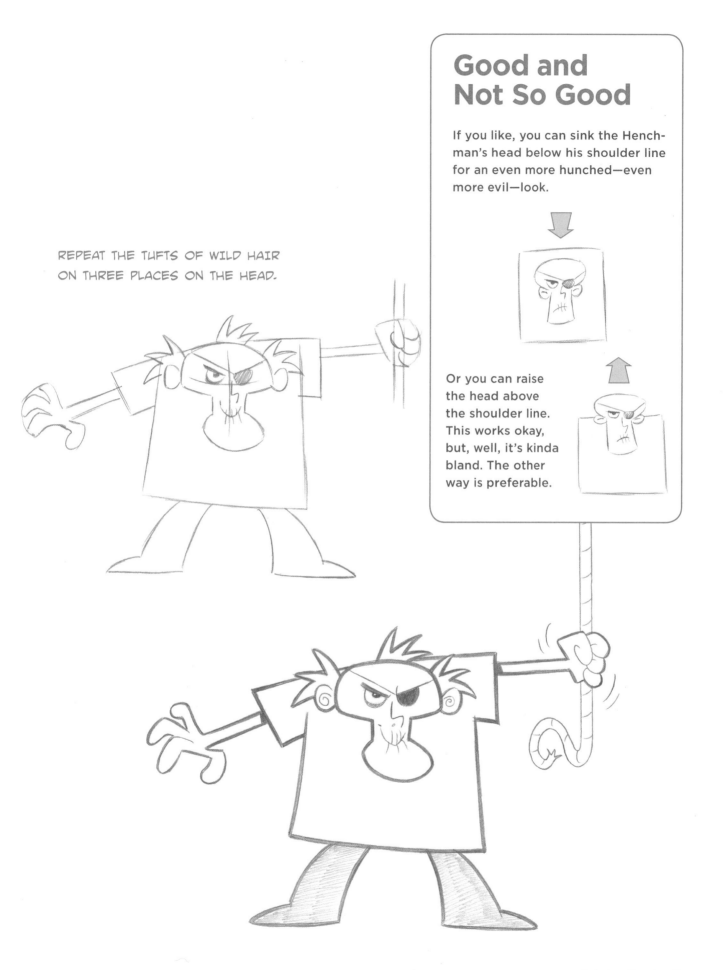

REPEAT THE TUFTS OF WILD HAIR ON THREE PLACES ON THE HEAD.

Good and Not So Good

If you like, you can sink the Henchman's head below his shoulder line for an even more hunched—even more evil—look.

Or you can raise the head above the shoulder line. This works okay, but, well, it's kinda bland. The other way is preferable.

Goofy Office Worker

Look at this guy's zany proportions: His head is actually bigger than his body, and the pointing arm stretches to twice the length of the relaxed arm! But what really makes him look silly is the placement of his facial features. Let's figure this out, or you might miss the subtlety of the construction—if you can call anything about this fella subtle!

NOTICE THAT BOTH EYES APPEAR MOSTLY ON THE SAME SIDE OF THE CENTER LINE. AND THE OPENED MOUTH IS ALSO WAY OVER TO ONE SIDE. THIS IS THE KEY TO HIS WACKY EXPRESSION. (NOTICE, TOO, THAT HIS BOTTOM OVERHANGS HIS LEGS.)

WHEN YOU DRAW THE POINTING ARM, EXAGGERATE THE SIZE OF THE INDEX FINGER AS WELL AS THE LENGTH OF THE ARM.

THE OFFICE WORKER'S TIE DOESN'T FALL STRAIGHT DOWN. IT CURVES AROUND HIS CHUBBY TORSO, FOLLOWING THE CURVE OF THE BODY'S CENTER LINE.

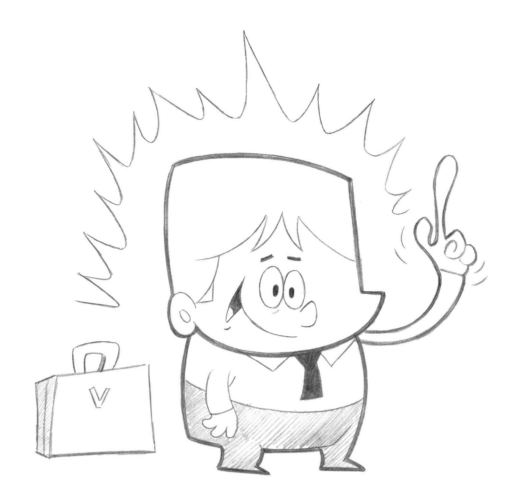

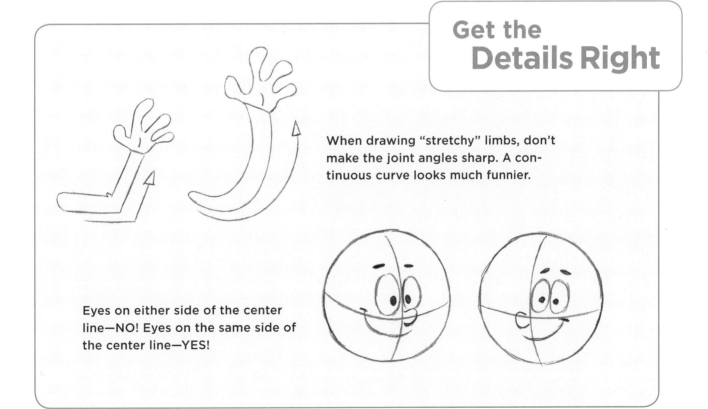

Get the Details Right

When drawing "stretchy" limbs, don't make the joint angles sharp. A continuous curve looks much funnier.

Eyes on either side of the center line—NO! Eyes on the same side of the center line—YES!

Harried Boss

He's "in charge," but not much seems to be going according to plan. Extra pounds—lots of 'em—are a good way to show that a character is stressed out and sublimating his anxiety with pizza and jumbo fries. But the fries have no trans-fats, so he's not worried. Ahem.

This guy's physique is built purely on carbs and coffee. Look at that back of his—it's just screaming for a chiropractor. And he's got an equally bulging tummy. There's no muscle tone in those arms, either. The only iron he's been pumping is the handle on the refrigerator door.

FOR ADDED VISUAL INTEREST, DRAW THE FRONT AND BACK BULGES ASYMMETRICALLY.

A HIGHER SHOULDER MIGHT LOOK MORE NATURAL, BUT A LOWER, SLOUCHING SHOULDER IS FUNNIER.

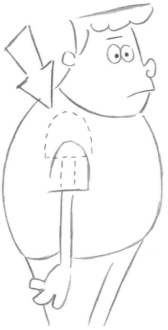

THE LINE OF THE BACK
MAKES AN S CURVE.

INDENT HERE

THE WIDER THE HARRIED BOSS
OPENS HIS MOUTH, THE FURTHER
BACK IT CUTS INTO HIS HEAD.

AMERICAN-STYLE MANGA

American-style manga blends Japanese manga and American cartoons. It's found mainly on TV animation. I'm not talking about those fake-out shows that pretend to be real Japanese anime but that in fact are done by American studios. American-style manga cartoons are definitely American and don't pretend to be anything else. But they do have a manga flair. They feature bouncy, attractive characters with some telltale similarities to their Japanese counterparts. Usually, they tell school stories or adventure stories. (Often the two are combined.)

American Manga Girl

The girl's small nose and mouth are borrowed from manga style. The head is constructed with a pointed chin, like most manga heads. But we don't need to add the giant eye shines that are typical of manga characters. We're not mimicking manga, only using some of its stylistic elements.

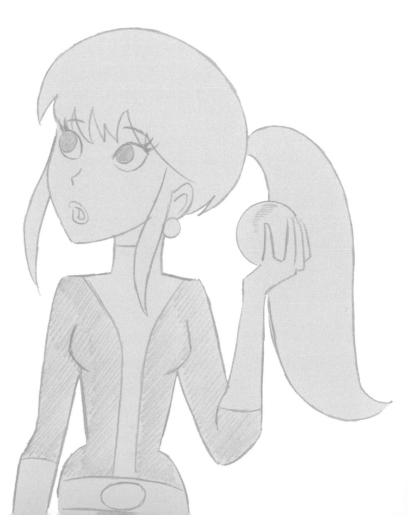

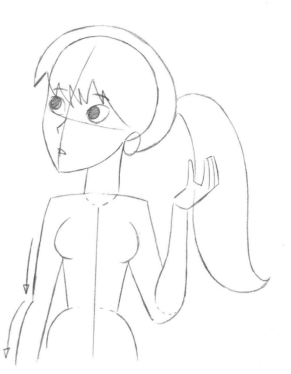

THE OUTER LINE OF HER ARM IS ROUNDED; THE INNER LINE IS STRAIGHT. THE WISPS OF HAIR FALLING IN FRONT OF THE EARS ARE PURE MANGA—MOSTLY SEEN ON "MAGICAL GIRL" TYPES IN THE MANGA SHINJO-FANTASY GENRE.

American Manga Boy

Like the girl, he sports a pointy, manga style chin. Note his pointy nose and tight mouth—both reminiscent of Japanese manga.

THE BOY'S HAIR FALLS FORWARD IN A SPIKY WAY, SHOWING A PRONOUNCED MANGA INFLUENCE.

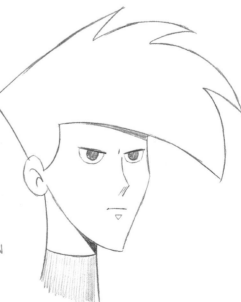

IN THIS THREE-QUARTERS VIEW, THE OUTLINE OF THE BOY'S FACE CURVES OUT ABOVE THE CHEEKBONE AND THEN TURNS IN TOWARD THE CHIN.

Costuming a Character

Cartoon costumes instantly bring characters to life. Costumes perform five major functions that casual, everyday attire can't do:

- They place a character in time—especially important if the character is a historical figure, like a pirate.
- They identify a character's occupation.
- They establish a character's a rank.
- They add glitz, glamour, and visual impact.
- They can make a character representative of a group.

Costumes are also fun to draw. A good costume doesn't have to be complicated to be appealing, but sometimes success lies in the details. The right accoutrement can be essential—whether it's a pirate's sword or a ray gun holstered at the side of a space commander's suit.

Now we're going to take the cartooning principles we've been practicing and extend them into the realm of cartoon costumes. I think you'll like this section because this stage usually comes after the hard work of constructing the character has already been done. So enough *talking* about costumes—let's get started drawing them!

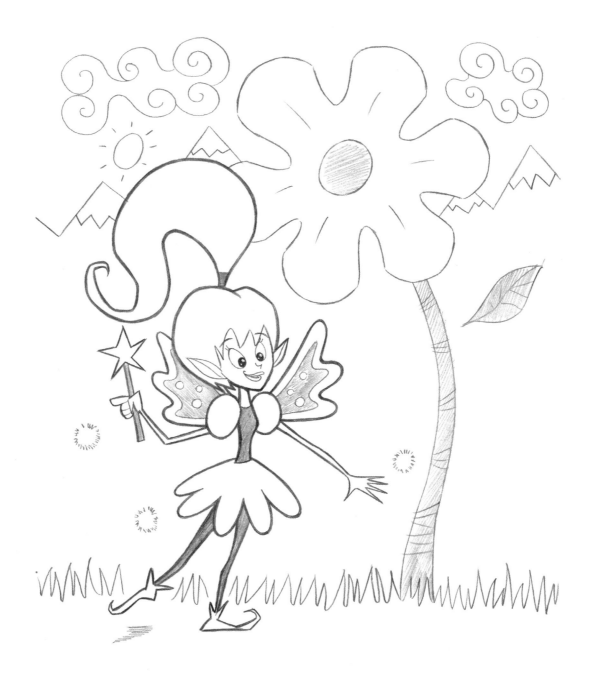

Pirate Captain

Aaarrrgggh! Pirates—those gluttonous, swashbuckling, no-good adventurers of the high seas—are all the rage. They come in every shape and size, but I prefer to draw the ship's captain, because he's got the most personality and wears the coolest hat! Rations might be scarce on a long ocean voyage, but the captain makes sure he's well fed—and it shows in his portly figure. Most off-ship pirate adventures involve treasure hunting, and, as you can see, our Pirate Captain is not really keen about the concept of "sharing."

Before we draw his costume, we still have to create the foundation—and that means constructing the head and body, just as we've been doing all along.

GIVE HIM A THICK BODY WITH NO WAISTLINE. HE DOESN'T HAVE A NECK; INSTEAD, HIS HEAD SINKS DEEPLY INTO HIS SHOULDERS.

THE SLEEVES OF HIS SHIRT ARE BELLED.

HE WEARS A CUMMERBUND (OR WIDE
BELT) AND A COCKED HAT. HIS HAIR IS
LONG—AND DON'T FORGET THE SIDE-
BURNS AND MUSTACHE. EQUIP HIM WITH
FENCING-STYLE SWORDS, AND PUT HIM
IN RIDICULOUSLY SMALL BOOTS, WHICH
ADD A FUNNY TOUCH ON THIS HEAVYSET
CHARACTER.

Confused King

It's fun to go against type. That's why I like to draw kings as weak and confused characters—feckless, but dressed in elaborate, incredibly self-important costumes. I've purposely made the King skinny, so that he looks overpowered by that oversized robe. The robe goes all the way down to the ground, so that we don't even see his feet. The robe's collar and cuffs are made of ermine—a prized fur that is white with black flecks in it. Traditionally, it was worn by royalty. (Note that the base of the crown also has a band of ermine.)

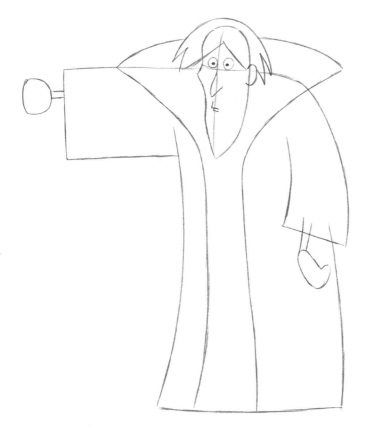

GIVE THE KING HUNCHED SHOULDERS, A LONG FACE WITH SMALL EYES, AND SKINNY WRISTS STICKING OUT OF THOSE HUGE SLEEVES.

THE ROBE'S COLLAR GOES WAY UP, ABOVE THE KING'S SHOULDERS. ADD A PROMINENT CHEEKBONE TO EMPHASIZE HIS GAUNT LOOK.

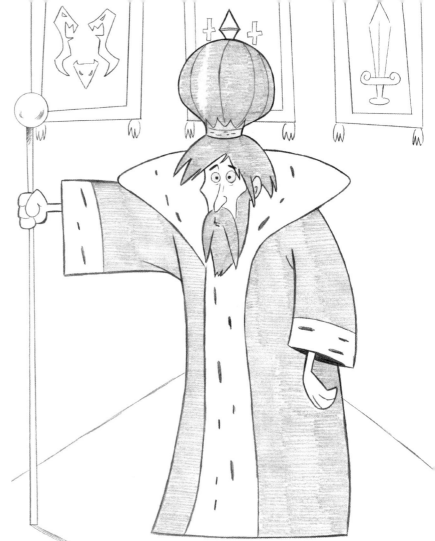

AND DON'T FORGET THE CROWN! ORDINARY THREE-POINTED CROWNS ARE A LITTLE TIRED, SO TRY TO DO SOMETHING NEW WITH THE CROWN. ADD A LITTLE STYLE. I LIKE TO GO OVERSIZE AND DO A NEW SHAPE. BY MAKING THE CROWN HUGE, I UNDERSCORE HOW UNIMPRESSIVE THE CONFUSED KING IS, BY COMPARISON.

Kid Jungle

Hey, with no television in the jungle, you gotta figure out some-thing to do with your time! So why not juggle a few coconuts? This wild-child is short and skinny but has long limbs. The long hair helps give him a feral look—as if he hasn't seen a barber in . . . well, not ever. His minimal costume features animal-skin spots. (By the way, you always need to match up characters' hairstyles with their costumes.)

THE BIG HEAD ON THE SKINNY NECK IS FUNNY, BUT IT ALSO SERVES THE IMPORTANT PURPOSE OF EMPHASIZING THE CHARACTER'S YOUTH. HIS BIG FEET UNDERSCORE THE GOOFY LOOK. NOTE THAT THE BASIC SHAPE OF THE TORSO INCLUDES THE KID'S LOINCLOTH, WHICH IS WHY IT WIDENS OUT AT THE BOTTOM.

HIS LEGS AND ARMS ARE CURVED, NOT STRAIGHT.

HIS BRIGHT-EYED EXPRESSION, SHOWS HE HASN'T BEEN JADED BY CIVILIZATION.

THE DIAGONAL STRAP ACROSS THE SHOULDER IS IMPORTANT. WITHOUT IT, THE COSTUME WOULD LOOK TOO MUCH LIKE A BATHING SUIT. IF YOU PREFER, YOU CAN FRAY THE BOTTOM OF THE LOINCLOTH, TO MAKE THE KID LOOK A LITTLE WILDER. BUT WHATEVER YOU DO, DON'T PUT SANDALS ON THOSE BARE FEET!

Hula Girl

This Polynesian beauty has a little body language going for her—the hip action in her native dance. Her grass skirt is worn low on the hips, below the navel. Ankle jewelry is a nice accent. Her top is designed to be reminiscent of seashells. Be bold with the earrings—large hoops instead of small studs. And a flower in the hair adds the quintessential Polynesian touch.

If you can get this drawing right, you're really raising your skill level! It's no easy feat to draw a character so that it really looks like she's dancing. One important hint: Draw the head slightly off to one side so that the neck is drawn on a diagonal.

ONE LEG IS PLANTED DIRECTLY UNDER THE HIPS AND BEARS MOST OF THE BODY WEIGHT. THE RELAXED LEG MOVES AWAY FROM BODY; ONLY THE TOE TOUCHES THE GROUND.

NOTE THAT HER FACE IS ACTUALLY AN OVAL, NOT A CIRCLE.

AS SHE SWAYS, HER LONG HAIR SWEEPS TO ONE SIDE.

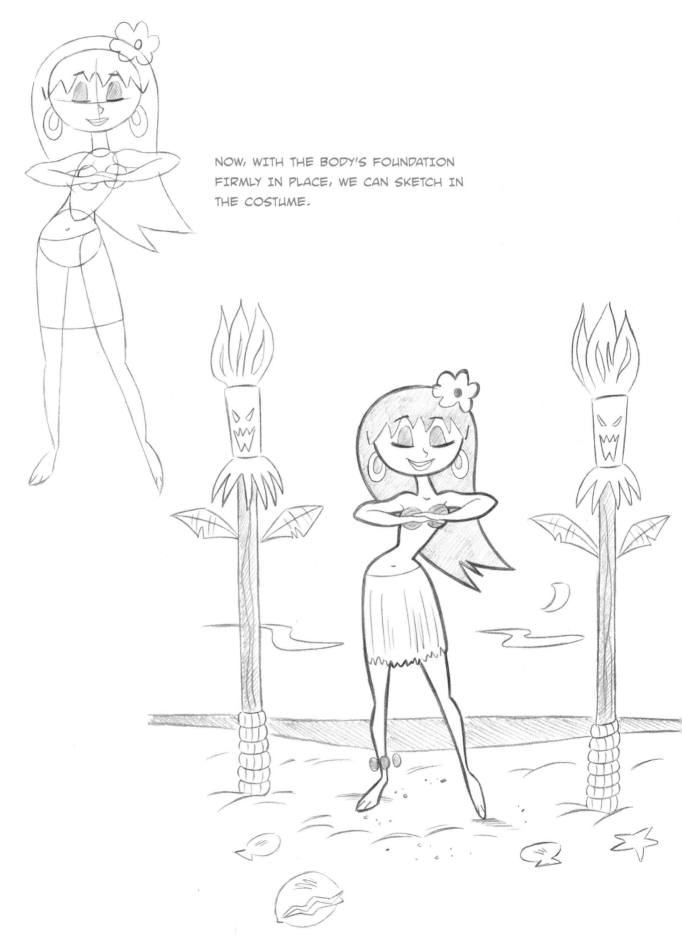

NOW, WITH THE BODY'S FOUNDATION
FIRMLY IN PLACE, WE CAN SKETCH IN
THE COSTUME.

Gigantic Genie

When you're creating a costume, what you leave out can be as important as what you put in. Gigantic Genie is a perfect example of this: He wears minimal clothing—nothing more than a loincloth, a turban of sorts, earrings, and thick bracelets. (Some genies also wear vests.) The beard is so essential to this genie's character that I consider it to be part of his costume. Some genies have mustaches as well as beards, but to make him unique, I've left the mustache out.

Take special note of the symmetrical pose. Comic poses are typically symmetrical, whereas dramatic poses are asymmetrical. That's why this totally symmetrical pose is funny, and you could never take this genie character seriously.

THE GENIE'S BODY IS A GIGANTIC EGG SHAPE.

THE OUTSTRETCHED ARMS SHOW ACTION WITHOUT PLACING THE BODY IN MOTION.

FOR A FLAT, GRAPHIC LOOK, DRAW THE LEGS ENTIRELY WITHIN THE OUT-LINE OF THE BODY.

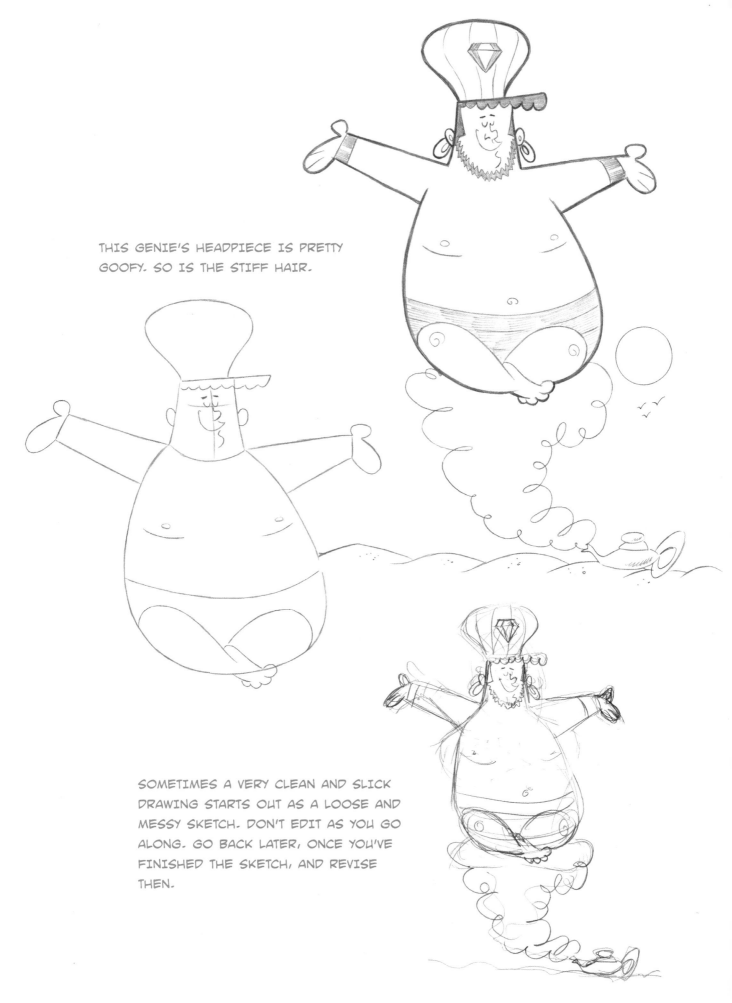

THIS GENIE'S HEADPIECE IS PRETTY GOOFY. SO IS THE STIFF HAIR.

SOMETIMES A VERY CLEAN AND SLICK DRAWING STARTS OUT AS A LOOSE AND MESSY SKETCH. DON'T EDIT AS YOU GO ALONG. GO BACK LATER, ONCE YOU'VE FINISHED THE SKETCH, AND REVISE THEN.

Lovable Viking

Historically, the Vikings were fierce and strong. When it comes to cartoon Vikings, though, you can toss those adjectives aside in favor of *fat* and *slow*! These terrible warriors of the past have been transformed by into lovable cuddle bears through the magic of the cartoonist's pencil—to the point where, today, most cartoon fans don't even know how brutal the Vikings really were.

If there is any costume element that's more iconic than a Viking's horned helmet, I don't know it. Instead of the kite-shaped shields typically used by knights of olde, Vikings used circular shields. They also wore animals skins and armor. I prefer to leave out the armor when drawing a Viking, however, since it tends to confuse readers. (Armor makes them think the character might be a knight.)

THAT'S QUITE A BELLY ON THIS LOVABLE VIKING. A LITTLE TOO MUCH MUTTON, EH? NOTE: WHEN DRAWING THE BASIC OUTLINE OF HIS FACE, INCLUDE ROOM FOR HIS CONSIDERABLE BEARD.

THE RIDICULOUSLY SHORT SWORD IS FUNNY. THE SHORT LEGS HOLDING UP SUCH A BRAWNY BODY ARE ALSO A HUMOROUS TOUCH.

VIKINGS WORE THEIR HAIR LONG IN BACK.

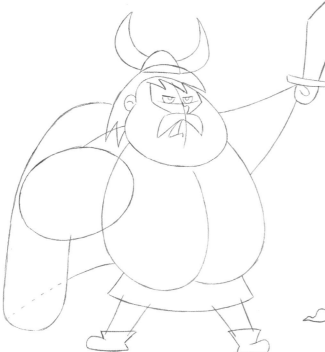

ANIMAL SKINS, WON IN BATTLE, DRAPE OVER HIS SHOULDERS LIKE A CAPE. DON'T FORGET THE MOST FAMOUS EM-BLEM OF THE VIKING'S COSTUME: HIS TRADEMARK HORNED HELMET. AND LAST BUT NOT LEAST, GIVE HIM A VERY VI-KING-LIKE EXPRESSION TO GO ALONG WITH HIS COSTUME. A ROBUST BATTLE CRY LEADS THE CHARGE.

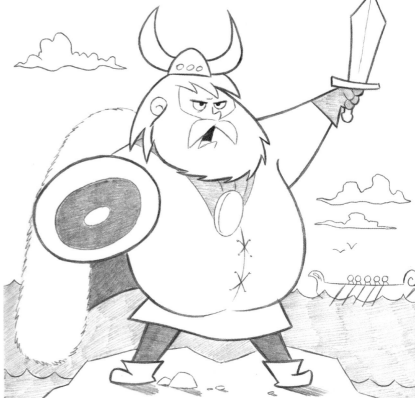

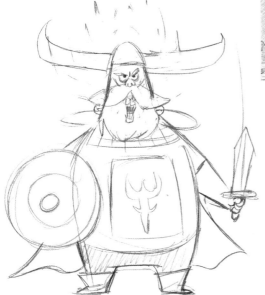

THIS WAS AN EARLY VERSION OF MY VIKING CHARACTER THAT NEVER MADE IT INTO THE "FINALS." I LIKED HIM, BUT HE JUST DIDN'T HAVE ENOUGH BRAVADO.

Rugged Roman

Here's a slightly different style—a look you'd be likelier to see in feature film animation than on TV. Our Roman soldier is a rugged, semi-realistic looking character rather than one of the more rubbery characters we've been drawing. It's good practice to try your hand at a few different styles.

Without the costume, the Roman soldier could be Joe Anybody—a modern newspaper reporter or even a suburban dad. But when he's outfitted with a battle helmet, chain mail, cape, and chest protector, his identity becomes crystallized.

Add some finishing touches: a little bit of hair peeking out from under the helmet, some crosshatching to indicate the chain mail, and a few rivets on the helmet and chin guard. I also like to shade the feathered top, so that you can tell it's made out of different material from the rest of the helmet. Add a lion—or your own emblem—to the front of the helmet. That space is good "real estate," so use it to create a logo for your character.

RUGGED CHARACTERS HAVE BIG, SQUARE CHINS AND THICK NECKS. NOTE, TOO, HOW ALL THE FACIAL FEATURES ARE DRAWN CLOSE TOGETHER IN THE CENTER OF THE HEAD SHAPE.

THE HELMET, AT FIRST, LOOKS LIKE A BASEBALL BATTER'S HELMET, WITHOUT EAR PROTECTORS!

CHAIN MAIL GUARDS THE
EARS AND NECK.

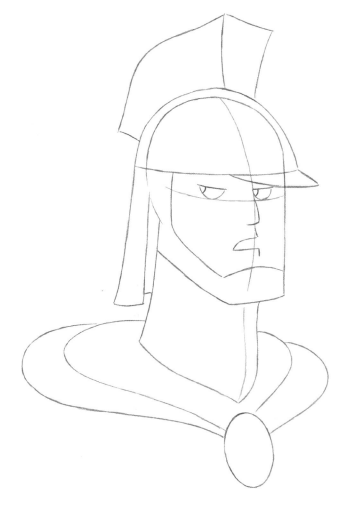

NOW ADD THE CHIN GUARD AND FACE GUARD.
CROWN THE TOP OF THE HELMET WITH AN
ELABORATE FEATHERED DECORATION. THEN
ENCIRCLE THE NECK WITH THE CAPE.

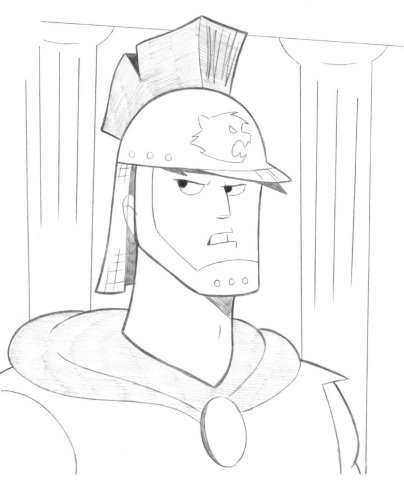

omic Cowpoke

This guy's wearing the "official cowboy uniform." Remember that costumes can help create comedy in a scene. If you were to give your sheriff a hat that's slightly wider than his head, it might always be sliding down over his face when he's threatening bad guys. The bad guys would just look at the camera, impatiently, while the sheriff struggled to pull the hat back up so that he could see.

You can also add little stars at his heels to indicate spurs, although you want to be careful that the picture doesn't start to look too busy. Leaving off the gun doesn't hurt the character any, and, besides, it's more politically correct!

Allow your Comic Cowpoke some sideburns and a little chin stubble, as he's been riding for days without a shave. As for the horse, think of it as one of the cowboy's props; wherever the cowboy goes, the horse goes too.

Now let's put all of the basic elements together.

NOTE THE FUNNY PROPORTIONS: THE UPPER BODY IS WAY TOO LARGE FOR THE BOTTOM HALF (WHICH FEATURES BOW LEGS). GIVE THE COMIC COWPOKE POINTY SHOULDERS, FOR A HIGHLY STYLIZED LOOK. THE PANT LEGS COVER MOST OF THE BOOTS—BUT MAKE SURE THE HEELS AND POINTY TOES SHOW!

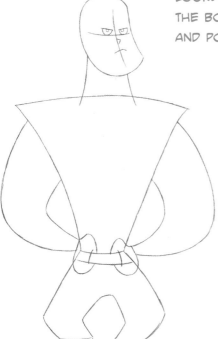

THE COWBOY'S HANDS CLUTCH HIS THICK LEATHER BELT, WHICH HAS A BIG METAL BUCKLE AT THE CENTER.

INDENT THE CROWN OF HIS HAT.
AND GIVE HIM A LEATHER VEST—
IT'S A MUST!

A COWBOY WEARS A SCARF OR
BOWTIE—NEVER A REGULAR TIE.

Super Villain

Now we move from past to future—and to some super-ridiculous heroes and villains. Let's start with the bad guys.

Some of the funniest villains of all time are little squirts. Imagine all that greed, ruthlessness, and ambition bundled up in a miniature package. These tiny fanatics make great characters, with their outsized personalities so completely at odds with their lack of physical prowess. Part of his "costume," we can fairly state, is his shadow. It acts as his alter ego, portraying an enlarged version of himself. It's just the way he envisions himself to be—incredibly impressive and important!

In super-characters' uniforms, the gloves and boots are often the same color—or have the same shaded tone—to tie them together visually. You'll notice this on many other cartoon characters in this book and in cartoons in general. Note how the black and white areas of the costume alternate, which makes it easy to read. Try this "checkerboarding" technique in your costume design.

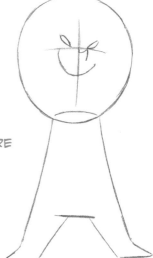

THE ENTIRE FIGURE IS LITTLE MORE THAN TWO HEADS TALL.

HIS ARMS OVERLAP HIS HEAD.

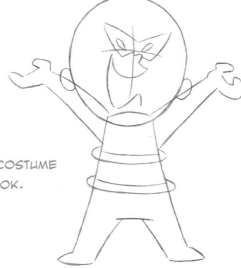

THE BANDS AROUND THE COSTUME GIVE IT A FUTURISTIC LOOK.

HIS OVERSIZED CAPE IS BIG ENOUGH FOR
HIM TO TRIP OVER! AND NOTE HOW SMALL HIS
EYE MASK IS: TEENY MASKS ARE FUNNY!

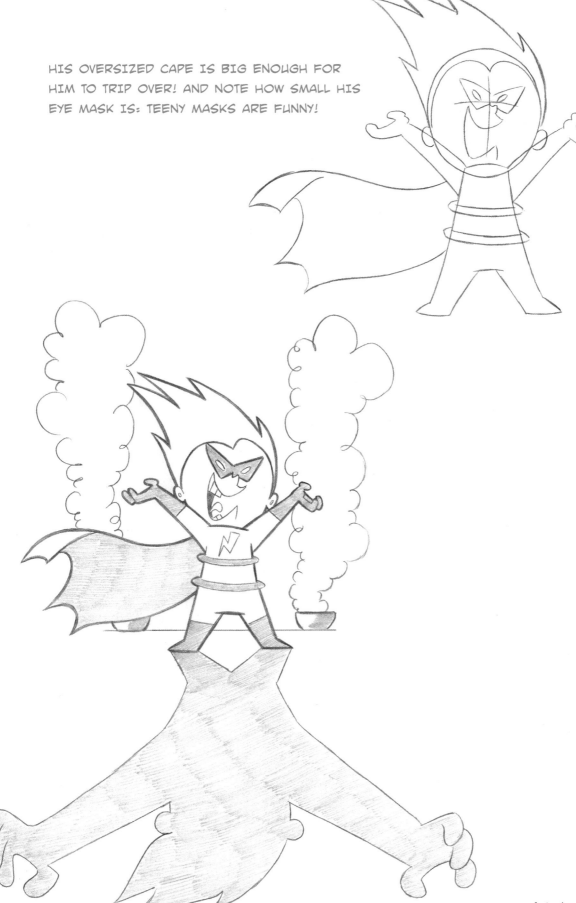

Super Kid

When not busy saying stupid stuff to girls in school or dozing off in the middle of math class, this kid is fighting crime and saving the human race from mutants from outer space. Since he's decidedly goofy, we're going to dress him in a sloppy super outfit, which should appear a little oversized. Forget about showing any shoulder muscles! Instead, we'll slide the lines of his neck directly down to form the lines of his torso. But just a few seconds under the Zentron 190 Atomic Incrediblizer, and our Super Kid's powers will be up to maximal capacity!

LEAVE OUT ANY HINT OF SHOULDER MUSCLES. HIS FACIAL FEATURES ARE PLACED LOW, NEAR THE BOTTOM OF HIS GIANT HEAD.

HIS EARS ARE FLAPPY, AND HIS UNTUCKED SHIRT HANGS LOW ON HIS TORSO.

HIS CAPE BLOWS DRAMATICALLY IN THE WIND. (WELL, MAYBE NOT DRAMATICALLY, BUT IT BLOWS IN THE WIND, ANYWAY!)

INDICATE THE BOOT AND GLOVE LINES.
AND DON'T FORGET THE INSIGNIA IN THE
MIDDLE OF SUPER KID'S CHEST!

Spaceship Commander

Here are the commander and his sidekick dog, who is still only an ensign.

Streamlined is the keyword for sci-fi costumes. They usually feature one-piece body suits. In the future, everyone wears uniforms, which generally look a little like . . . dare I say it? Pajamas! These non-wrinkling, non-creasing materials (you need never show a fold or a crease mark on them) are almost always form fitting, meaning that they hug the body and reveal the outline of the figure. It's a nice, clean look. Boots and gloves are important, but leave off the cuffs—that's old school.

THE SPACESHIP COMMANDER HAS WIDE, TOTALLY SQUARE SHOULDERS.

HIS ARMS ORIGINATE A TAD BELOW THE SHOULDER LINE, LEAVING THE SHOULDERS LOOKING POINTY.

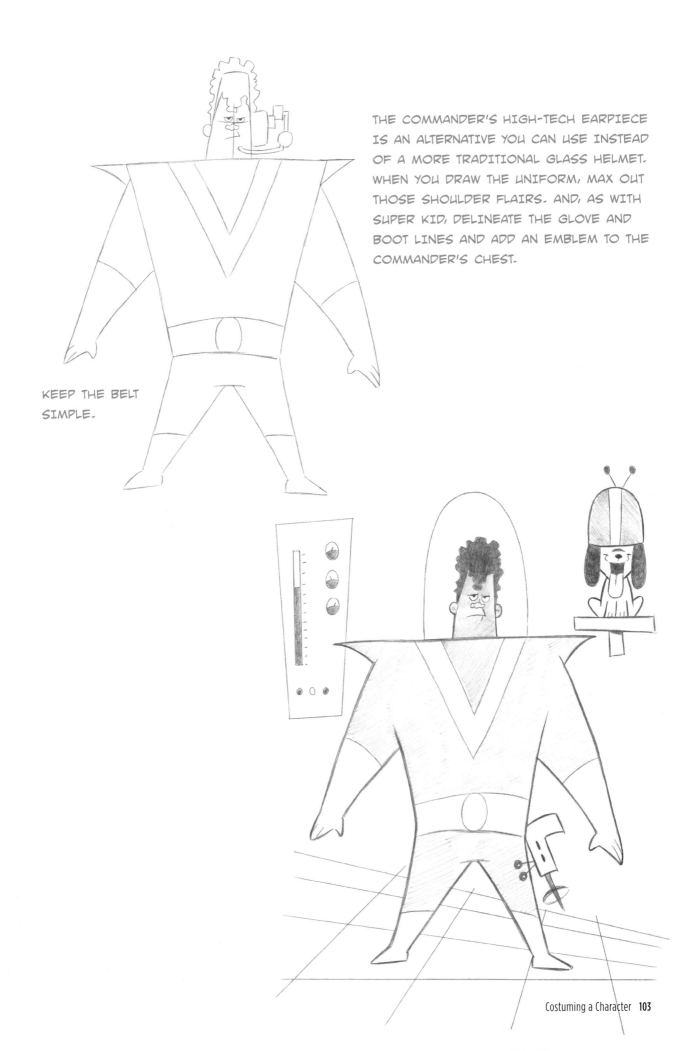

THE COMMANDER'S HIGH-TECH EARPIECE IS AN ALTERNATIVE YOU CAN USE INSTEAD OF A MORE TRADITIONAL GLASS HELMET. WHEN YOU DRAW THE UNIFORM, MAX OUT THOSE SHOULDER FLAIRS. AND, AS WITH SUPER KID, DELINEATE THE GLOVE AND BOOT LINES AND ADD AN EMBLEM TO THE COMMANDER'S CHEST.

KEEP THE BELT SIMPLE.

Aqua Gal

Pretty mutants of the deep require only a few adaptations to their basic anatomy. But these adaptations must have an aquatic theme. Anatomically, Aqua Gal has been given external fins and elf-like ears.

In addition, we have the shell motif: Her upper body is covered in a shell-themed piece of clothing. And the skirt's hemline is reminiscent of the scalloped edges of a shell. The necklace she wears has a scallop pendant. The earrings are starfish. The miniskirt and high boots give the costume a trendy look.

Before going on to the steps for creating this character, take a look at the background. What's the one element that's absolutely essential for underwater scenes, to make them *look like* they're underwater? A few fish swimming about? Well, that might help, but the fish aren't essential. It's the bubbles. Yep, simple bubbles. Without those, the surrounding environment will look like air. Add a few bubbles, though, and the atmosphere is suddenly transformed into water.

AQUA GAL'S BODY SHAPE IS SIMPLE AND SYMMETRICAL. HER LONG, THIN LEGS ARE LONGER THAN THE ENTIRE HEIGHT OF THE TORSO AND HEAD PUT TOGETHER!

GIVE HER ELFIN EARS AND FULL LIPS. NOTE THAT HER COLLARBONE GOES STRAIGHT ACROSS, FROM SHOULDER TO SHOULDER.

THE WAVY HEM OF HER SKIRT
MAKES IT LOOK LIKE IT'S FLOWING
IN THE WATER.

ADD THE EXTERNAL FINS BEFORE
PUTTING THE FINISHING TOUCHES
ON HER COSTUME.

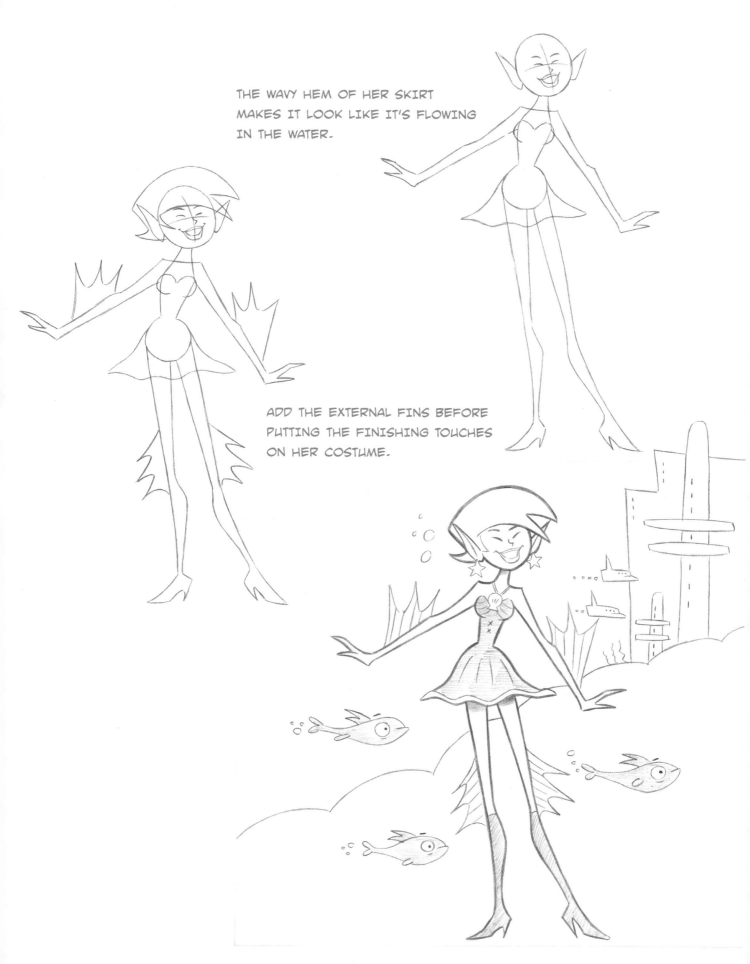

Conveying Body Language

Cartoon characters have many ways of expressing themselves: Animated characters use spoken dialogue; comic strip characters use speech balloons. But *all* cartoon characters communicate through gestures and poses. As the next step in our progress, we are going to take our ability to draw characters—which you're now probably having some success with—and raise it to the next level, applying body language to make our characters convey specific thoughts, attitudes, and emotions.

Posture

Posture can either energize a character or rob it of its energy. If a character's posture is drawn with feeling, the reader will be able to tell something about that character's personality—even without seeing the facial expression. Posture is the most basic component of body language—the pillar upon which a pose is based. As the drawings show, there are four basic postures, which correlate with four basic types of characters:

FORWARD LEANING
(AGGRESSIVE OR EAGER TYPE)

BACKWARD LEANING
(EASYGOING TYPE)

NEUTRAL (CUTE TYPE)

BENT KNEE (GOOFY TYPE)

Leg Placement—Standing Characters

When you first begin cartooning, you probably don't think too much about the placement of the legs in a pose. It may not seem as if there are a lot of options available to you, so you just draw the legs together each time. That's good enough to start with, but as you progress you'll want to add variety to your poses to increase visual interest. Fortunately, there are a host of standing leg positions to choose from. Here are five.

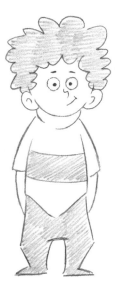

BENT LEG

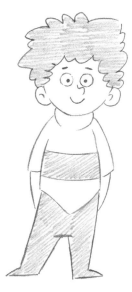

ONE LEG OUT

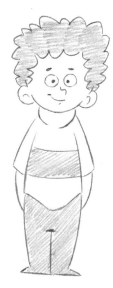

BOTH LEGS TOGETHER

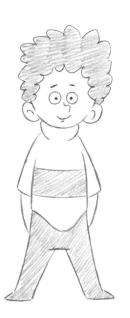

LEGS SPREAD APART

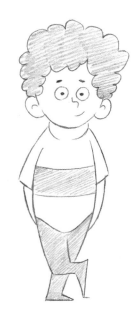

CROSSOVER

PUTTING PERSONALITY IN POSES

Have your character perform a little gesture to one side, show some shoulder action on the other side, and pretty soon you've constructed a pose that is absolutely adorable. Readers don't know why it's so darn appealing—they don't know the techniques and can't see the hard work that went into the drawing, but it's all there.

As cartoonists, we have to bring personality into poses. An expression never stops at the face; it continues through the entire body. There's one commonality to all the poses you're about to practice: They all have energy and vitality, even when the pose is glum instead of ebullient. It's essential that you infuse your characters with energy—that will make them pop off the page and grab the reader's attention. And you do that by focusing not so much on the task the character is performing (walking or running, say) but rather on the character's state of mind behind it (determined, frightened). That's because someone who is frightened will run in a very different manner than will someone who is determined.

Here are some important tools to use when creating personality in poses:

- Posture
- Shoulder Action
- Head Tilt
- Wrist Bends
- Tummy Sticking Out or Sinking In
- Proud or Sunken Chest
- Bend in the Knees
- Arching or Bent Back
- Hand Gestures
- Arm Gestures (Folded, Arms Akimbo, etc.)
- Stiff or Relaxed Body
- Foot Placement

Now, let's look at some specific examples.

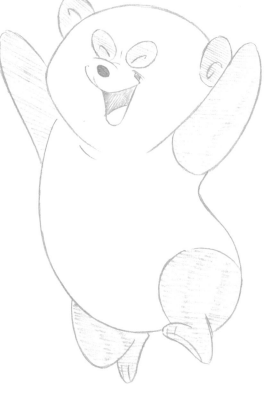

I'm Extremely Confident.

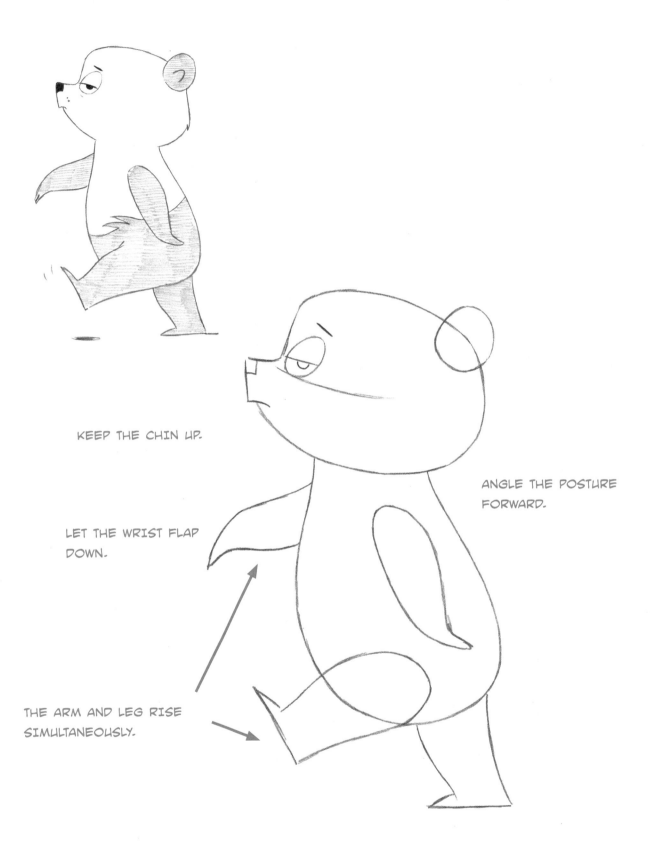

KEEP THE CHIN UP.

ANGLE THE POSTURE FORWARD.

LET THE WRIST FLAP DOWN.

THE ARM AND LEG RISE SIMULTANEOUSLY.

Brilliant Idea!

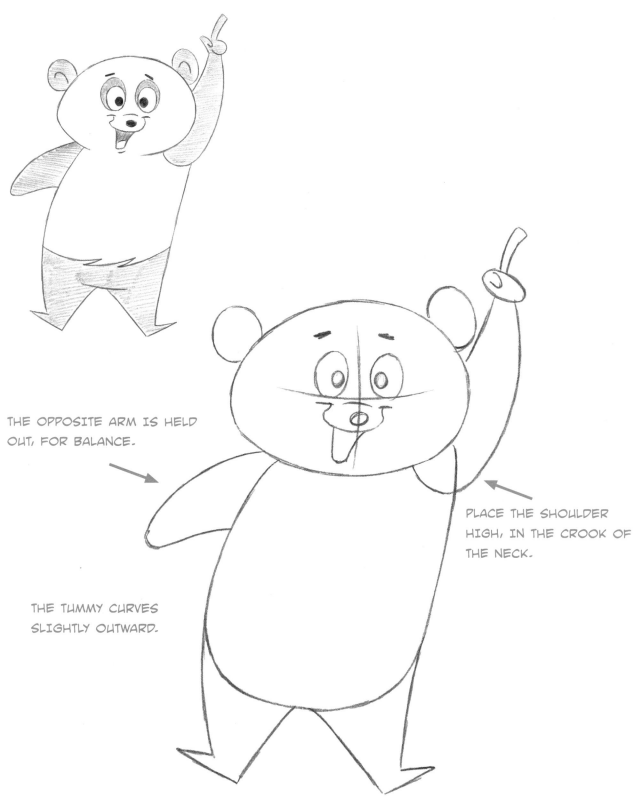

THE OPPOSITE ARM IS HELD OUT, FOR BALANCE.

PLACE THE SHOULDER HIGH, IN THE CROOK OF THE NECK.

THE TUMMY CURVES SLIGHTLY OUTWARD.

ROCK HIM BACK ON HIS HEELS.

I Just Remembered!

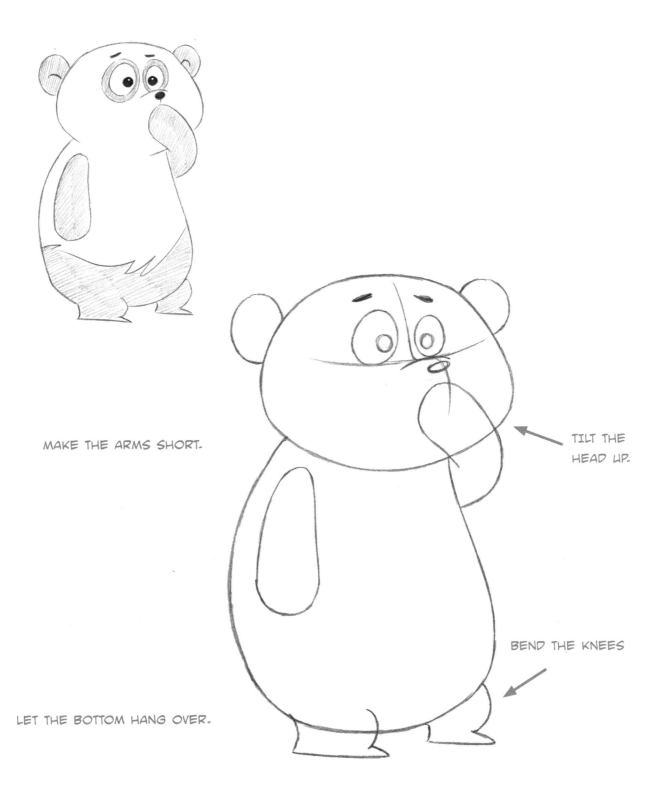

MAKE THE ARMS SHORT.

TILT THE HEAD UP.

BEND THE KNEES

LET THE BOTTOM HANG OVER.

Now Where Was I?

THE PAW GESTURE SHOWS
CONFUSION.

THE TUMMY'S OUT, AND THERE'S
A SLIGHT SWAY TO THE BACK.

PLACE THE OTHER PAW
HIGH ON HIS HIP.

I'm Madder than Heck!

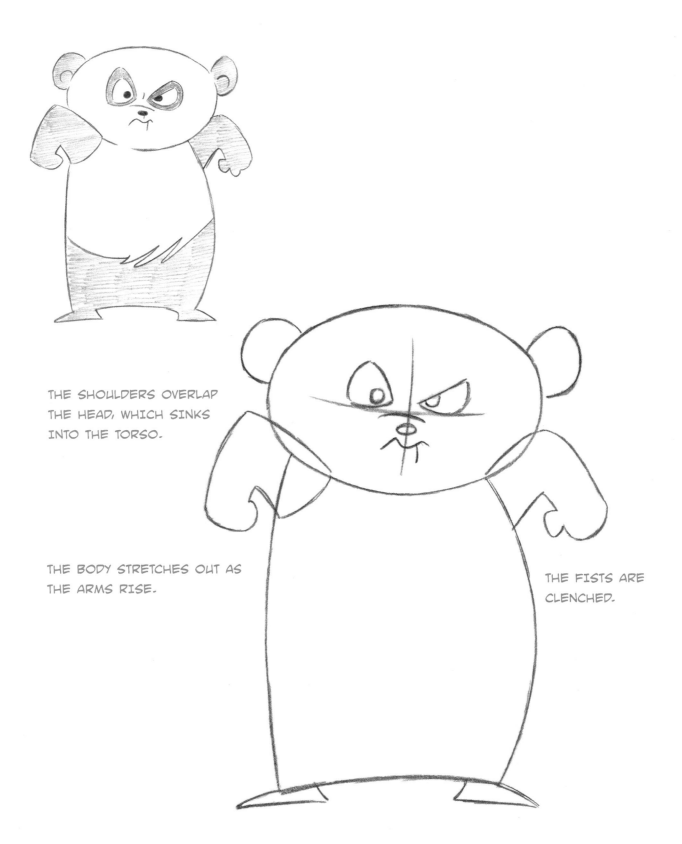

THE SHOULDERS OVERLAP THE HEAD, WHICH SINKS INTO THE TORSO.

THE BODY STRETCHES OUT AS THE ARMS RISE.

THE FISTS ARE CLENCHED.

I Don't Have All Day.

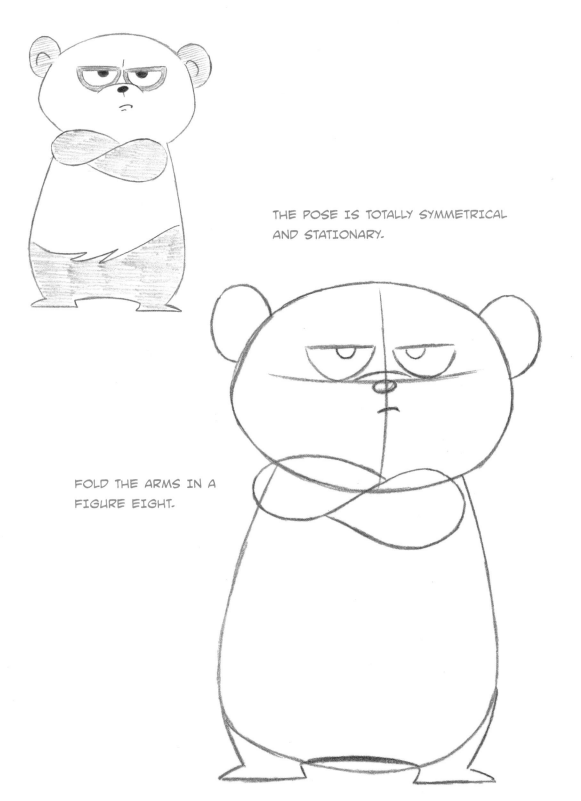

THE POSE IS TOTALLY SYMMETRICAL
AND STATIONARY.

FOLD THE ARMS IN A
FIGURE EIGHT.

THE FEET POINT OUTWARD.

I'm Overjoyed!

MOVE THE ARMS INSIDE THE
BODY OUTLINE; THE WRISTS
KNOCK TOGETHER.

HIS HEEL TAPS THE GROUND—TOES UP.

Don't Trust Me!

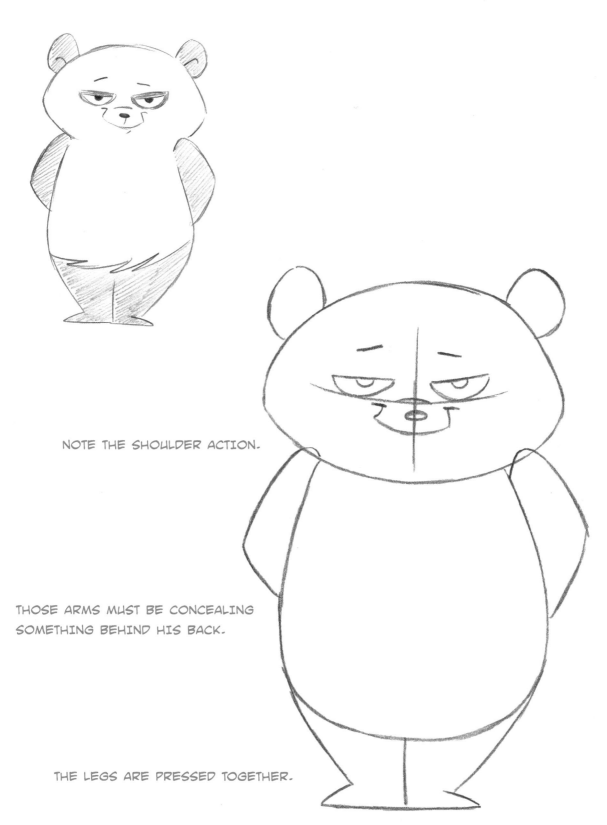

NOTE THE SHOULDER ACTION.

THOSE ARMS MUST BE CONCEALING
SOMETHING BEHIND HIS BACK.

THE LEGS ARE PRESSED TOGETHER.

OMG!!!

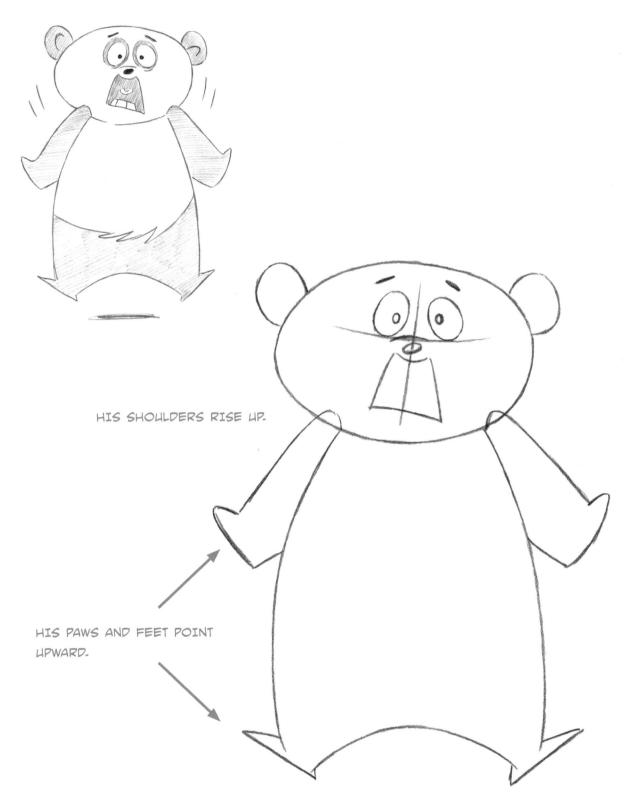

HIS SHOULDERS RISE UP.

HIS PAWS AND FEET POINT UPWARD.

THE FEET SPRING OFF THE GROUND.

I'm Bored by This TV Show.

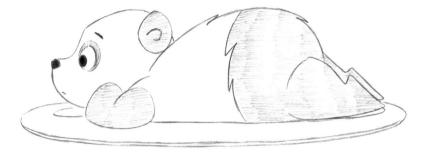

GIVE THE REAR END A BIG ARCH.

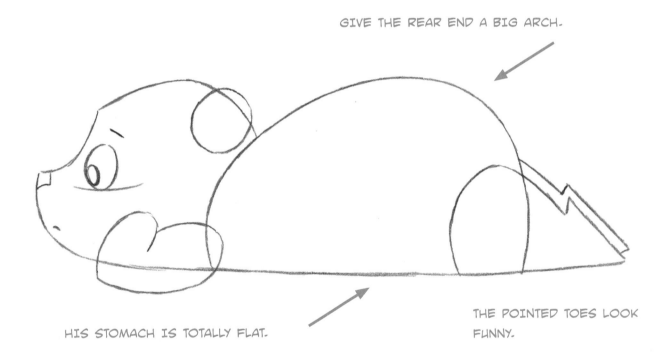

HIS STOMACH IS TOTALLY FLAT.

THE POINTED TOES LOOK FUNNY.

I Never Heard Anything So Funny!

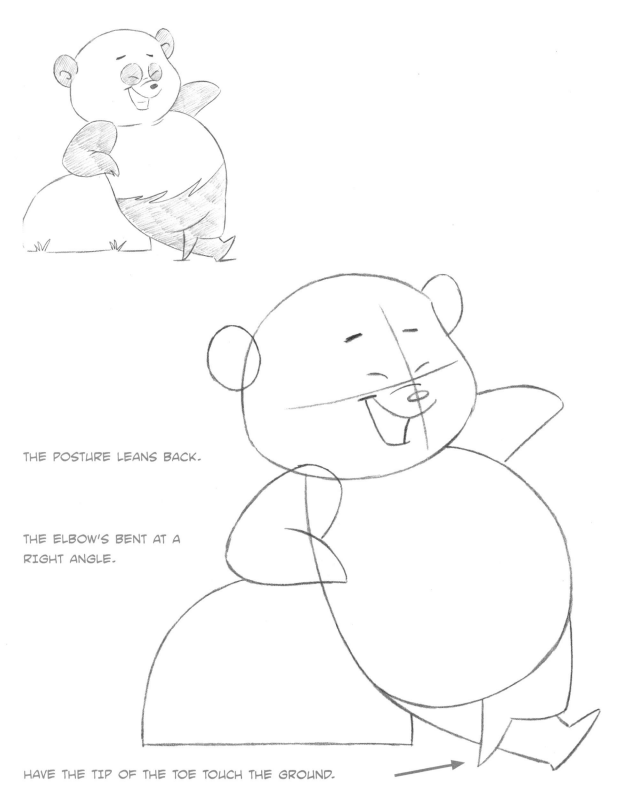

THE POSTURE LEANS BACK.

THE ELBOW'S BENT AT A
RIGHT ANGLE.

HAVE THE TIP OF THE TOE TOUCH THE GROUND.

THE BACK LEG IS STRAIGHT; THE FRONT
LEG CROSSES OVER.

Now You Listen to Me!

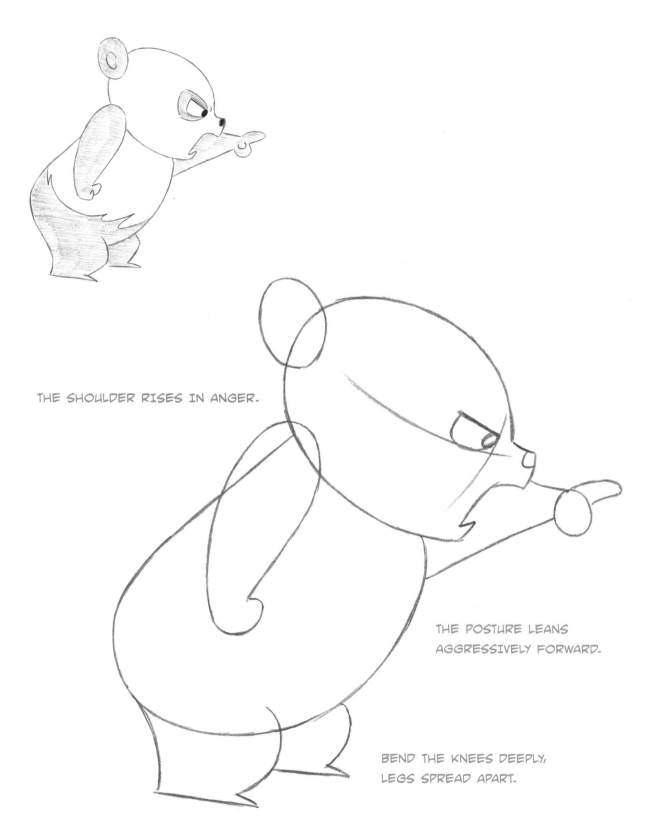

THE SHOULDER RISES IN ANGER.

THE POSTURE LEANS
AGGRESSIVELY FORWARD.

BEND THE KNEES DEEPLY,
LEGS SPREAD APART.

I Didn't Do It!

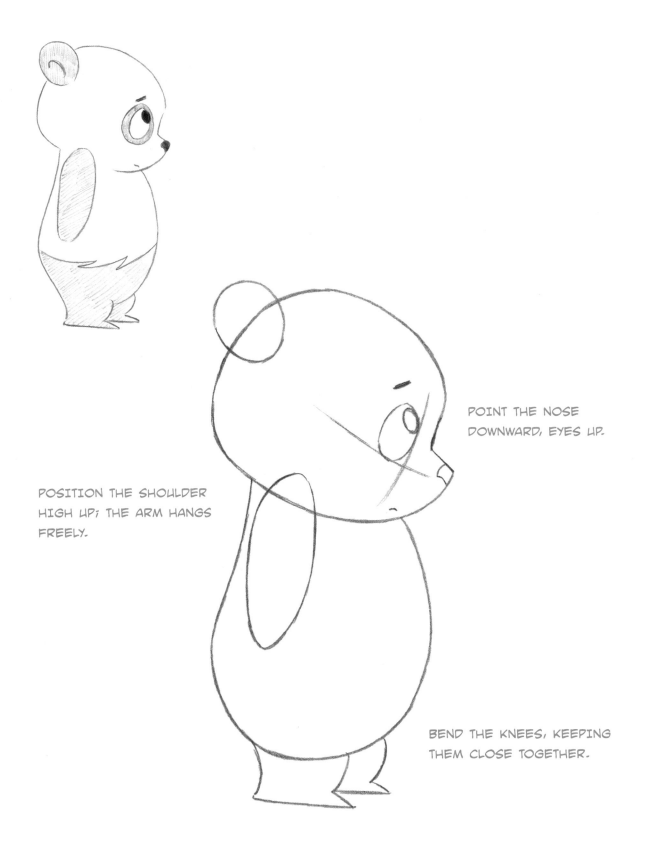

POINT THE NOSE
DOWNWARD, EYES UP.

POSITION THE SHOULDER
HIGH UP; THE ARM HANGS
FREELY.

BEND THE KNEES, KEEPING
THEM CLOSE TOGETHER.

Whoopee!

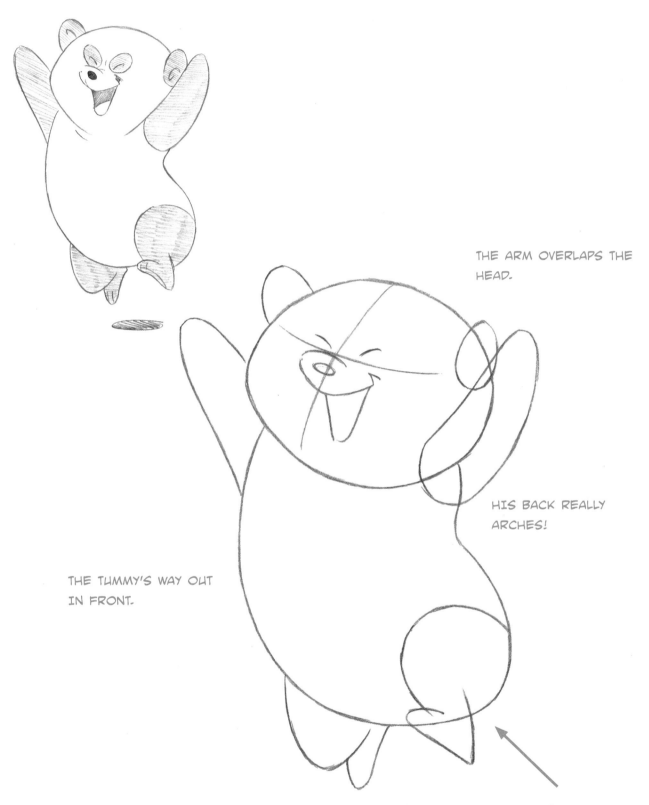

THE ARM OVERLAPS THE HEAD.

HIS BACK REALLY ARCHES!

THE TUMMY'S WAY OUT IN FRONT.

BRING THE LEG INTO THE OUTLINE OF THE BODY; "BUNCH IT UP" AS IT BENDS, TO MAKE IT LOOK CHUBBY!

Aren't I the Greatest?!

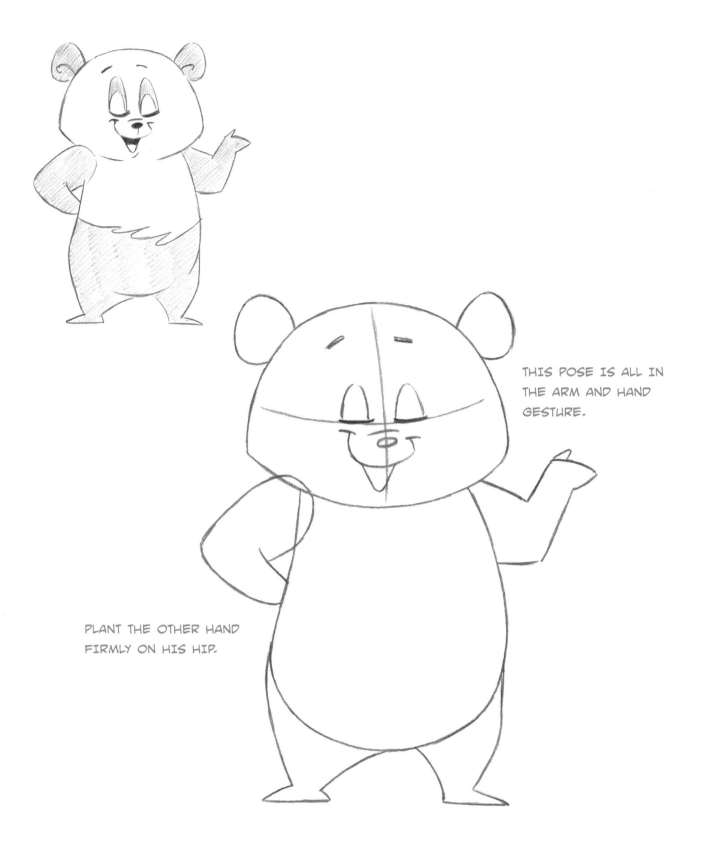

THIS POSE IS ALL IN
THE ARM AND HAND
GESTURE.

PLANT THE OTHER HAND
FIRMLY ON HIS HIP.

He Went Thataway!

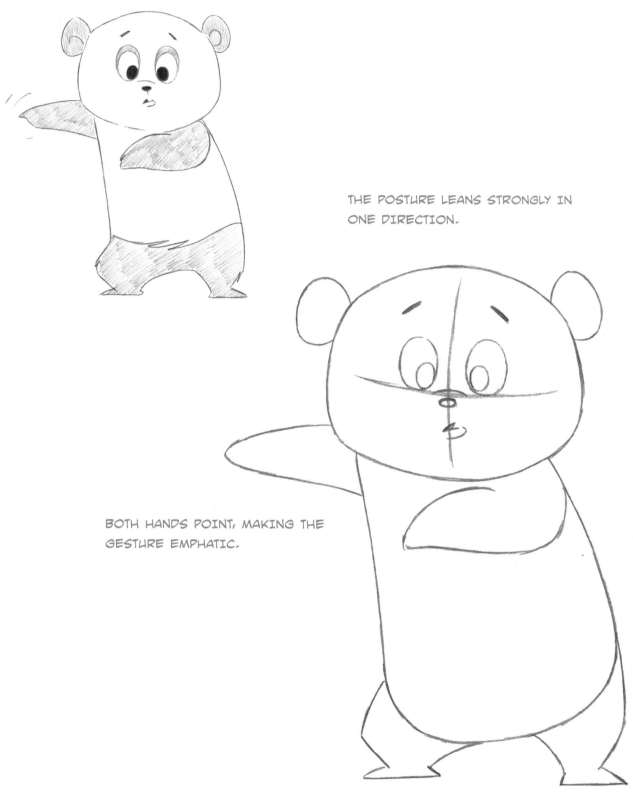

THE POSTURE LEANS STRONGLY IN ONE DIRECTION.

BOTH HANDS POINT, MAKING THE GESTURE EMPHATIC.

SPREAD THE LEGS APART, WITH THE KNEES BENT.

TURNING A WALK INTO A RUN

There are many ways you can do a "cartoon walk." The three I talk about here are among the most popular. Each "cartoon run" is derived from the cartoon walk of the same name. All you need to do is to tweak the cartoon walk with a few flourishes, and you can turn it into an equally silly run.

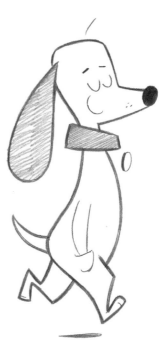

THE "BICYCLE WALK"

Both feet are in constant motion, off the ground, with the feet angled up, as if peddling. Place the hands down by the sides, or in the pockets. (Does a dog have pockets? Cartoon dogs do!)

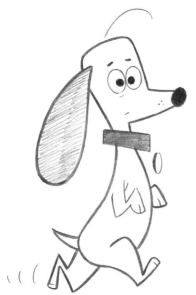

THE "BICYCLE RUN"

Based on the bicycle walk, the "bicycle run" spreads the legs farther apart, and the body is higher off the ground than in the bicycle walk. The arms are held steady at chest level. Note the trailing speed lines following the far foot. It's a particularly funny cartoon-style run.

THE "HURDLE WALK"

Like a runner leaping over a hurdle, this walker has one straight leg out in front, with the other leg bent behind. The heel on the contact foot should be pointed down. It's an enthusiastic gait.

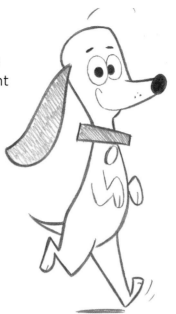

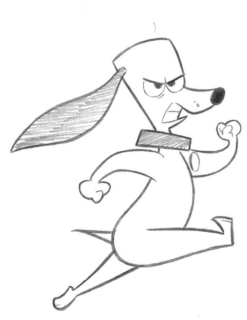

THE "HURDLE RUN"

For this gait, lean your character way forward into the run. The arms should be down at the sides, so they don't compete with the dramatic leg action. Trail the ears to show speed.

THE EXTENDED LEG WALK

This is the silliest walk, with two stiff legs and no bend in the knees whatsoever! Note the rounded tummy protruding.

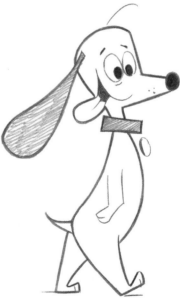

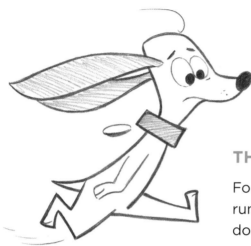

THE EXTENDED LEG RUN

Really get those arms pumpin' for this pose. And arch the back for a very determined run. The legs are in the widest possible position in this ridiculous style of run.

Designing Basic Layouts

Say you want to show more than one cartoon character in a scene. How do you lay them out so they grab the viewer's eye? Or maybe you'd like to include some cartoony backgrounds. You might have some gnawing questions about basic perspective that you hope can be answered without complicated diagrams. Well, dear friends, this chapter should do the trick!

The term *layout* means composition. A good layout does three things:
- It directs the viewer's eye where you want it to go.
- It gives the drawing a sense of rhythm.
- It establishes the scene.

PUTTING TWO CHARACTERS IN A SCENE

Give a beginning cartoonist the assignment of drawing a scene with two characters talking to each other, and you'll most likely get back a picture of two heads facing one another. Well, okay, that works . . . but it's sort of . . . plain. There's not much, visually speaking, to write home about. So let's look at some alternatives. Part of the lesson here is that you should always take a moment to pause and consider your layout options *before* you begin to draw.

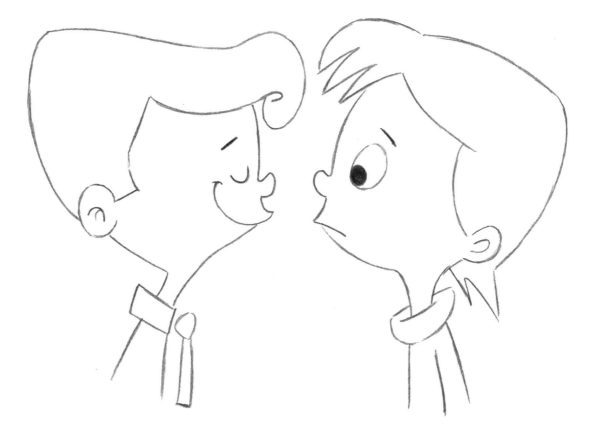

Turn One Character Toward the Reader

As I say, showing the two characters in profile is a dependable enough layout, but it's nothing fresh. Also, the characters look uncomfortably close—but if you separate them too much, the scene loses energy. What can be done about it? Well, by turning one character to face the reader, you open up the scene. Now it *feels* like there's more room between them, even though the distance between them hasn't changed.

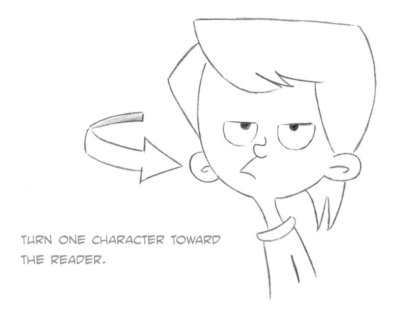

TURN ONE CHARACTER TOWARD THE READER.

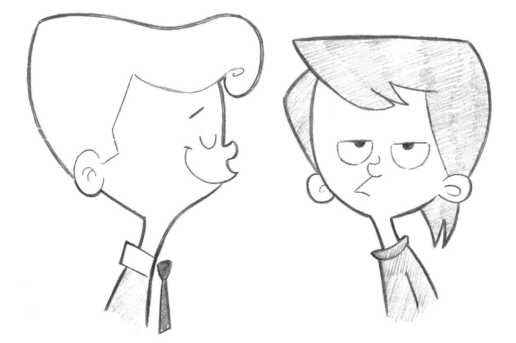

Try a "Reverse Angle"

This angle, shot from behind one character's head as he looks at another character (shown in three-quarters view), is called a "reverse angle." It allows you to squeeze the characters closer together on the page without getting uncomfortable. Why all this emphasis on placing characters close together? Because spacing them farther apart will lessen the energy of the scene.

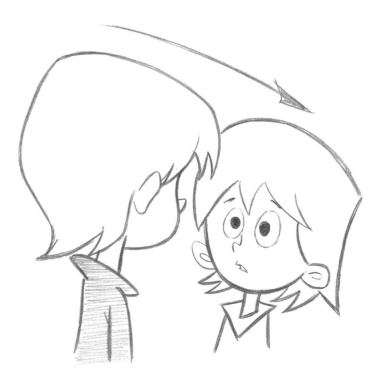

Have Both Characters Face the Reader

These two characters are talking, but they're both looking in the same direction, facing the reader. Be sure to overlap them, with one standing in front of the other. This allows you to favor the speaking character by situating him nearer the reader. It also builds a nice visual rhythm.

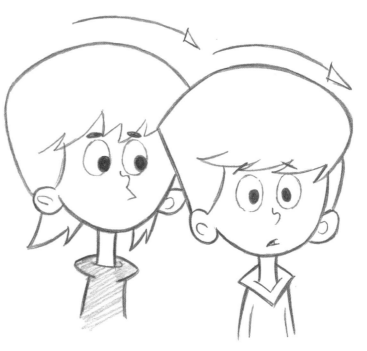

Have One Character Call Out to the Other

Of course, you'll need to widen the space between the characters when one is calling to another. Make sure that the speaking character's mouth is opened wide, to let the viewer know that he is shouting.

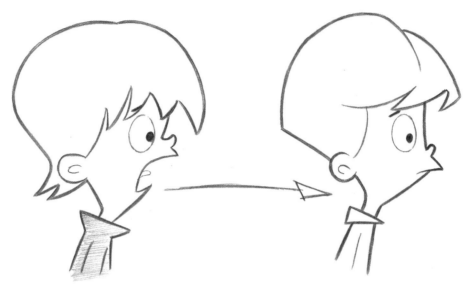

Make One Character Bigger than the Other

You can overlap characters, making the bigger one tower over his poor victim, to humorous effect.

DRAWING OBJECTS IN PERSPECTIVE

Everything we see, we see in perspective. Perspective will make objects in your drawings look more solid and three-dimensional, as if they exist in space. When you, as a cartoonist, use perspective, sometimes you'll do it subtly—and sometimes you'll greatly exaggerate it. It all depends on the effect you're looking for.

There are three types of perspective we need to know about to draw cartoon objects and props from various angles: one-point perspective, two-point perspective, and three-point perspective. Let's look at each kind.

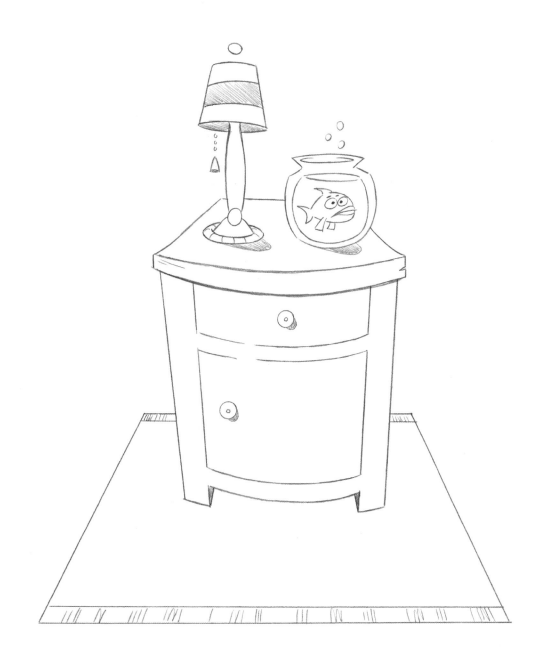

One-Point Perspective

One-point perspective is the most basic. In one-point perspective, you are looking straight at the object. (Often, cartoonists like to draw from a vantage slightly above the object.) From this vantage, the object looks as if it is receding toward a single point in the background. That's why it's called "one-point" perspective.

Give it a try with this simple cartoon cabinet. Here, instead of sketch guidelines like the ones we use when drawing faces and bodies, we use lines called *vanishing lines*.

Vanishing lines are guidelines that represent the way our eyes see through space in perspective. Our vision travels along these vanishing lines, making the object appear to diminish in size the farther back it goes.

First, we need to pick a spot where the two vanishing lines meet. That spot, which is called the *vanishing point*, is placed on the *horizon.* So how do I know where to place the horizon? I don't! I just put it anywhere I want to—wherever I think the horizon would appear if I could look through the wall and see the horizon in the distance. Notice how the tabletop diminishes along vanishing lines to the vanishing point, which resides on the horizon line. Whew! Say that last sentence five times fast!

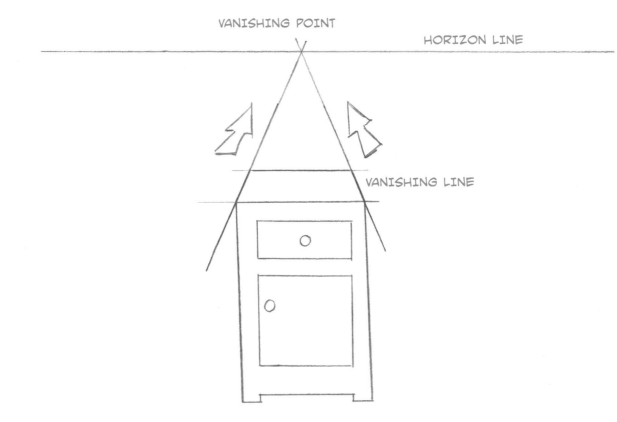

HERE'S A GOOD EXAMPLE OF ONE-POINT
PERSPECTIVE FROM AN EXTREME ANGLE—
IN THIS CASE FROM BELOW THE OBJECT.
AS YOU SEE, THE VANISHING POINT IS
WAY, WAY ABOVE THE CABINET.

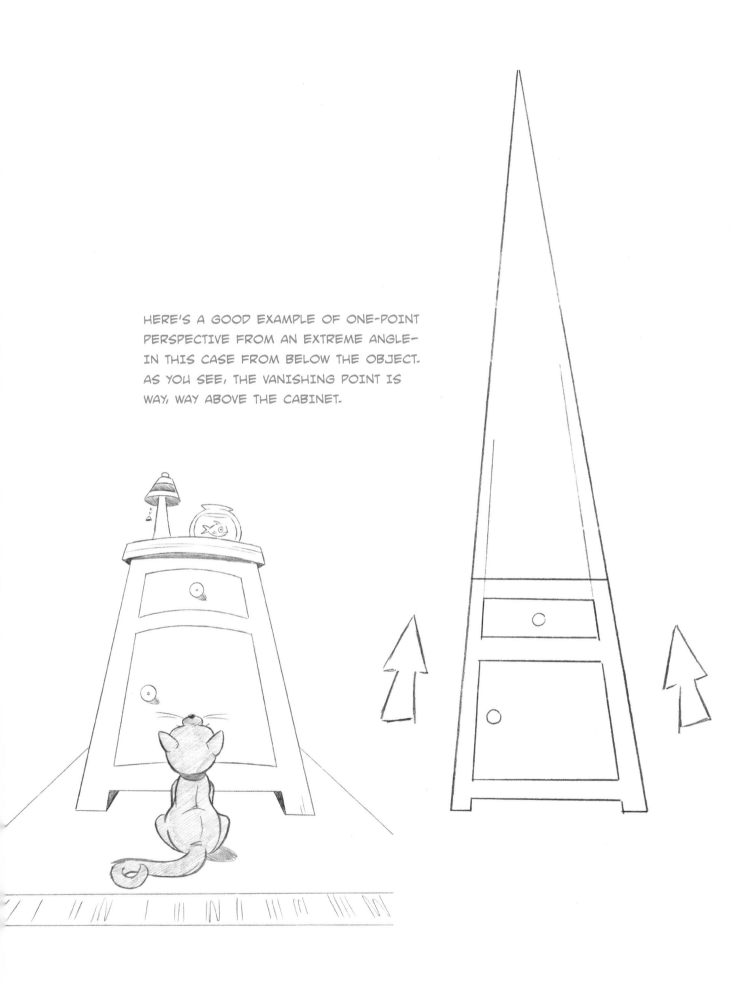

Two-Point Perspective

You see an object in two-point perspective when it's at eye level but you're looking at it from an angle that's off to the side. There's still a horizon line, but now there are two vanishing points, and four vanishing lines leading to them: two that recede toward the vanishing point on the left and two that go toward the vanishing point on the right.

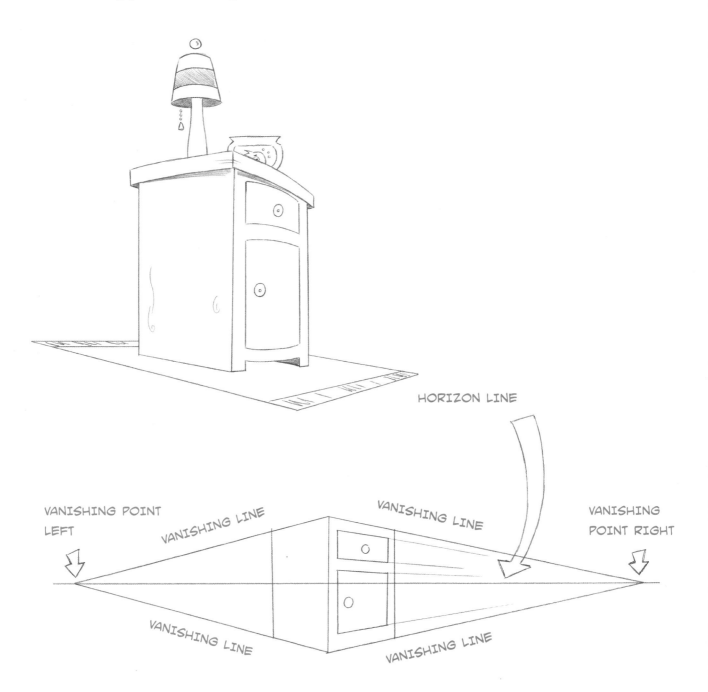

HORIZON LINE

VANISHING POINT LEFT

VANISHING LINE

VANISHING LINE

VANISHING POINT RIGHT

VANISHING LINE

VANISHING LINE

Three-Point Perspective

Three-point perspective makes this little cabinet appear huge. Here, the vanishing points are to the right and left of the object but also at a spot far above it.

In three-point perspective, you're viewing an object from two angles at the same time—for instance, looking at one of the object's corners from a position above or below the object. This kind of perspective can make an object look awesome!

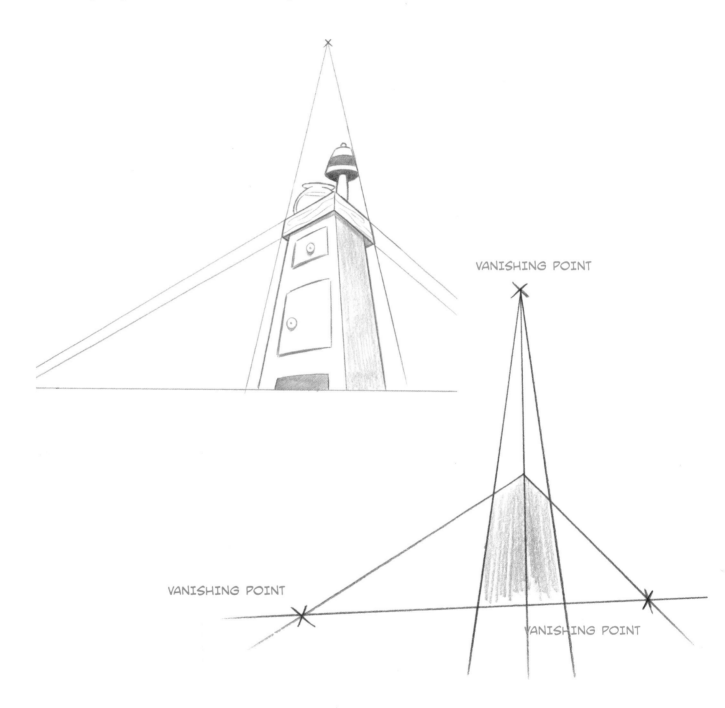

VANISHING POINT

VANISHING POINT

VANISHING POINT

Kooky Perspective

For a cartoonist, it's sometimes better—yes, better—to draw incorrectly *on purpose*. Look at these drawings. True perspective requires the floorboards to look as they do in the drawing below. But by tossing in a few slats that slant in the wrong directions, we get a kooky-cartoony look that immediately reads as *funny*.

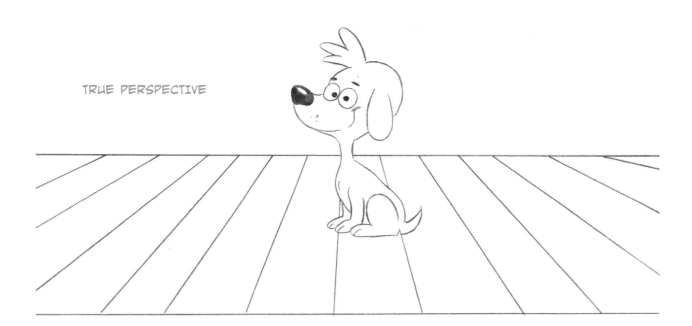

TRUE PERSPECTIVE

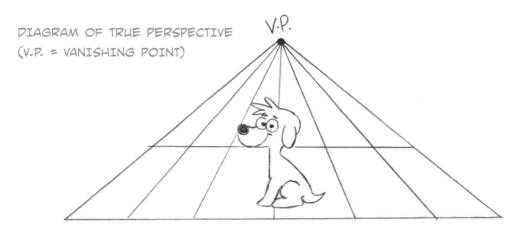

DIAGRAM OF TRUE PERSPECTIVE
(V.P. = VANISHING POINT)

V.P.

KOOKY PERSPECTIVE—MORE FUN!

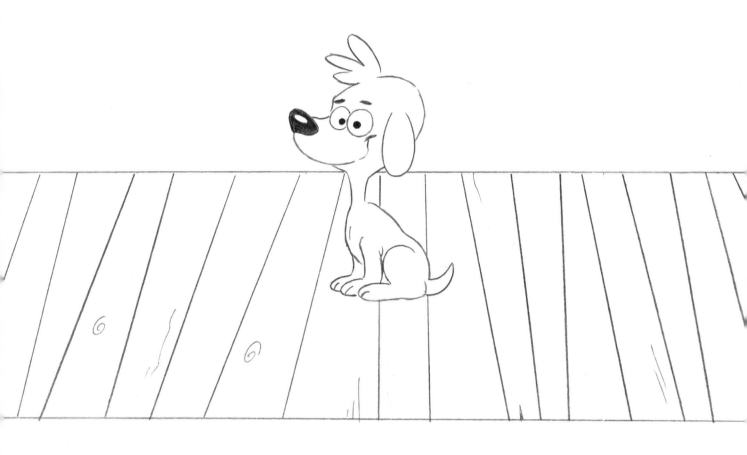

DRAWING A ROOM—MADE SIMPLE!

The interior of a room is basically a box with four walls, a ceiling, and a floor. But how should you set it up? How many walls should you show? Should you show the floor? What about the ceiling?

Here is a sampling of classic layouts for staging interior scenes for your cartoon creations. Some examples show depth, while others are purposely flat. Choose the ones you prefer, and give those a practice try. Always keep the décor simple, so as not to compete with your cartoon characters.

FLOATING WINDOW

This look is very flat, graphic, and modern.

CORNER SHOT

Looking down into the corner makes the pup (or any object) look small.

SIMPLE HORIZON LINE

Keep it low across the bottom third or quarter of the panel.

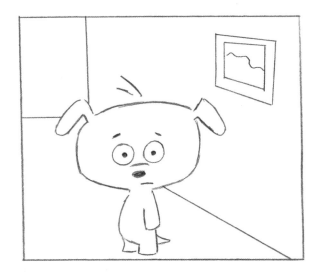

LOOKING INTO THE HALLWAY

This option opens up the house or apartment.

TWO WALLS AND A FLOOR

This setup requires furniture, so the place looks lived-in.

TWO WALLS AND A CEILING

To make this angle work, you need to cut the character at mid chest level.

DRAWING EXTERIOR LAYOUTS

Remember that backgrounds are just that—backgrounds. They are meant to recede. So keep them simple. Lots of detail tends to bring them to the fore, making them compete with the characters in the foreground. If there are no characters in the scene, a too-complicated background will make the image lose its cartoony feel.

BIG SKY

The low horizon line gives this panel its feeling of boundless space.

FRAMED SHOT

In this panel, one object (the boat) is framed between two bookending objects (the heads).

THE COUNTRY

The high horizon line topped with a thick row of trees gives the feeling of dense woods.

ENDLESS ROAD

The road zigzags to infinity—or at least to the horizon line!

MOUNTAINS

Draw many peaks, shading each of them on the same side.

ROOFTOP VIEW

Peering over the roof to the vista is a good way of establishing a scene or environment.

VALLEY/FARM

The rolling terrain is emphasized by the rows of crops going in different directions.

FOREGROUND OBJECT(S)

Looking through foreground objects to the subject in the background is a good way of establishing depth.

GROUPING OBJECTS

When you group objects in a panel, you establish a visual rhythm. Are they spread out evenly, or are they grouped in clusters? Usually, the visual rhythm is more interesting if the objects are clustered—and the more unexpected the cluster, the more interesting the rhythm. If you just spread things out evenly across the background, the result will probably be boring. Here are some examples showing the difference.

OBJECTS SPREAD APART—
BORING

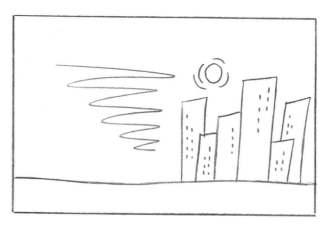

SOME OBJECTS CLUSTERED—
DYNAMIC!

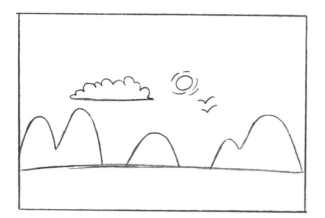

OBJECTS SPREAD APART—
BORING

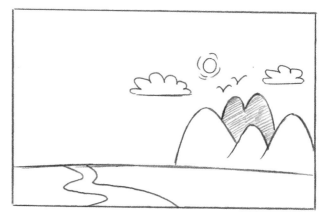

SOME OBJECTS CLUSTERED—
DYNAMIC!

DRAWING CARTOON BUILDINGS

The kind of domicile your character lives in says a lot about who he or she is. Is the home upscale? Downscale? In the city? In the 'burbs? When drawing cartoon dwellings, go to extremes. If your character is rich, make the home a mansion. If he or she is middle class, make it a super-basic suburban house. If the character lives in the city, consider an apartment in a tenement rowhouse.

Be sparing in your use of detail—just enough to produce a humorous effect. For example, you might want to add shutters to the windows, but there's no need to draw details such as plants lining the windowsill. That wouldn't add to the quick, overall impression you want to create. We cartoonists are all about the big picture.

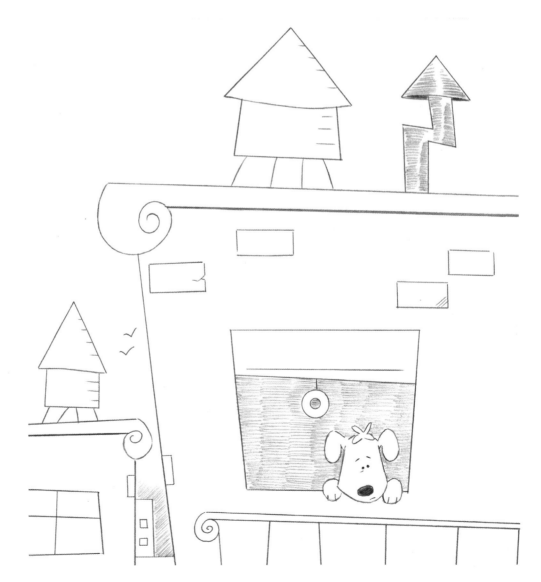

Middle-Class Family Home

Here's a little patch of heaven, in an unending sea of identical suburban houses. It's important to show that the houses are practically within arm's reach of each other. The garage is featured prominently—in fact, it takes up as much room as the house itself. There's a little awning out back for summer barbecuing. And it's also got a swatch of lawn and a white picket fence. Who could ask for more?

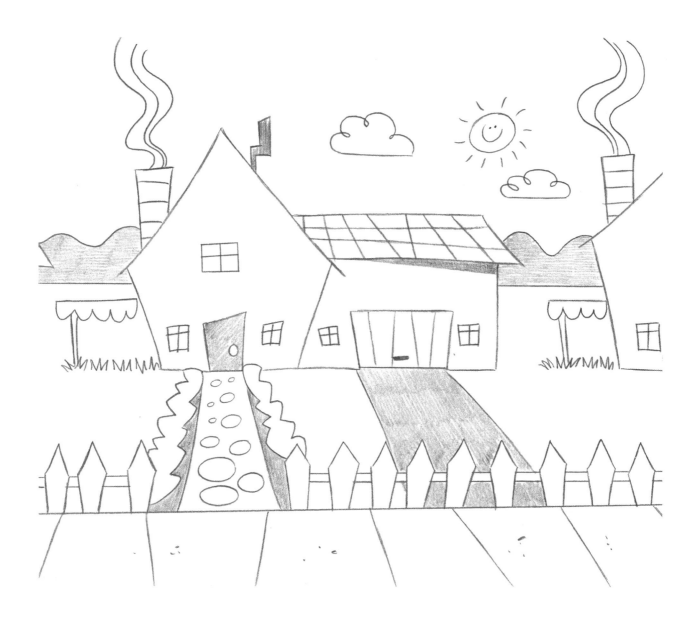

The Manor House

You can tell this is a Tudor-style estate because of the twin towers and the decorative wooden planks on the facade. Only rich people's houses have more than one front door, and this one has three. I've added massive chimneys and dormers to the rooftops, just in case you missed the point that this place is expensive. Rule of thumb: If it looks like you'd need more than one maid to clean the joint, the character is *rich*. (An impressive driveway is also a must-have.)

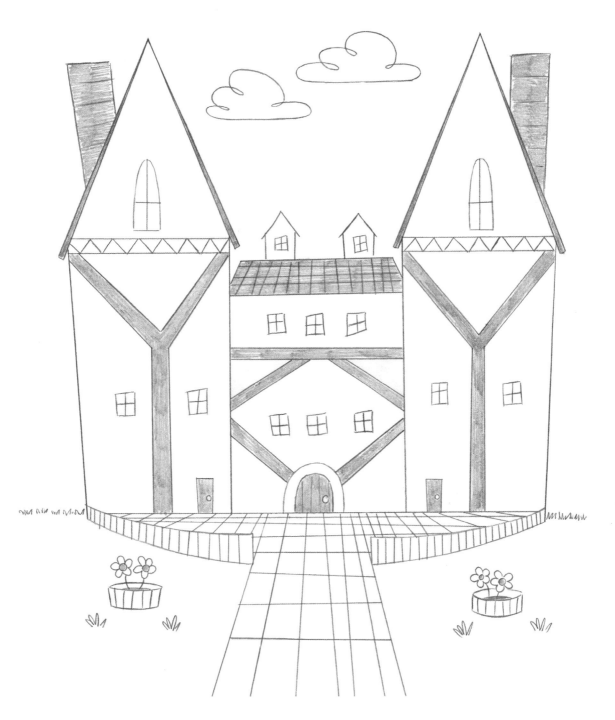

Tenement Apartment

The city is crowded, with many buildings jammed together. Overlap them as they go off into the distance. Each window represents a different person's apartment and an entirely different life story. If you cut in close enough to one of the windows, you can draw the character or characters inside one of those windows. Tenement-type buildings typically feature moldings, brick walls, rooftop water towers, piping, and fire escapes.

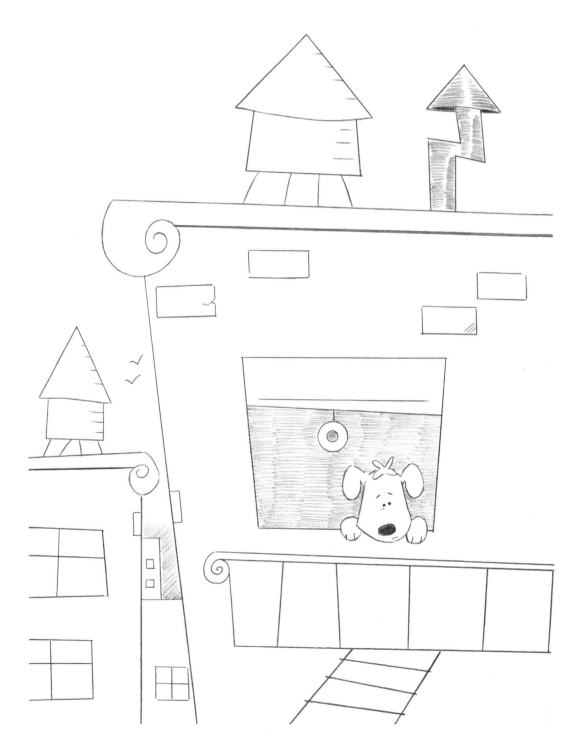

Skyscrapers

The metropolitan skyline is punctuated with concrete rect-angles, each dotted with little windows representing different floors. But put away that ruler! It'll suck the life out of the draw-ing. Instead, draw your buildings freehand, and curvy. Note that the outline of the buildings is thick but the interior lines are thin. This gives the image a flat look, which is great for a graphic-style background. If you're going to shade the buildings, make sure to shade all of them on the same side, as the light source (moon or sun) will hit them from the same direction.

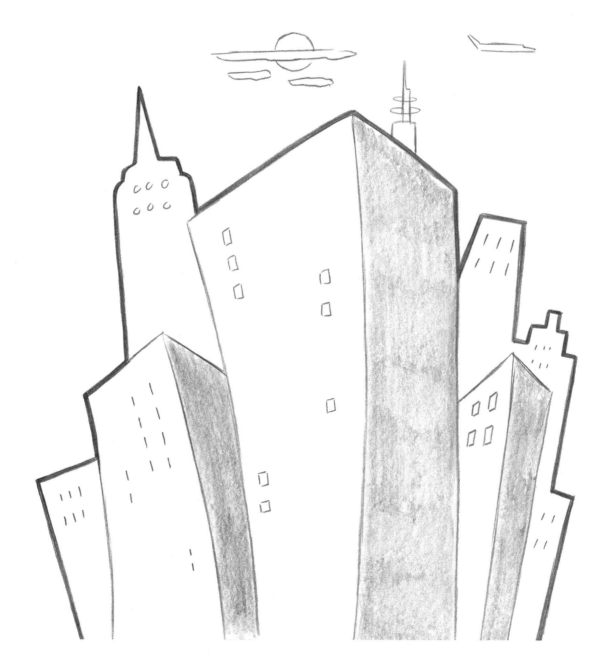

Special Characters: Robots

Funny cartoon robots have been popular ever since the Rosie the Robot Maid character made her debut on *The Jetsons* animated TV show way back in 1962. And they have only grown more popular since then, especially in the wake of recent box-office smash hits like *Robots* and *WALL∗E*.

Creating characters based solely on the imagination, as robots are, is challenging. When you're drawing cartoon animals, you at least know what the real thing is supposed to look like and can therefore use it as a guide. The thing to remember is that you're drawing cartoons first, robots second. Don't get so caught up in the gadgetry that you forget to create a basic overall construction for the head and figure. Everything should be drawn freehand, which gives the pencil line a look of vitality and infuses personality into robot cartoon characters.

Keep it simple, using only a few techno-gadget decorations or other doodads—just enough to make the character look like a robot. Anything extra will detract from a pleasing simplicity of design, which is what you want. This is cartooning, not intricate science-fiction illustration.

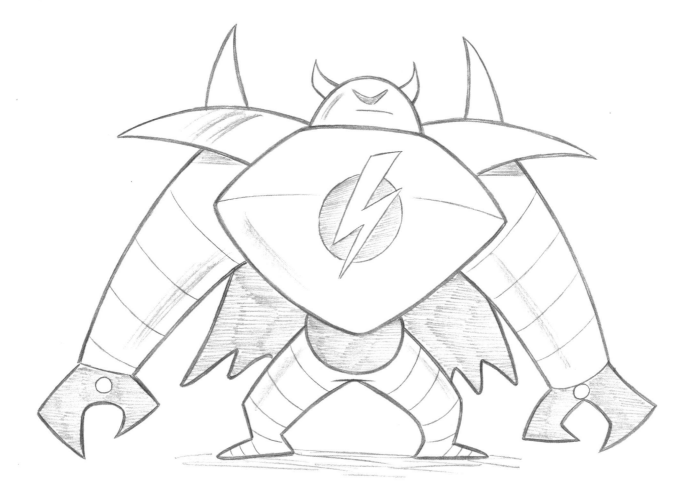

Cute Robot

To make a human or animal character cute, you put a big head on a small body—and the same technique works for robots. This robot's clamp-like hands are reminiscent of mittens, which makes them cute and harmless looking, too.

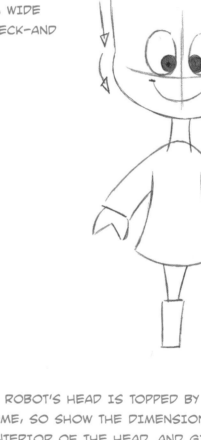

BUMP OUT THE CHEEKS ON EITHER SIDE OF THE ROBOT'S HEAD, FOR A WIDE SMILE. GIVE HIM A SKINNY NECK—AND NO SHOULDER MUSCLES!

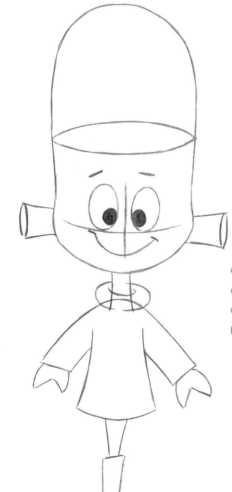

OUR CUTE ROBOT'S HEAD IS TOPPED BY A GLASS DOME, SO SHOW THE DIMENSION OF THE INTERIOR OF THE HEAD. AND GIVE HIM LITTLE TUBS FOR EARS.

And add a shine to the helmet, too. Always draw the shine on the top, where overhead light would naturally hit it.

Add a shine to the wheel.

Letting the sleeve fall over the clamps makes the character look younger—just like an oversized shirt on a little kid.

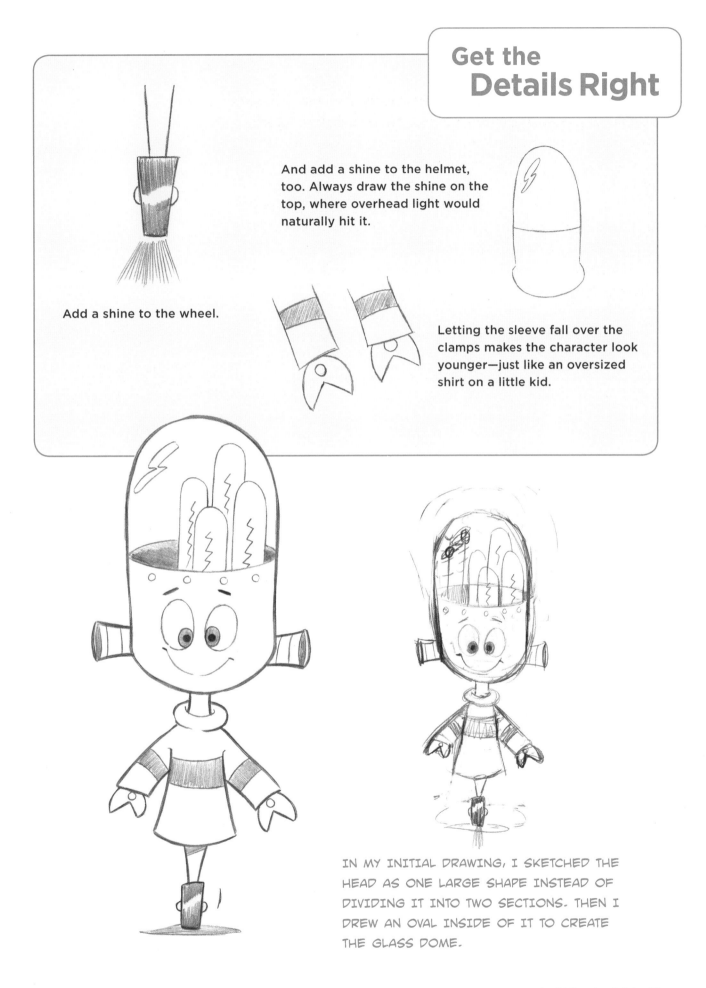

IN MY INITIAL DRAWING, I SKETCHED THE HEAD AS ONE LARGE SHAPE INSTEAD OF DIVIDING IT INTO TWO SECTIONS. THEN I DREW AN OVAL INSIDE OF IT TO CREATE THE GLASS DOME.

Robot Brute

This massive guy means trouble. Robots brutes can crush and destroy. But how do we draw him so that he looks powerful? It's all in his proportions. They're classic. It doesn't matter whether you're drawing a human or a robot: A small head, a barrel chest, and a small lower body equal power!

We know this robot's a battler, because he's wrapped in armor. Notice those humongous shoulder spikes. His claw-hands look quite sharp—ouch! And note how the head is screwed down right on top of the shoulders, with no neck at all—a very bulky, strong look.

THE SINGLE EYE-SLIT, WHICH POINTS DOWN-WARD, IS TYPICAL OF BAD GUYS. THE CURVED LINE ACROSS THE CHEST HELPS SHOW THAT THE CHEST PLATE IS MADE OF METAL, AS DOES THE SHARPLY ANGLED TORSO. NOTE THE SMALL HIPS.

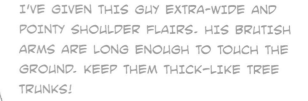

I'VE GIVEN THIS GUY EXTRA-WIDE AND POINTY SHOULDER FLAIRS. HIS BRUTISH ARMS ARE LONG ENOUGH TO TOUCH THE GROUND. KEEP THEM THICK—LIKE TREE TRUNKS!

THE TWO SETS OF HORNS AND THE CAPE COMPLETE THE LOOK.

HERE'S MY INITIAL PENCIL SKETCH FOR THIS
CHARACTER. ORIGINALLY, I'D TOYED WITH
THE IDEA OF GIVING HIM A MORE MASSIVE
HEAD—BUT IT WOULD HAVE MADE HIS BODY
LOOK TOO SMALL BY COMPARISON.

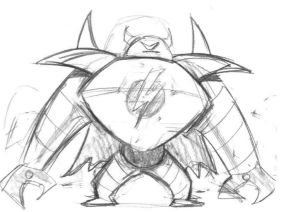

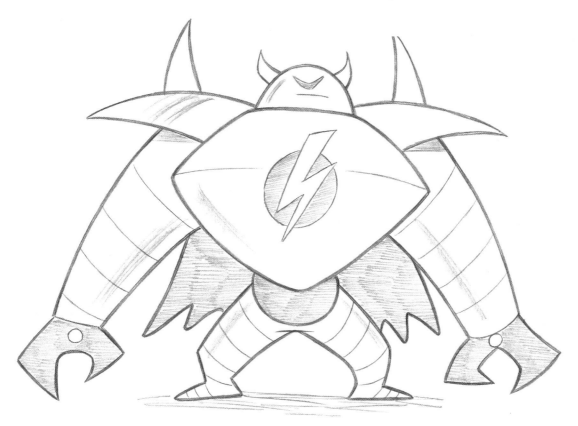

Tip

When shading the metal, use
the side of the pencil, not the
point.

Human-Type Robot

For the torso of this humorous robot, I've used a triangle for the ribcage, another triangle for the pelvis, joining them with metal tubing that functions like a spinal column. Notice the economy of the gadgets: Just a few repeated buttons and a couple of antenna are all that's needed. More would be overkill. Note, too, that his arms and legs are not perfectly straight but slightly curved. I drew them this way on purpose to avoid a ruler-straight, static look.

The reason I haven't included a construction step for this robot is that he's little more than a construction step. Look at him—he's practically a how-to-draw stick figure!

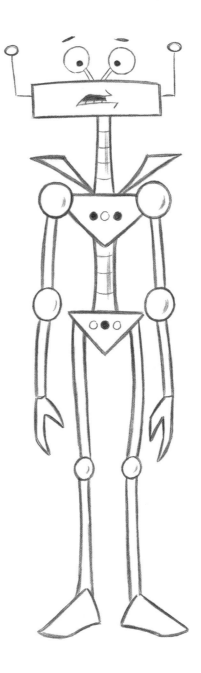

Robot Ears

A robot's ears are a great place to add gadgets. Here are some variations.

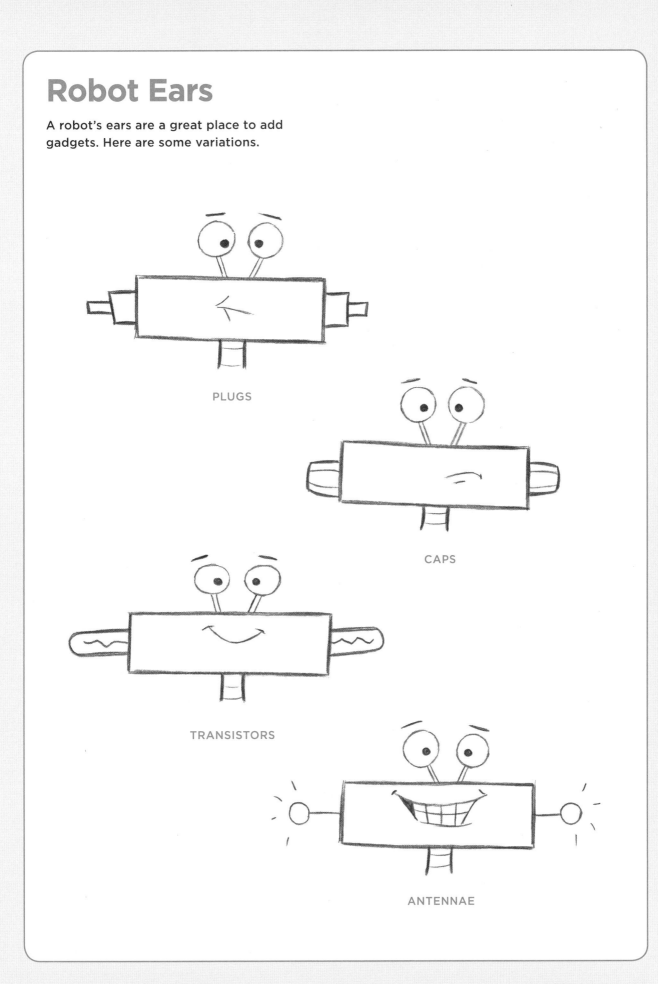

PLUGS

CAPS

TRANSISTORS

ANTENNAE

Female Robot

The trick to drawing a funny female robot is to give her a feminine physique that is impossibly strong and proportionally improbable. For example, look at how small this robot's head is. That's because she doesn't have a brain to think with—the receiver on top of her head gets command signals, and her head is just a small processing unit. Her arms are spread out far too wide, and her melon-sized shoulders give her a look of strength. Her waist is exceptionally thin, and she's also way too tall for a real female. All these weird proportions combine to give her an eerie but humorous appearance.

What shall we call her? How about something exotic, like Yoshiko? (By the way, a great place to find names for your cartoon creations is one of those pocket-sized books of baby names.)

HER HEAD IS A SMALL, TRUE CIRCLE. HER LEGS (INCLUDING THE KNEE-HIGH BOOTS) ARE LONGER THAN HER HEAD AND TORSO COMBINED!

HER SHOULDERS ARE CIRCLES, TOO—EACH THE SAME SIZE AS THE HEAD. LEAVE SPACE BETWEEN HER RIBCAGE AND SHOULDERS.

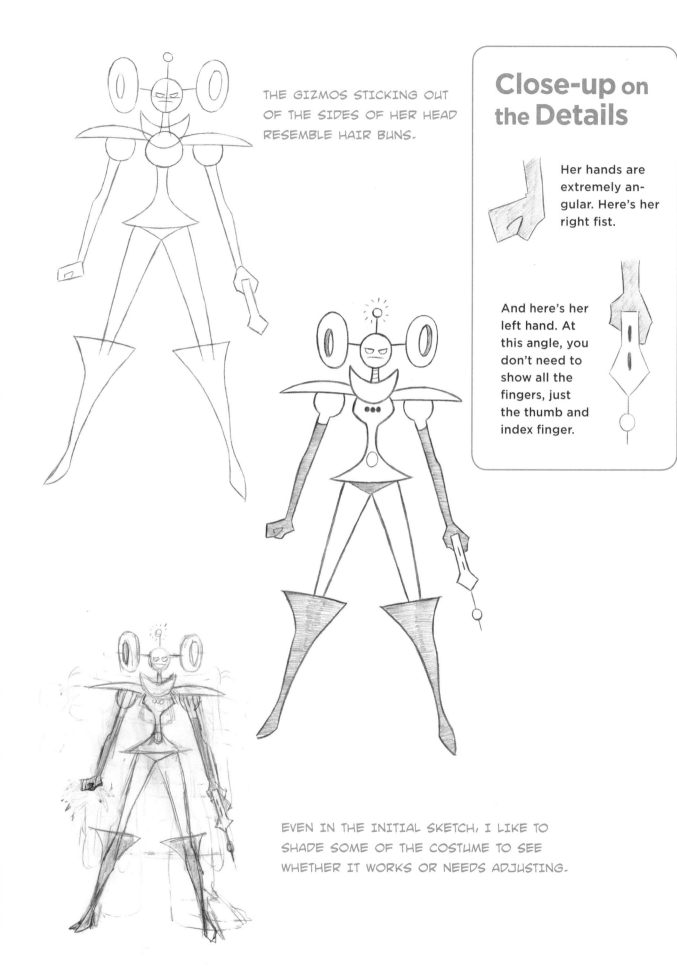

THE GIZMOS STICKING OUT OF THE SIDES OF HER HEAD RESEMBLE HAIR BUNS.

Close-up on the Details

Her hands are extremely angular. Here's her right fist.

And here's her left hand. At this angle, you don't need to show all the fingers, just the thumb and index finger.

EVEN IN THE INITIAL SKETCH, I LIKE TO SHADE SOME OF THE COSTUME TO SEE WHETHER IT WORKS OR NEEDS ADJUSTING.

Helper Robot

Helper robots are harmless little cuties who are short, goofy, and slightly on the nervous side. Their only job is to take care of the household chores—and to avoid short-circuiting themselves while multitasking.

This robot provides a good example of how you can take an ordinary shape—in this case a rectangle—and add bits and pieces to it, until you've created a complete character. The simpler the shape, the cuter the character.

When I shaded the final pencil drawing of this character, I pressed down hard on the pencil to achieve an almost black tone for the legs and hand clamps. I made the briefcase and umbrella a softer gray and also shaded the underside of the robot's body because overhead lighting would leave it in shadow. (That's also why a dark tone is a good choice for the legs; it just makes visual sense.)

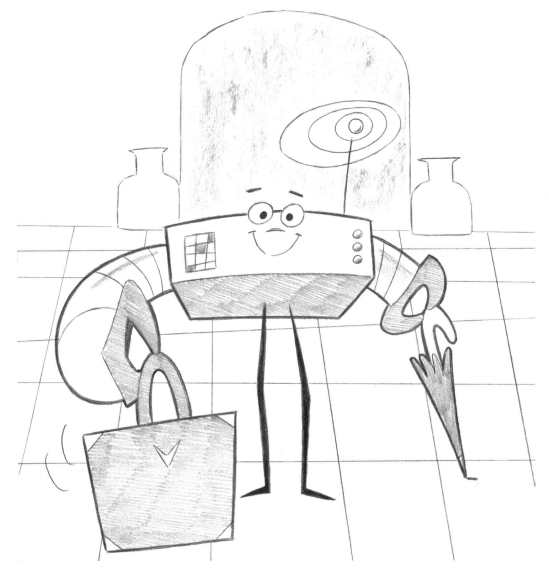

IN MY ORIGINAL PENCIL SKETCH, I DIDN'T USE ANY FORESHORTENING (THAT IS, PERSPECTIVE) ON THE ARM HOLDING THE BRIEFCASE. IN THE FINAL DRAWING, I ADDED PERSPECTIVE BY ENLARGING THE FOREARM, WHICH MAKES IT LOOK LIKE THE ROBOT IS HOLDING THE SUITCASE OUT IN FRONT OF HIMSELF, OFFERING IT TO THE MASTER OF THE HOUSE.

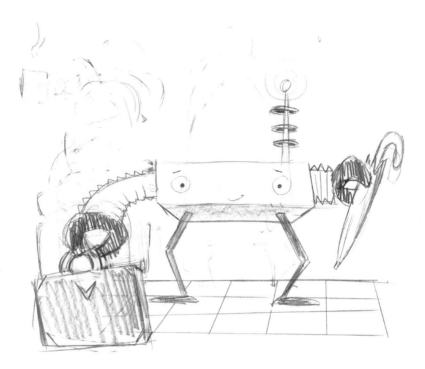

A Simple Rectangle—But with Dimension

Depending on which way this character is turned, you will see two or three sides of the rectangular box.

Seen from above

Seen from below

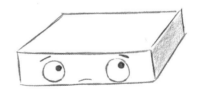

Three-quarters angle, from above right

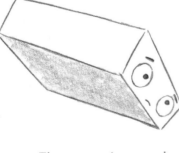

Three-quarters angle, from below left

Three-quarters angle, from above left

Tough Little Worker Robot

This geometrically shaped robot is super serious about its mission. Its body is a hexagon—a six-sided figure. But it could just as easily have been an octagon (eight sides) or a pentagon (five sides).

The three caps on top of its basic shape prevent the character from looking like just a shape with eyes. Also notice that this guy is the first robot we've drawn that has actual eyes inside its eye slits. To make this work, I've blackened the area surrounding the eyes, which makes the effect more mysterious.

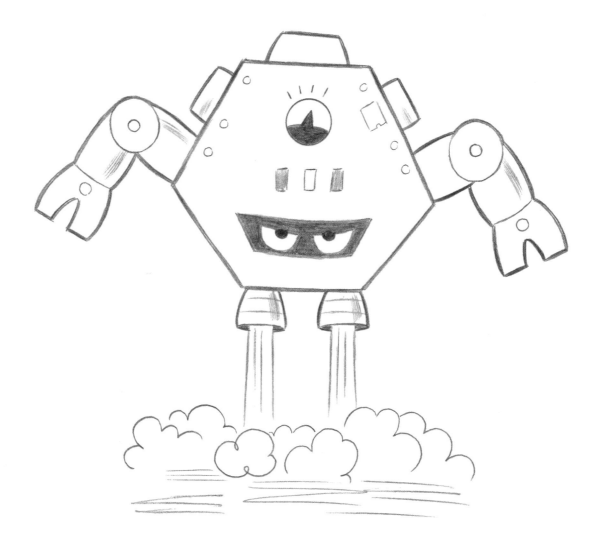

When the robot looks toward the reader's right, its eyes sweep up toward the right.

And when it looks left, it eyes sweep up toward the left.

Make the arm cylinders rounded, not straight lines.

You can make your hexagon regular (with all the sides and angles the same) or irregular. Your choice!

Cyber Pet

Nothing so warms the heart as seeing a boy and his robot playing fetch. The boy throws a stick, and robot dog sends a ray beam from his helmet to retrieve it. This character is an amalgam of a robot and a dog, which is why he's a cyber pet. His body is that of a regular cartoon dog, except for that wild ring orbiting its tail. I've made his head over-sized to show the power of his brain-helmet.

THE BASIC CONSTRUCTION IS THE SAME AS A REGULAR CARTOON DOG—EXCEPT FOR THE SLITS FOR THE EYES. HIS HEAD IS JUST A LARGE CIRCLE, AND HIS BODY IS A KIDNEY SHAPE, WITH A ROUNDED TUMMY.

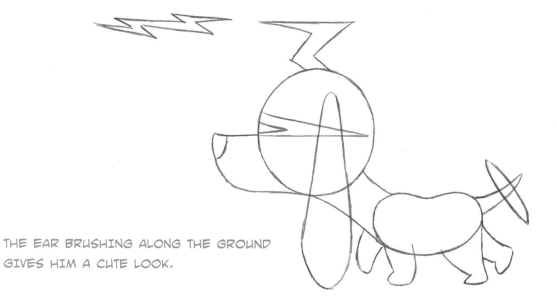

THE EAR BRUSHING ALONG THE GROUND GIVES HIM A CUTE LOOK.

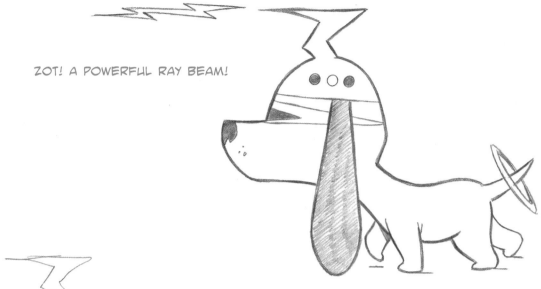

ZOT! A POWERFUL RAY BEAM!

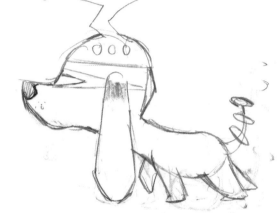

IN MY ORIGINAL PENCIL SKETCH, I GAVE OUR
CYBER PET THREE RINGS AROUND HIS TAIL.
I'M STILL NOT SURE WHICH LOOK I PREFER!

Lightning Bolts

Lightning bolts come in handy for special effects.
There are several popular ways to make them look as
cartoony as possible. Here are a few good ones.

Simple

Backward zigzag

Three zigzags

Long top bolt

Special Characters: Animals

Everyone loves cartoon animals. They star in comic strips, animated feature films, and animated TV shows.

In this chapter, we'll look at some of the most popular cartoon animal types, so you will have all you need to get started. The animal personalities range widely, from gregarious to shy and introverted—and everything in between! I've matched each animal with its generally accepted personality type.

When drawing a cartoon animal, be as specific as possible. Is it a boy animal or a girl? If it's a boy, make him look like a boy; if it's a girl, feminize her. If it's a dog, make it a specific breed— or perhaps a mutt. Friendly or mean? Sneaky or fun-loving? The more you can say about your character, the more appeal it will have.

THE BASICS

Before we begin drawing specific animals in a step-by-step way, let's go over some important basics. Think of these hints more as options than as instructions. They're really just choices that you may not even know you have!

Eye Placement in Profile Views

Because the bridge of the nose is so long on most animals, we often draw them in profile since it doesn't require us to fore-shorten the animal's lengthy snout. There are several good ways to place the eyes in profile, and some of these are "cheats"— they're really three-quarter-view eyes placed on profile heads.

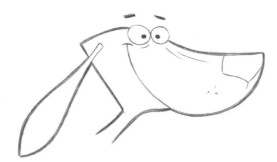

EYES BREAKING THE OUTLINE AT
THE TOP OF THE HEAD

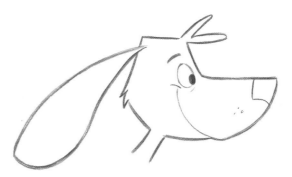

TRUE PROFILE EYE (SINGLE EYE)

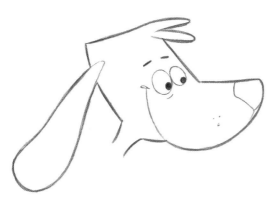

TWO EYES SPACED TIGHTLY TOGETHER

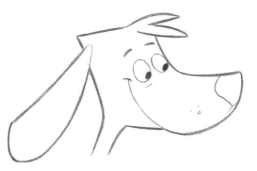

TWO EYES SPACED FARTHER APART

Animal Noses

Different animals have different types of noses. That's only natural. But cartoon animal noses should be exaggerated. Often, you can use a simple oval (as on dogs) or a small triangle (as on cats). But sometimes you've got to be more specific to the species. For example, a male lion generally has a specific type of nose shape.

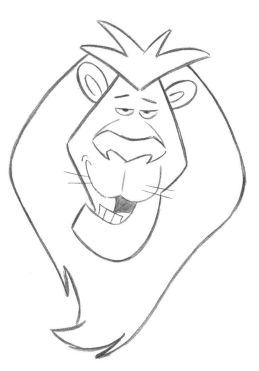

LION—MODIFIED TRIANGLE

BEAVER—FAT AND ROUND

COW—SEPARATE MUZZLE

PIG—SMALL SNOUT

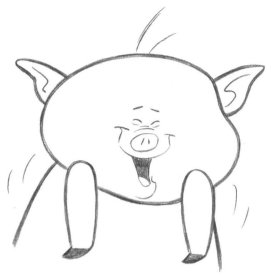

APE OR MONKEY—M-SHAPED CURVE

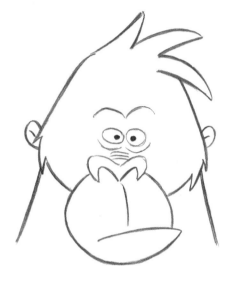

DOG—SIMPLE OVAL

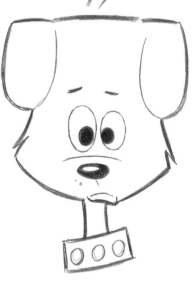

CAT—PETITE TRIANGLE

Snouts and Beaks

Most animals have a prominent bridge of the nose (snout or beak). And since cartoon heads are so malleable, you can play with the shape, keeping it straight or curving it up or down. Certain animals lend themselves certain shapes, as you can see.

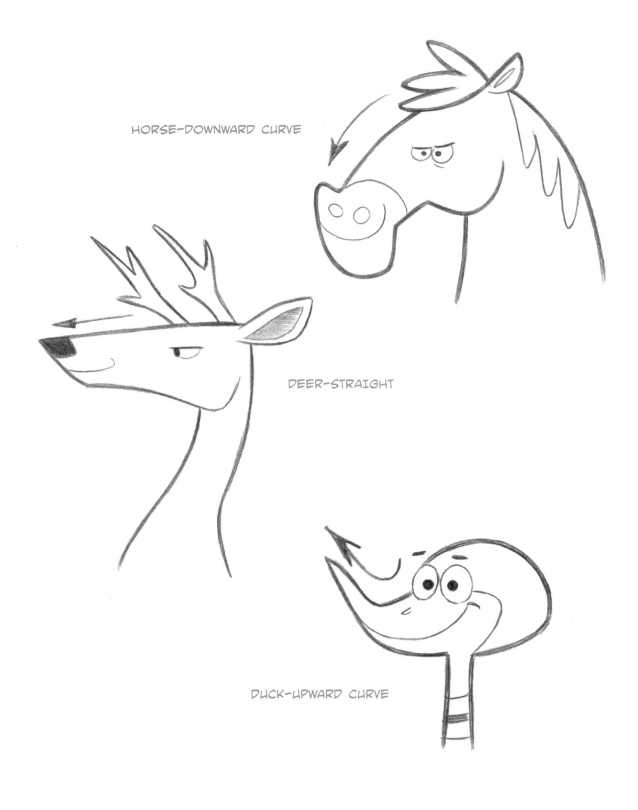

HORSE—DOWNWARD CURVE

DEER—STRAIGHT

DUCK—UPWARD CURVE

Animal Teeth

The toothy smile is a cartoon staple, and cartoonists often use a toothy smile to increase a character's appeal. Some carnivorous animals—sharks, bulldogs, lions—are famous for their teeth. But even plant-eating animals can have funny buck teeth. Here are the cartoon teeth styles I find most appealing.

SHARP CANINES

Make sure they're curved, not straight.

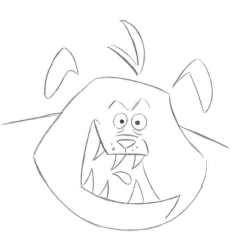

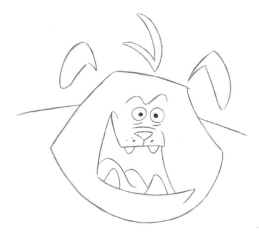

SOFT CANINES

For a friendlier look, smooth out the sharp points.

UNEVEN BUCK TEETH

For a truly goofy look, keep each pair close together.

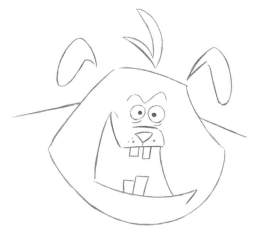

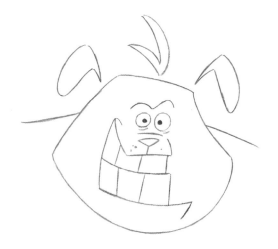

HUMAN-STYLE TEETH

Make sure the teeth line up evenly.

Animal Bodies—Four-Legged

By adjusting the curve of the spine and the shape of the tummy and the chest, you can create different body types (and different personalities) without altering anything else. Of course, to create totally different characters, you also have to rework the head, tail, legs, and so on. But here we keep the rest of the dog the same to illustrate just how big a difference the shape of the torso can make to the overall character design.

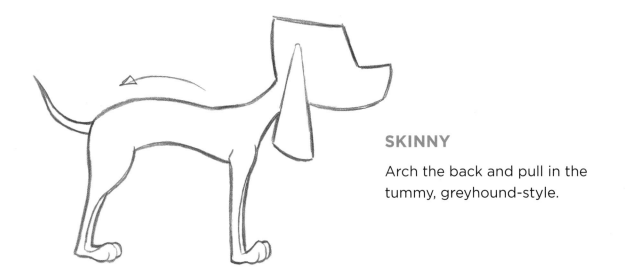

SKINNY

Arch the back and pull in the tummy, greyhound-style.

ATHLETIC

Bump out the shoulders on top and the chest underneath; narrow the waistline significantly.

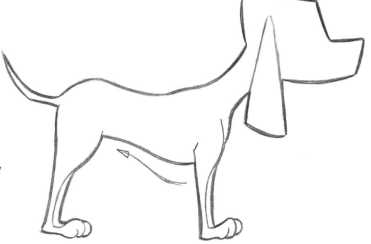

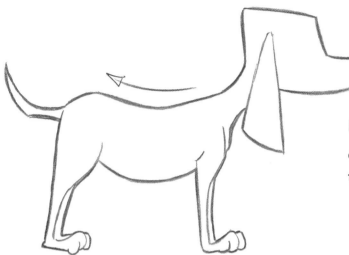

NEUTRAL (BUT CARTOONY)

Curve the back, and make the tummy obvious.

CHUBBY

Let the tummy hang down low, and give him a sway back to accentuate it.

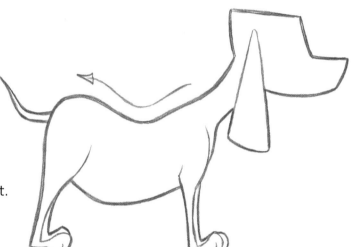

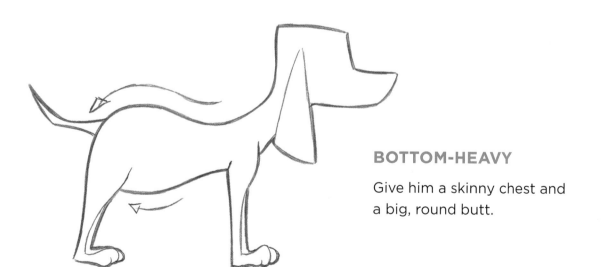

BOTTOM-HEAVY

Give him a skinny chest and a big, round butt.

Animal Bodies—Two-Legged

In cartoons, animals that are four-legged in nature can stand up and walk around like people. Generally, cartoonists give them very short legs and long torsos. You can make up any body type you like, but it will usually fall roughly into one of the five categories depicted here. Each type suggests a personality and an attitude.

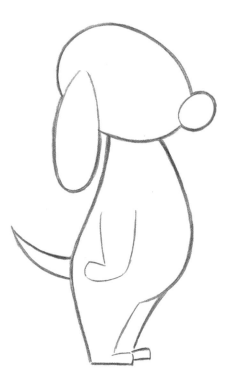

CLASSIC

He's got good posture—it's just that his tummy keeps getting in his way! Never misses a meal.

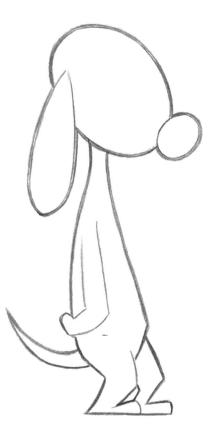

SLOW WITTED

He's got deeply bent knees, a concave chest, and a long neck. Make him lean back slightly.

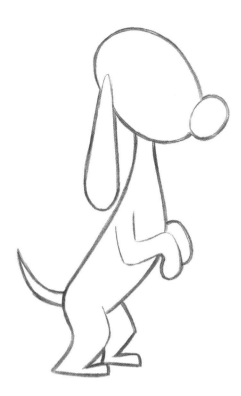

GOOFY

He's eager, energetic, and forward leaning, with a slightly athletic build.

SMART

He's pocket-size! His head is nearly half his overall height. Give him a rounded tummy.

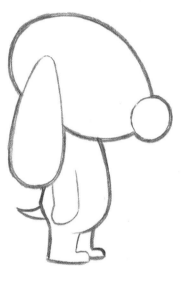

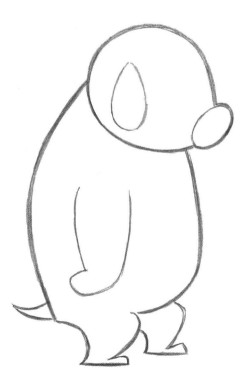

BUDDY—OR BULLY

The classic formula for this type of character is a hunched back with high shoulders and no neck, little legs and teeny feet, and thick, powerful arms. A tiny muzzle on a large skull. A small tail.

HOW CARTOON ANIMALS STAND

One cartoonist may draw an animal on all fours, while another may draw the same kind of animal standing up, like a person. Both are, of course, okay, but different skills are required for each approach. That's why I present several ways to draw them. Having alternatives opens up more possibilities, which is what cartooning is all about.

Chimp, Gorilla, and Monkey

We lay people tend to think of gorillas and chimps as monkeys, but of course they aren't really—they're apes. Even so, there are some definite similarities when it comes to drawing monkeys and apes. Just remember that gorillas, chimpanzees, and monkeys are different kinds of animals, and their cartoon versions are usually given different personality traits and cast in different roles.

CHIMPANZEE

The cartoon chimp is portrayed as wise, intelligent, even erudite. He can be cast as an adviser to humans (who are less intelligent than he), or he can simply be a funny sidekick. Chimps have longer faces than gorillas or monkeys, and they walk on the knuckles of their hands.

GORILLA

The gorilla can be one mean, nasty dude. Immensely huge and strong, with barn-wide shoulders and teeny-weeny legs, the cartoon gorilla is always a tad on the grumpy side and should look as if he hasn't slept in days.

MONKEY

The cartoon monkey is a hyperactive, incredibly annoying fellow who gets into everyone's business, making all sorts of mischief. Bounce him in and out of scenes. Remember that monkeys have tails—unlike chimps and gorillas. I like to give my cartoon monkeys really furry, puffy arms.

Dog—On Four Legs

Man's best friend is as popular in comic strips, comic books, and animated films and TV shows as he is in the average family home. I like to draw terriers because they have so much vitality. This little Westy is raring to go. His body is compact, and his head is oversized but fluffy—it's a winning combination.

Dogs should always wear collars, or they tend to look like strays. The exceptions are cartoon dogs that wear human clothes. They don't need doggy collars.

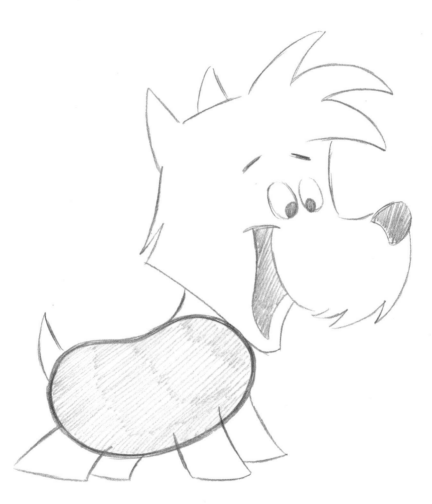

GIVE YOUR CARTOON TERRIER A SIMPLE BODY SHAPE, WITH A SLIGHTLY SWAYED BACK. HIS TAIL IS SHORT, AND HIS SHORT LITTLE LEGS KEEP HIS TUMMY LOW TO THE GROUND.

Like all terriers, this West Highland White—or "Westy," as they're better known—has pointy ears that stick straight up.

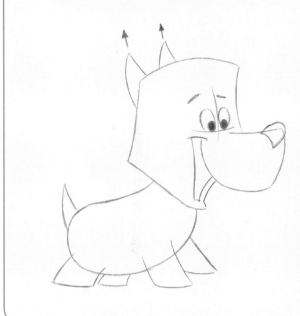

The line from the bottom of the nose and the line at the center of the tongue both sweep downward in the same direction. Terriers have wiry hair, so ruffle the fur of the Westy's upper lip and cheek area.

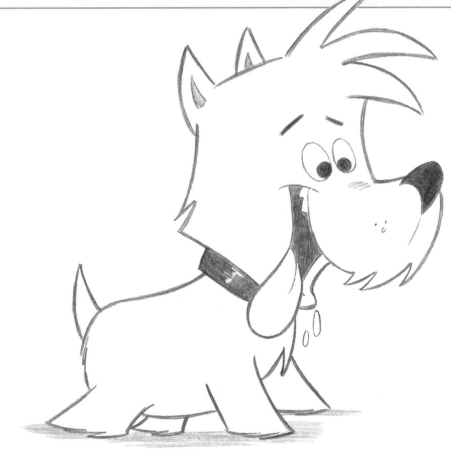

Dog—On Two Legs

This sweet little fella is a mutt. Mutts are often depicted as walking upright like people, because they're smart and live by their wits. After all, they can't get by on their well-groomed good looks alone, like purebred dogs.

To make the head look three-dimensional, let the far ear dangle behind the head, where we can see it. Note that most of the doggy anatomy has been removed from this pup. His body looks human—except for the paws and tail.

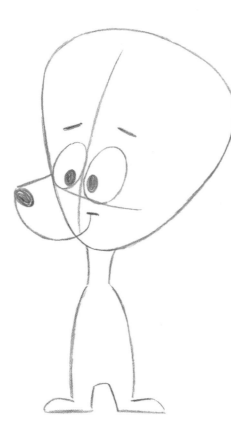

HIS HEAD IS BIGGER THAN HIS BODY, WHICH MEANS HE'S A YOUNG PUP!

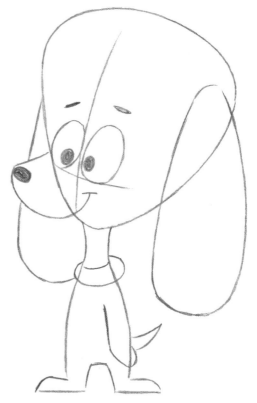

OVERSIZED EARS ARE ALSO AN INDICATION OF A YOUNG ANIMAL. NOTE, TOO, THAT PUPPIES HAVE SHORT TAILS.

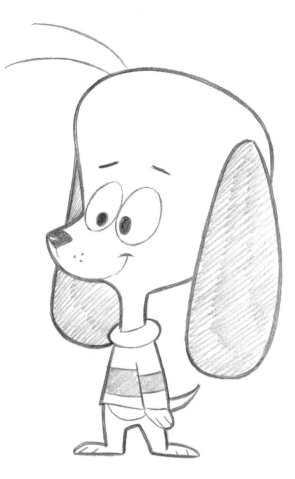

Small Chin or No Chin?

Small chins are *cute.* No chins are *goofy!*
Take your pick.

A small chin doubles as
the lower lip.

When there's no chin, the lower
lip goes directly into the mouth.

Cat—On Four Legs

Cats give a fluffy impression of a soft coat without hard muscles. A cat's torso calls for a small chest and larger hindquarters. That doesn't mean it looks fat. It's just that cats lack the powerful physique that a big chest provides. And they always have small, petite paws.

A full-grown cartoon cat's head is wide, whereas a cartoon kitten's head is tall. This cat's head is based on a wide oval. The muzzle is also petite, with a tiny nose. Cartoon cats' noses are always small—just like real cats'.

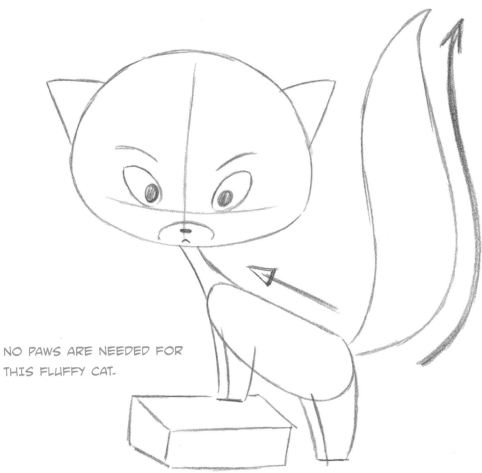

THIS CAT'S POSTURE IS SET AT A DIAGONAL. NOTICE THE DEFINITE S-CURVE OF THE TAIL.

NO PAWS ARE NEEDED FOR THIS FLUFFY CAT.

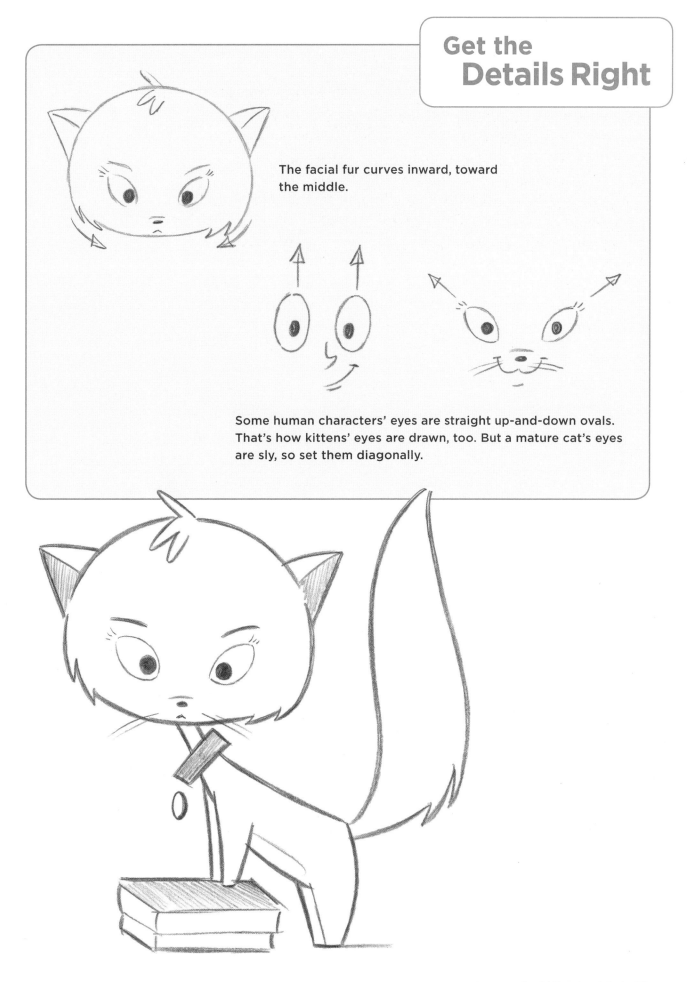

The facial fur curves inward, toward the middle.

Some human characters' eyes are straight up-and-down ovals. That's how kittens' eyes are drawn, too. But a mature cat's eyes are sly, so set them diagonally.

Kitten

There are many ways to draw kittens, but I think the most appealing kittens have oversized heads and miniature bodies. I also leave out the toes in the paws, because the legs are so small they just won't fit!

A cartoon kitten's basic features include a big head with small ears and nose, tiny whiskers, ruffled fur on the cheeks, and eyelashes. And don't forget that adorable bow!

Big pupils are also a must. How do I get those great "eye shines" in the middle of the eyes? First, I make the eyes very dark, by pressing down hard with a regular pencil (a no. 2 pencil is fine). Then I go back and put two small drops of paint on each eyeball, with a fine-tipped paintbrush.

THIS KITTY'S HEAD IS A VERTICALLY POSITIONED OVAL. NOTICE HER CHUBBY LITTLE THIGHS.

THE ALL-IMPORTANT RUFFLES OF FUR ON HER CHEEKS ARE VERY CATLIKE. THIS KITTEN ALSO HAS A BUSHY TAIL.

Cartoon Tails

Real kittens have small tails. But cartoonists don't play by the rulebook. A big, bushy tail is irresistible—so we can use it on a kitten, if we make it fluffy and squeezably cute enough.

Hmm. This adult-style cartoon tail just doesn't work here.

Neither does this little tail—even though it's realistic.
it's just not impressive.

This bushy tail is just right. (And by the way, you can also use a bushy tail on adult cats.)

Squirrel—Natural Stance

The stance may be natural, but this drawing of a squirrel is flat, highly stylized, and cartoony. The paws look like they're floating in the middle of the squirrel's body, and the feet don't look as if they're attached to the legs. These tricks give the character a profoundly two-dimensional appearance, especially when combined with the thick pencil outline. It's very retro.

Cartoon squirrels have trademark features that distinguish them from other little woodland critters: small ears, buck teeth, wide cheeks, and (especially) that huge, bushy, two-toned tail.

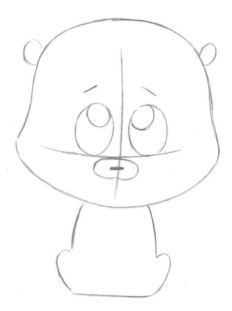

SQUIRRELS' BODIES ARE ALWAYS A LITTLE BOTTOM-HEAVY. GIVE THE SQUIRREL TINY EARS, A KIDNEY-SHAPED MUZZLE, AND BIG EYEBALLS INSIDE LARGE EYES.

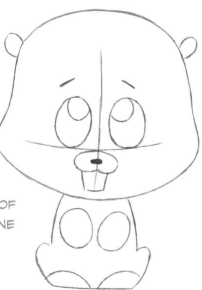

FLOAT THE PAWS, WHICH ARE REALLY JUST A PAIR OF OVALS, INSIDE THE OUTLINE OF THE BODY.

NOTE THE EXTREMELY BUSHY TAIL—AND THE LITTLE TOPKNOT OF FUR ON THE SQUIRREL'S HEAD.

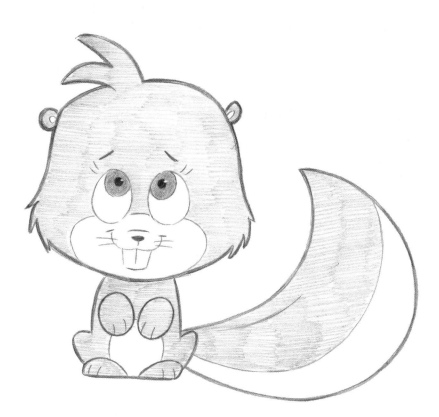

Fur-Line Markings

There are two basic ways of demarcating the fur line on the squirrel's face. Both ways are good, but one is more modern.

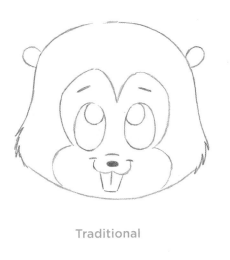

Traditional

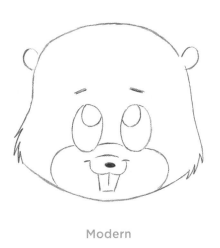

Modern

Penguin—Small Head

Penguins are so popular that they have been featured in their own comic strips and their own animated movies. These birds are brimming with personality—always perky, peppy, and on the go. Their rubbery form was just made for cartooning!

In reality, penguins have very small heads on top of seriously thick bodies. In fact, their heads are so small that I have difficulty drawing cartoon eyes within the head's outline—so I let the eyes break the outline at the top of the head. It gives the character a kooky look.

Also note how I've simplified the penguin's markings: His stomach has a single patch of white. (An important rule of cartooning is to simplify wherever possible.) Real penguins' wings are surprisingly long, and long wings work well for this more or less realistically proportioned penguin.

PENGUINS' BODIES AREN'T JUST FAT-THEY'RE ALSO LONG. THE LEGS ARE SHORT AND THE FEET ARE MEDIUM SIZED.

DON'T SHOW THE FORE-HEAD LINE OVER THE EYES. AND EVEN THE EYE-BROWS CAN FLOAT ABOVE THE HEAD! THE PENGUIN HAS NO SHOULDERS AT ALL, AND HE'S GOT A VERY SMALL TAIL.

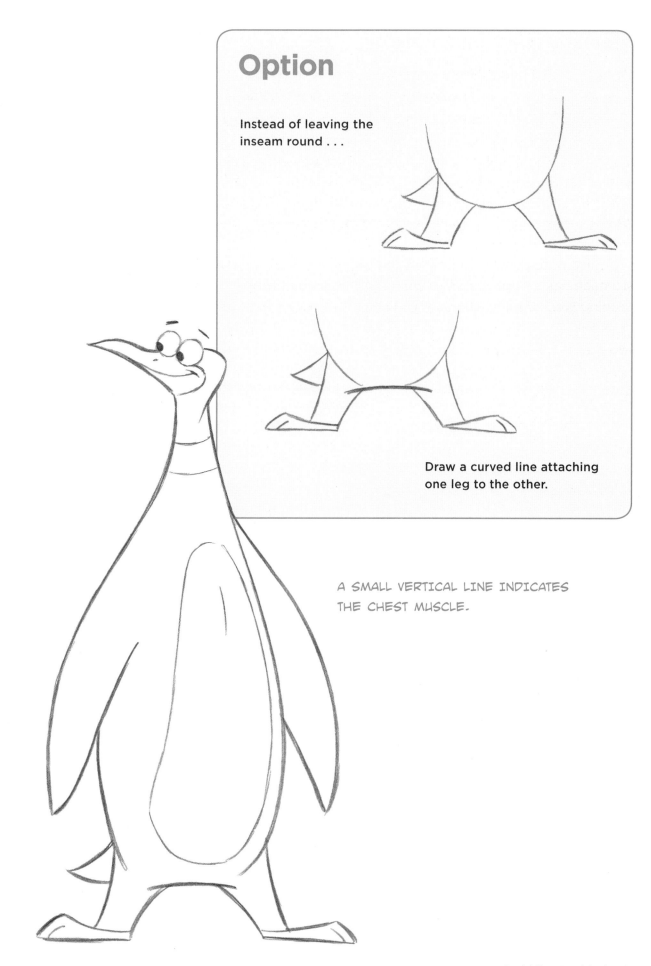

Option

Instead of leaving the inseam round . . .

Draw a curved line attaching one leg to the other.

A SMALL VERTICAL LINE INDICATES THE CHEST MUSCLE.

Penguin—Large Head

Now let's cute that cartoon penguin up a bunch, by giving him a larger head. It's a testament to the adaptability of penguin characters that they can be stretched and molded into so many different shapes. We, the viewers, have gotten so used to seeing cartoon penguins with big heads that we don't even realize how wrong these proportions are.

The large penguin head is a baby-head shape: big and round in the back, with big cheeks and eyes and some baby fat under the chin.

THERE'S LOTS OF MASS IN BACK OF THE HEAD. THE BEAK HOOKS SLIGHTLY—BETTER FOR CATCHING FISH! HIS BIG EYES ARE SET LOW—AND DON'T FORGET THE BABY FAT BENEATH THE CHIN.

ARCH HIS BACK IN A LONG, SWEEPING LINE FROM TOP TO BOTTOM.

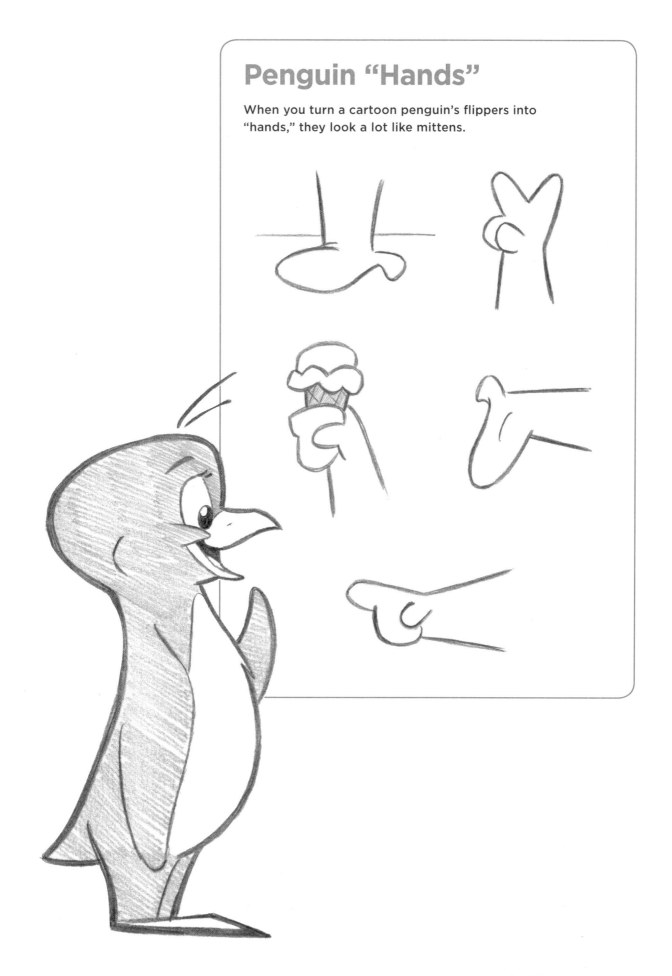

Penguin "Hands"

When you turn a cartoon penguin's flippers into "hands," they look a lot like mittens.

Camel—On Two Legs

Is this weird, or what? A camel standing on two legs, with a huge hump on its back. But as long as it's funny-weird, it works. Many cartoons get by on their quirkiness alone, and this guy is no exception. People look for novelty in today's cartoons, so if you can find a new way to reinvent a character, so much the better.

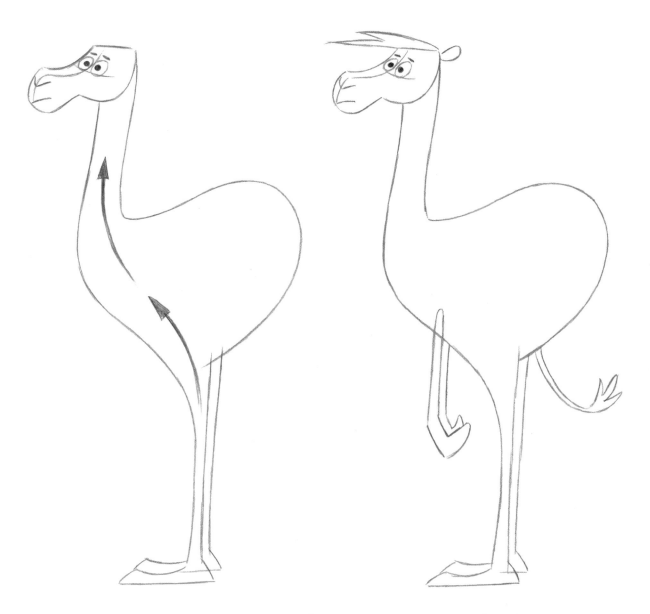

THE NECK BULGES AT THE FRONT, AND THE "ARMS" ARE SET BACK.

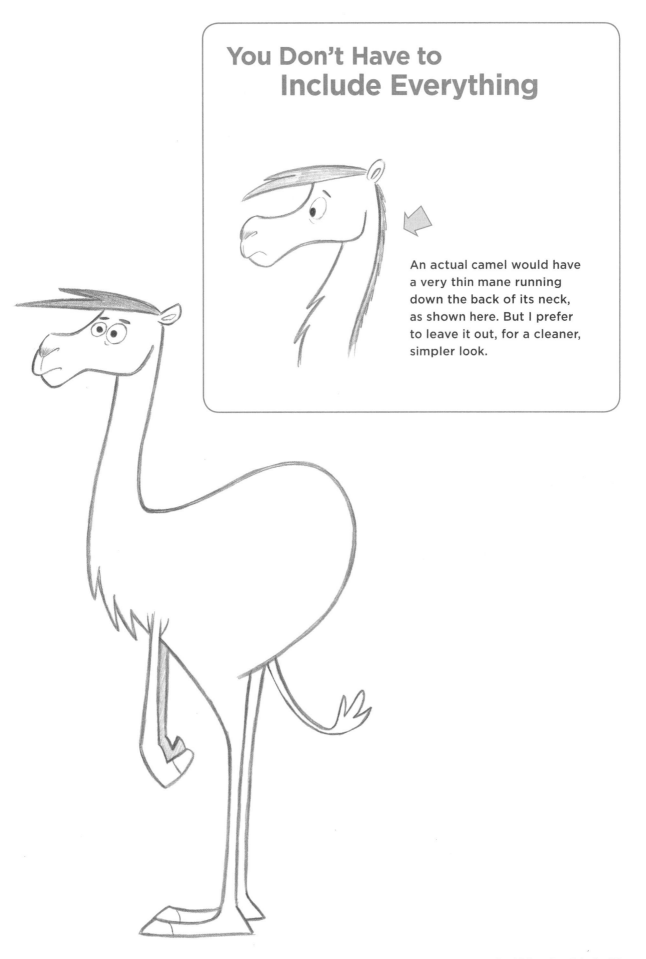

You Don't Have to Include Everything

An actual camel would have a very thin mane running down the back of its neck, as shown here. But I prefer to leave it out, for a cleaner, simpler look.

Bear—On Two Legs

This is an exuberant pose: All the limbs are spread out, as the bear looks directly at the reader. As we move away from the more realistic animal stance, we also move away from real animal anatomy. His long snout is shortened, and his ruffled fur has been eliminated. Instead of flat paws, he now has chubby hands and feet.

I've drawn the head flat across on top, which gives him a stylish look. But add some hair to it, so that he doesn't look like a bald bear! For goofy-looking characters like this bear, set the eyes close together.

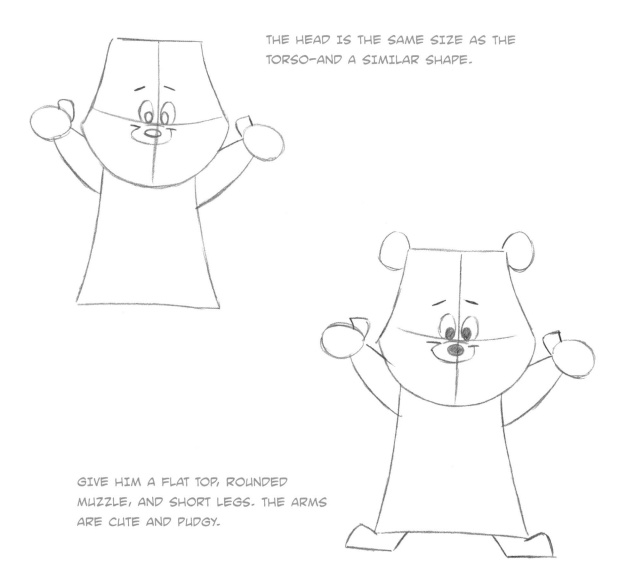

THE HEAD IS THE SAME SIZE AS THE TORSO—AND A SIMILAR SHAPE.

GIVE HIM A FLAT TOP, ROUNDED MUZZLE, AND SHORT LEGS. THE ARMS ARE CUTE AND PUDGY.

Bear Cub

This little cub has all the attributes of a cute character, including a large head on a tiny body and very big, soulful eyes.

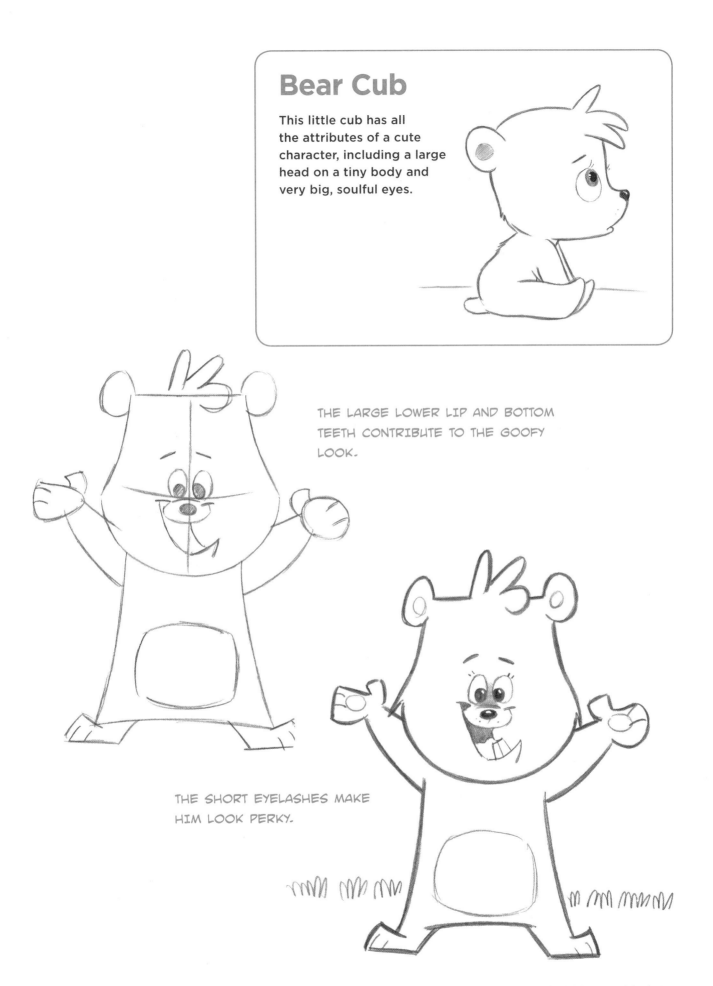

THE LARGE LOWER LIP AND BOTTOM TEETH CONTRIBUTE TO THE GOOFY LOOK.

THE SHORT EYELASHES MAKE HIM LOOK PERKY.

Lioness—Seated

The lioness is a sleek, evil-looking character. She makes a great villain. Given the choice between drawing a lioness and a male lion (the one with the mane), I prefer her. Her lines are simple, pleasing, and balanced, whereas a male lion's mane has a way of visually drowning out everything else about the character. Since the female lion is the hunter of the pride, she is depicted as athletic: big shoulders, big chest, small waist and rump.

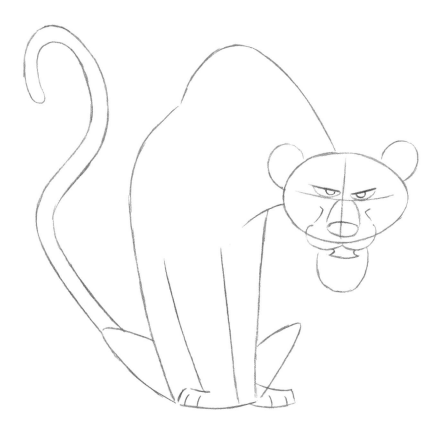

HER CRANIUM HAS A SQUASHED OVAL SHAPE, AND HER EYES ARE NARROW AND SNEAKY. NOTICE HOW SINUOUSLY HER TAIL CURLS AROUND. A REAL LIONESS'S TAIL WOULD BE MUCH STRAIGHTER, BUT THIS MORE SERPENTINE TAIL PROVIDES THE CARTOON CHARACTER WITH MORE VISUAL INTEREST.

The bridge of the lioness's nose is clearly defined, even in a frontal view. Give any lion—male or female—a huge chin. Consider showing the lower row of teeth. And note that her upper lip is split by a line extending down from the nose.

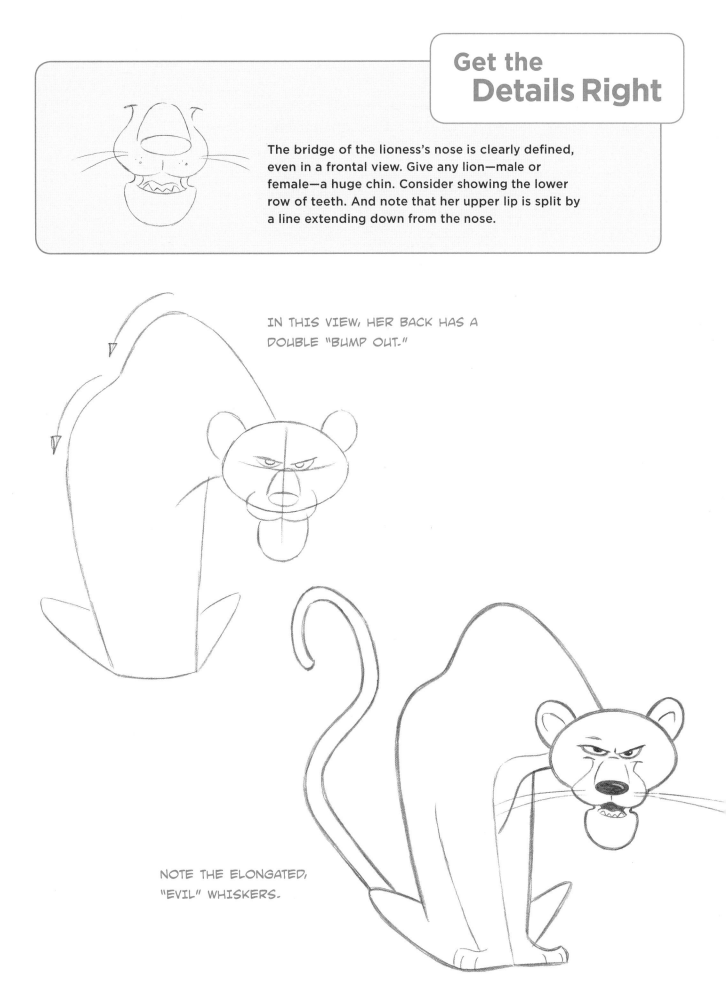

IN THIS VIEW, HER BACK HAS A DOUBLE "BUMP OUT."

NOTE THE ELONGATED, "EVIL" WHISKERS.

Elephant—On Four Legs

Elephants make some of the funniest animal cartoon characters, period. To bring out their humor, I like to exaggerate and juxtapose several key elements. First, I make the eyes teeny to contrast with the elephant's massive head. I also lower the head so that it's in the middle of the body, which gives the elephant a funny, high, rounded back. I make sure to draw the feet, which have to hold up several tons of blubbery body, improbably small—almost dainty. And last, but definitely not least, I exaggerate the "pinchers" at the end of the trunk.

THE ELEPHANT'S SHORT LEGS CURVE INWARD. (DID YOU KNOW THAT REAL ELEPHANTS ACTUALLY HAVE QUITE LONG LEGS?) PLACE THE EYES AT THE TOP OF THE HEAD, NOT IN THE CENTER.

THE GIANT EARS ARE SPREAD OUT AND GENTLY FLAPPING.

Option

If you like, you can feather the bottoms of the ears.

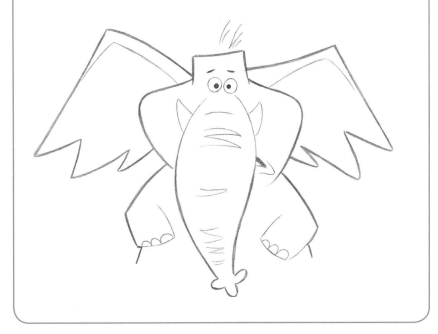

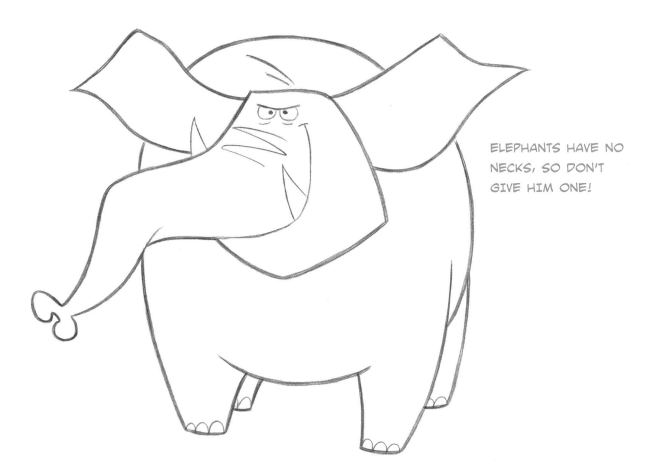

ELEPHANTS HAVE NO
NECKS, SO DON'T
GIVE HIM ONE!

Hamster—On Two Legs (Only!)

Hamsters—usually with nervous personalities—are popular characters in animated films and TV shows. If you draw them on all fours, hamsters tend to look a little too feral—like fat mice. So I only draw them on two legs.

Hamsters have fat cheeks—and therefore very wide faces. They're thick all over, with little arms and legs. The snout should remain small, which gives him an adorable quality. Tiny whiskers finish off the look. Often, cartoonists will choose to blacken the hands and feet.

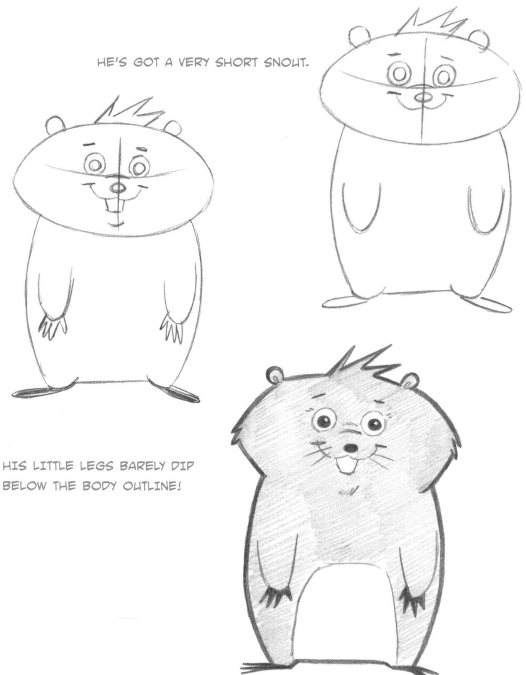

HE'S GOT A VERY SHORT SNOUT.

HIS LITTLE LEGS BARELY DIP
BELOW THE BODY OUTLINE!

The faster a character runs, the longer its stride should be. On the left is our hamster's normal run. On the right, his all-out run!

Double-breasted

Half-length

Short oval

Full-length

You also have a variety of choices when creating stomach markings for your hamster. (These also work for other small, woodland creatures.) Stomach markings, with their appealing two-toned look, make the character stand out.

Shark—Standing

Standing sharks are truly hilarious. They're totally improbable, but what the heck? In a cartoon, we can do anything we want—if we can pull it off convincingly. The funniest aspect of the standing shark is that this big, mean, threatening animal has to take teensy-weensy steps when he walks because his tail fins are so little. As for the head construction, trust me on this: It's funnier to have the two eyes on one side of his head, even though it's anatomically incorrect.

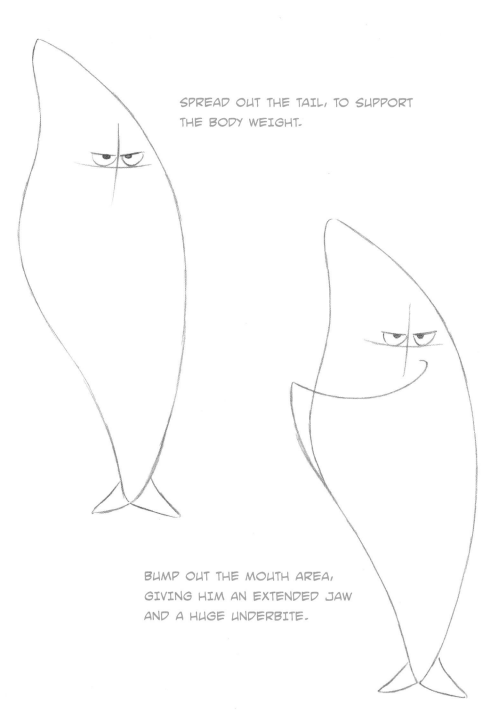

SPREAD OUT THE TAIL, TO SUPPORT THE BODY WEIGHT.

BUMP OUT THE MOUTH AREA, GIVING HIM AN EXTENDED JAW AND A HUGE UNDERBITE.

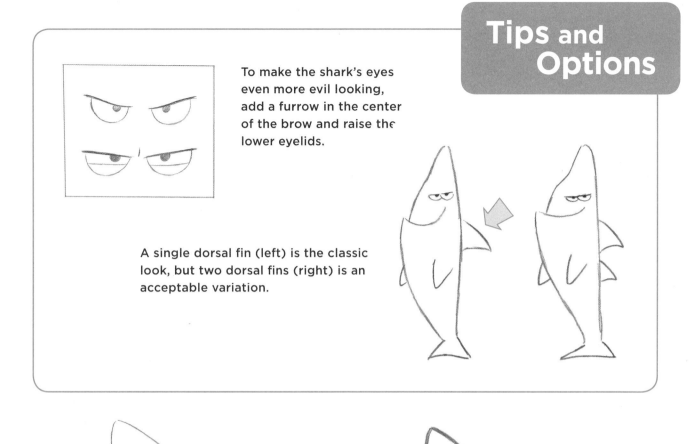

To make the shark's eyes even more evil looking, add a furrow in the center of the brow and raise the lower eyelids.

A single dorsal fin (left) is the classic look, but two dorsal fins (right) is an acceptable variation.

MAKE HIS FINS SHORT AND HUSKY. ADD A MARKING TO HIS UNDERBELLY.

Rhinoceros—On Four Legs

The rhino has a huge sway in its back, as well as along the bridge of its nose.(Actually, the entire length of its face is curved.) Its tummy is always round and droopy—that's just how the animal is built. The legs are short and sturdy. And here's something else to keep in mind: A rhino always hangs its head low to the ground, never holding it up high the way a horse does. If you don't draw the rhino this way, it will look weird.

There's an indentation in the rhino's nose just above its upper lip. And notice how deeply set the eye is on the rhino's narrow head.

Note how the back and front legs are differently configured.

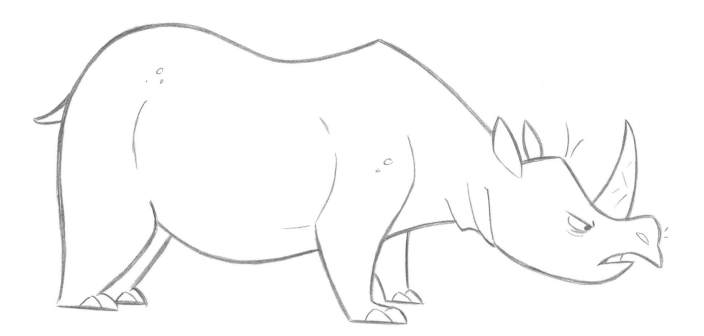

Rhino—On Two Legs

Here's the rule: If you want a villainous bad guy, place your rhino on four legs. If you want a funny character, stand him up on two legs, where he looks useless! In this two-legged, upright posture, he's just sort of a grumpy complainer. Keep the eyes deeply set inside the outline of the head, just as they are in the more realistic version of the rhino. Keep the swayback, too—even in the upright posture—as well as the rounded tummy. Oh, and by the way, rhinos don't have a shock of hair or a mane on top of their heads. I've given this character a little tuft of hair solely to humanize him.

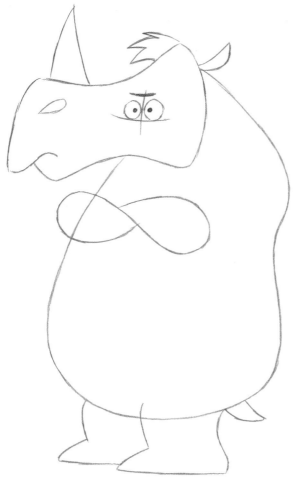

KEEP THAT SWAYBACK AND HANGING TUMMY.

MAKE HIS HEAD COME TO A POINT ON TOP, AND GIVE HIM A BIG OVER-BITE BY EXTENDING THE UPPER LIP.

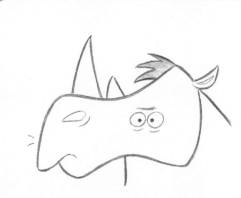

Some rhinos have two horns. But, frankly, I think that's redundant for cartooning purposes.

Elephants' feet are similar to those of rhinos—but subtly different. Compare the rhino's foot, on the left, with the elephant's, on the right.

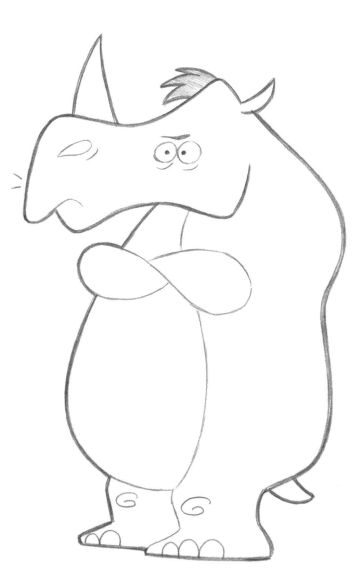

Special Characters: Fantasy Creatures

Now we have another category of creature altogether—from the world of fantasy. I've saved fantasy creatures for last, because they use every aspect of cartooning that we've learned up to now. All of them draw upon the realm of animal shapes, but some have half-human bodies, too. And all of them require us to think outside the box.

We have gone over quite a lot of useful material together, you and I. Now it's time to dig deep into that well of inspiration, to come up with wild and fanciful characters that will delight and tickle the audience's imagination. My humble character designs are just suggestions. You can depart from them at any time to create your own individual take on these fantasy creatures.

DRAGON

The more realistically drawn dragons, as seen in fantasy-adventure illustration, look like crocodiles with horns, large back plates, and wings. Not so with cartoon dragons, whose faces, particularly their snouts, are often large and bulbous. I especially like to make funny dragons fat, with skinny necks. That brings out their true goofiness. As for their dramatic wings—forget it! The smaller the wings, the funnier they are. (Useless is funny.)

Dragons are not complicated to draw, but they do have a lot of "stuff" on them—horns, teeth, back plates, wings, spots, scales, breast plates, and so on. All this "decoration" gets drawn after the basic construction is locked into place.

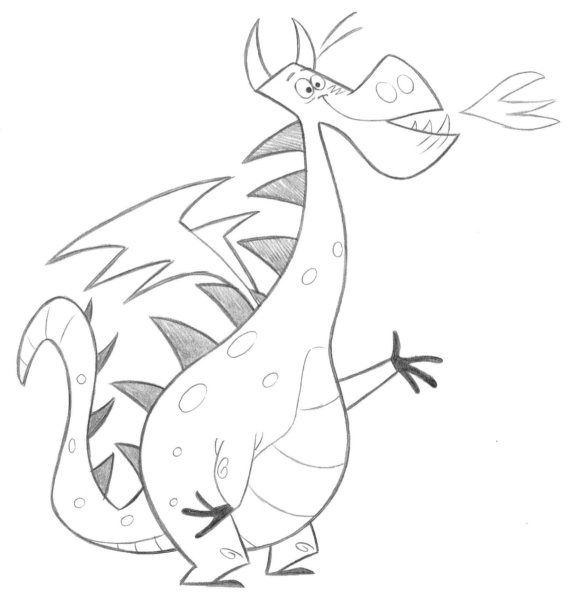

Dragon—On Two Legs

Because dragons are so tremendously popular, I want to show two different ways of drawing them. Here's a dragon standing—improbably—on his hind feet.

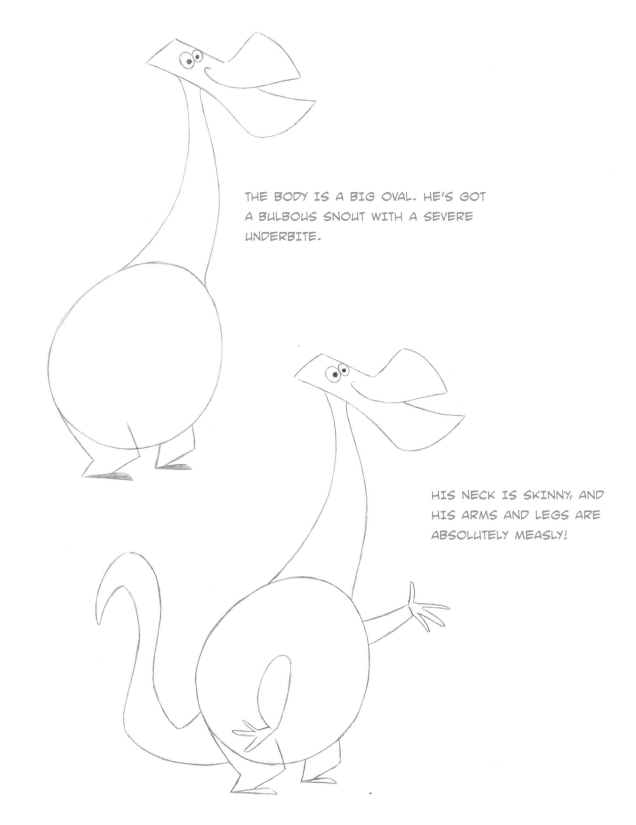

THE BODY IS A BIG OVAL. HE'S GOT A BULBOUS SNOUT WITH A SEVERE UNDERBITE.

HIS NECK IS SKINNY, AND HIS ARMS AND LEGS ARE ABSOLUTELY MEASLY!

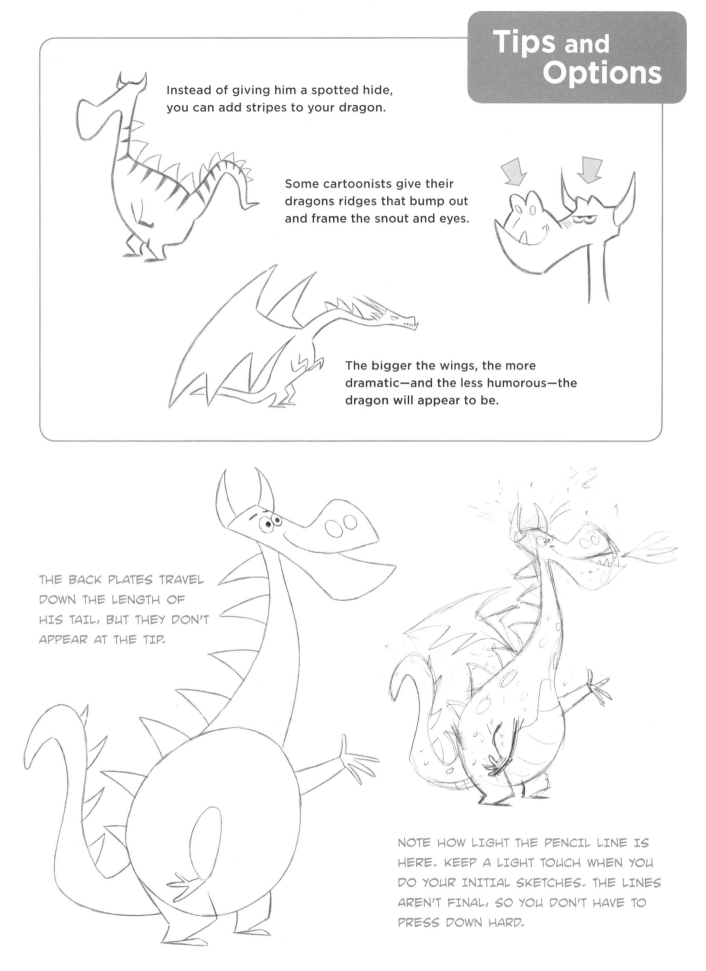

Instead of giving him a spotted hide, you can add stripes to your dragon.

Some cartoonists give their dragons ridges that bump out and frame the snout and eyes.

The bigger the wings, the more dramatic—and the less humorous—the dragon will appear to be.

THE BACK PLATES TRAVEL DOWN THE LENGTH OF HIS TAIL, BUT THEY DON'T APPEAR AT THE TIP.

NOTE HOW LIGHT THE PENCIL LINE IS HERE. KEEP A LIGHT TOUCH WHEN YOU DO YOUR INITIAL SKETCHES. THE LINES AREN'T FINAL, SO YOU DON'T HAVE TO PRESS DOWN HARD.

Dragon—On Four Legs

Instead of a fat tummy, this dragon has a hunched back. But it's still the lack of athleticism in his physique that makes him funny. Like a typical reptile's body, his is low to the ground, with short legs. He's ticked off about something, but his pouting lip and those little teeth are not going to scare anyone. Note that the flat feet give him a funny walk.

A word about how this picture was composed: I've got a vertical piece of paper to draw on—this book page. Yet, the dragon, with his long neck and long tail, is really a horizontal character. There are only two ways of fitting the head and tail on the same page—I could draw him really, really small, or I could bend his neck and tail upward, which is what I decided to do. This is called "working within the environment." It took some effort to make this pose look effortless and not cramped by the page dimensions.

LIFT THE HEAD WAY UP ON A STRONGLY VERTICAL NECKLINE.

HIS TAIL ALSO RISES VERTICALLY. AND HAVE FUN WITH HIS POUTING LOWER LIP AND FUNNY-LOOKING FLAT FEET.

LET'S GIVE THIS DRAGON RIDGES ON HIS NOSE AND EVEN SOME HAIR ON HIS HEAD. WHY NOT?

NOW WE'RE READY TO PUT ALL THE "STUFF" ON HIS BACK—THE PLATES AND WINGS. WHEN FINISHING THE DRAWING, YOU'LL WANT TO SHADE THE BACK PLATES BLACK, WHICH PROVIDES A GOOD CONTRAST AGAINST THE REST OF THE BODY, WHICH IS LEFT WHITE.

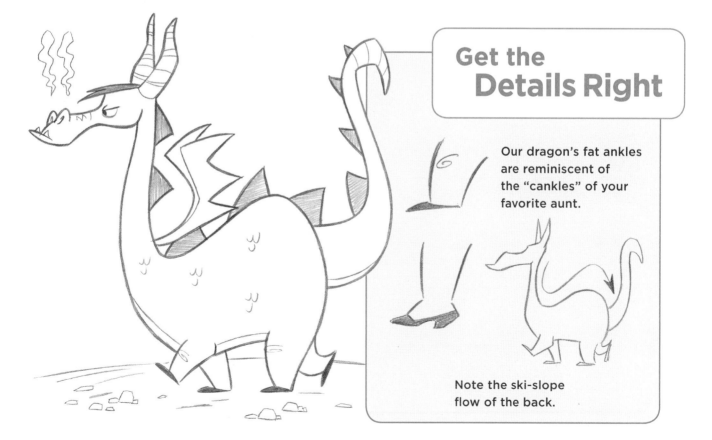

Get the Details Right

Our dragon's fat ankles are reminiscent of the "cankles" of your favorite aunt.

Note the ski-slope flow of the back.

Little Gargoyle

This little devil is an up-to-no-good but somewhat incompetent mischief maker. He can make your life miserable once he gets you in his sights. The gargoyle hides on the cornices of buildings and swoops down to terrorize the citizens of the city below. But cartoon gremlins have notoriously bad aim, and they wind up crashing into city buses more often than nabbing their victims. Ouch, that hurts!

These little creatures are sort of cute, but definitely not cuddly—they're too evil and skinny for that. And they lack the big, puppy-dog pupils of truly cute characters. Even so, they're basically humorous little fellows.

HIS HEAD'S A MODEST-SIZE CIRCLE, HIS BODY IS SKINNY, AND HIS LEGS ARE JOINED LIKE ANIMAL LEGS. PLACE HIS FEATURES ABOUT MIDWAY DOWN HIS FACE.

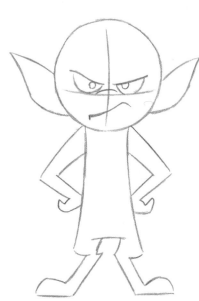

HIS EARS ARE LIKE A BAT'S EARS.

THE WING TIPS CURL SHARPLY INWARD.

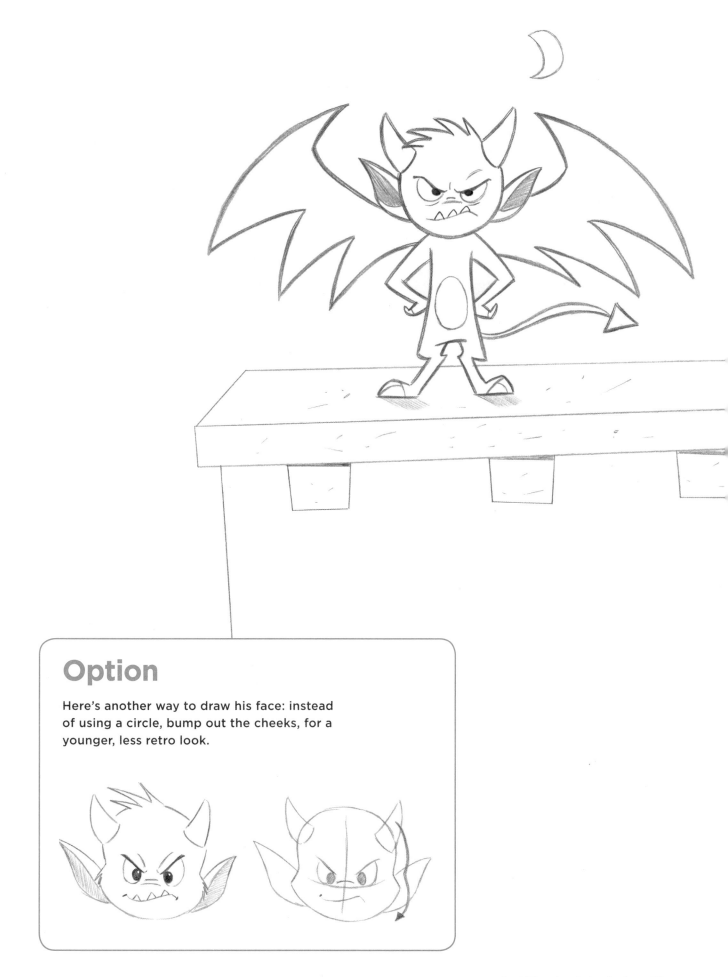

Option

Here's another way to draw his face: instead of using a circle, bump out the cheeks, for a younger, less retro look.

Centaur

A centaur is half-man, half-horse. The trick is in melding the two at the waist so that it doesn't seem as if you've unceremoniously stuck two separate drawings together. Notice that the man's waistline appears above the body of the horse and that the horse's back has a curve to it. A straight line is lifeless. Most important, the man's chest and the horse's chest are vertically aligned. Ready to give the centaur a try? It's challenging, but fun.

THE SHOULDER MASS EXTENDS PAST THE LINE OF THE MAN'S BACK.

THE MAN'S BODY APPEARS TO BE ANGLED VERY SLIGHTLY, SO THAT YOU CAN GLIMPSE THE PECTORAL MUSCLE ON THE OTHER SIDE OF HIS CHEST. THE POSTURE OF THE HUMAN HALF OF THE CENTAUR SHOULD ALWAYS BE PROUD, WITH ITS BACK ARCHED—NEVER SLOUCHING.

THE MAN'S WAISTLINE
CURVES INWARD JUST
ABOVE WHERE THE BODY
OF THE HORSE BEGINS.

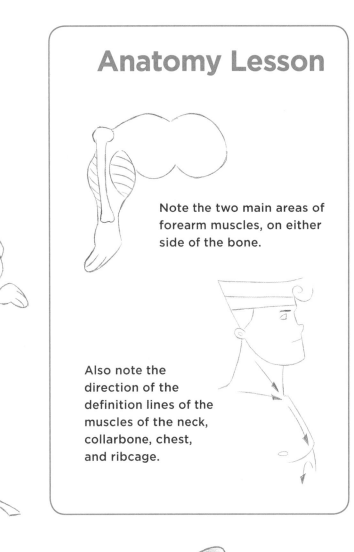

Anatomy Lesson

Note the two main areas of
forearm muscles, on either
side of the bone.

Also note the
direction of the
definition lines of the
muscles of the neck,
collarbone, chest,
and ribcage.

Mermaid

Mermaids are the class act of the sea. They are beautiful, grace-
ful, shy, and playful. They are perennial favorites among young
girls, as the mermaid is an idealized version of a beautiful young
lady who lives in a sort of water wonderland. The top half of the
mermaid is human (although it's got oceanic motifs), and the
bottom half is pure sea creature. The two halves meet in a zig-
zagging pattern just below the waist.

Remember, this is a fantasy character, so she should have
huge, fantasy hair—hair that gently flows with the current. I like
to give mermaids elf-like ears, but most of all she needs beautiful,
radiant eyes. Tilting them up slightly at the ends does the trick.

Find a good "floating" pose for your mermaid character.
Swimming poses are good, too. But remember that she should
look weightless, because she's under water.

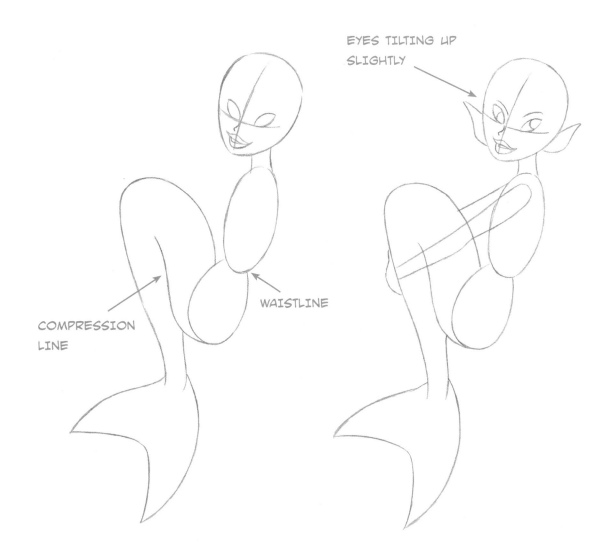

EYES TILTING UP
SLIGHTLY

WAISTLINE

COMPRESSION
LINE

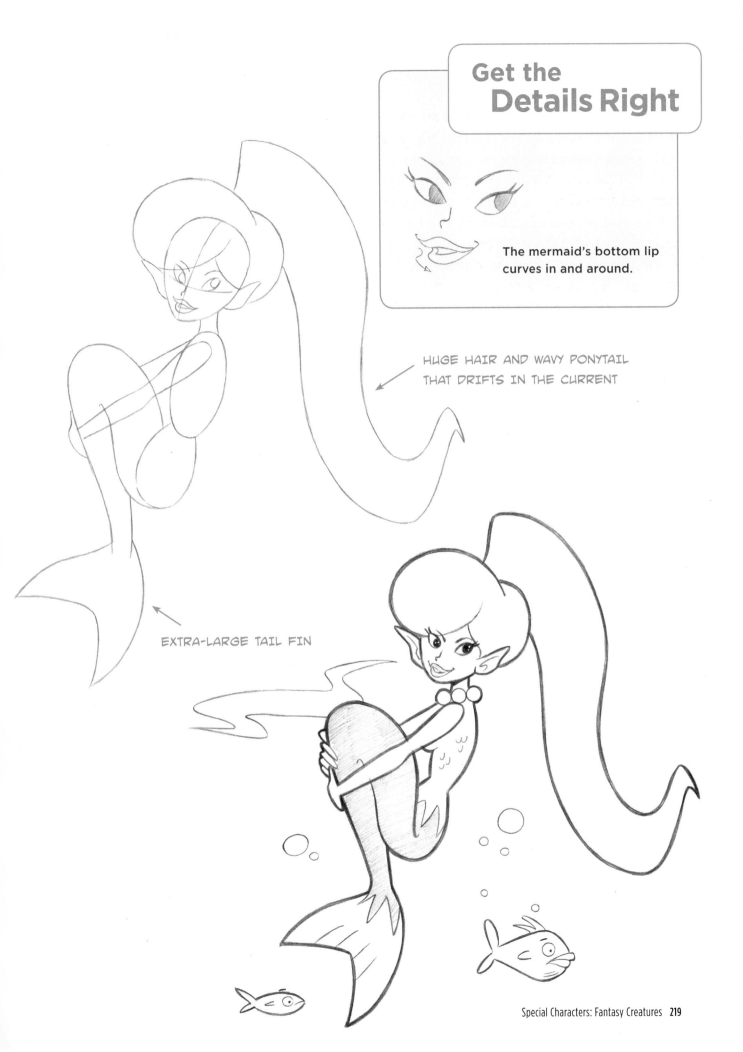

Get the
Details Right

The mermaid's bottom lip curves in and around.

HUGE HAIR AND WAVY PONYTAIL THAT DRIFTS IN THE CURRENT

EXTRA-LARGE TAIL FIN

Sea Serpent

A sea serpents is like a giant tube with an elongated string of dorsal fins running down its back. And puny little legs for swimming. It's pure evil, but not too bright.

You can have fun designing these any way you like, provided they have some mystery about them. I've given this guy dark circles under his eyes to make him look intense. He's got long, crooked horns that aim backward and a wild shock of hair. But those buck teeth and his stupid grin let us know he's not the sharpest tool in the shed.

Note how the long line of his tummy travels from his chest past the hind legs. That line and the short vertical lines drawn across the body help the eye follow the sea serpent's long, squiggly form.

MAKE HIS BODY VERY WIGGLY, AND SPREAD IS LONG FINGERS WIDE APART SO THAT YOU CAN ADD WEBBING BETWEEN THEM.

ADD LEGS AND ARMS ON THE FAR SIDE OF HIS BODY TO MAKE IT LOOK LIKE HE'S RUNNING UNDER WATER.

Funny Fins

Nope! This is how you draw the plates on a dragon's back.

Yep! This is how you do the fins on a sea serpent's back. The pattern mimics the crests of ocean waves.

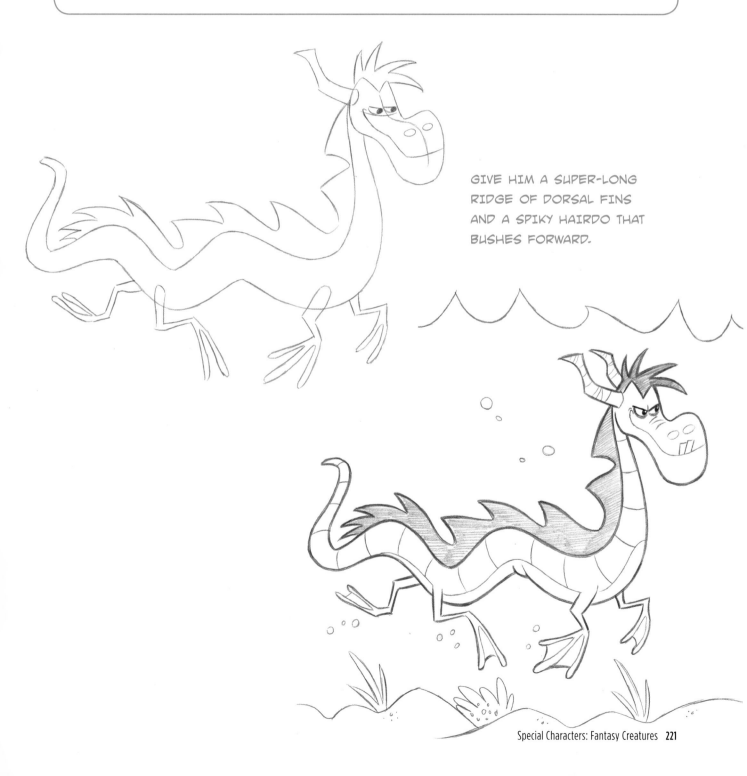

GIVE HIM A SUPER-LONG RIDGE OF DORSAL FINS AND A SPIKY HAIRDO THAT BUSHES FORWARD.

Leviathan

A leviathan is a giant sea creature. To make this creature *look* gigantic, we have to exaggerate the size of certain parts of him while making other parts smaller, for contrast. The tiny head and big body are a must, but the ridiculously long neck is the funniest part, ending in a goofy smile without a chin. Give him near-useless arms and legs, with just the smallest suggestion of hands and feet at the tips.

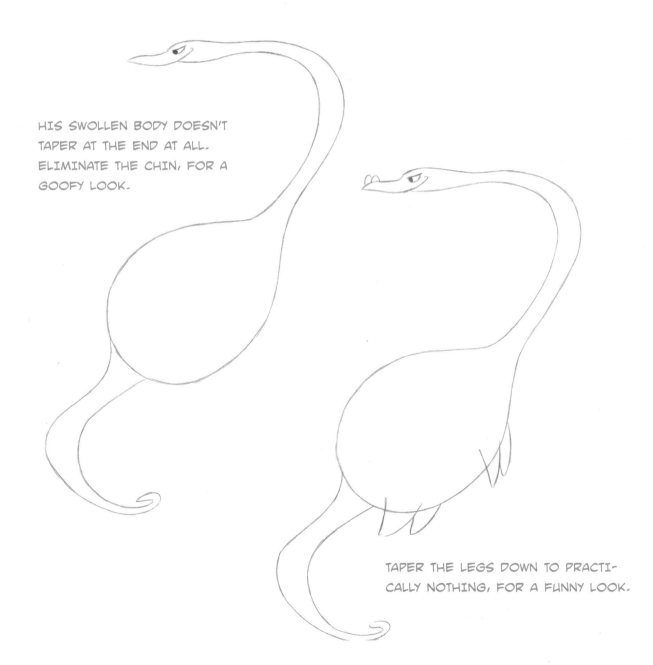

HIS SWOLLEN BODY DOESN'T TAPER AT THE END AT ALL. ELIMINATE THE CHIN, FOR A GOOFY LOOK.

TAPER THE LEGS DOWN TO PRACTI-CALLY NOTHING, FOR A FUNNY LOOK.

Underwater Fluidity

Draw the line of the back as one continuous, fluid line. And no matter whether your leviathan is floating, swimming, or hovering, the character will look more interesting if you position him on a diagonal rather than a static horizontal or perfectly vertical pose.

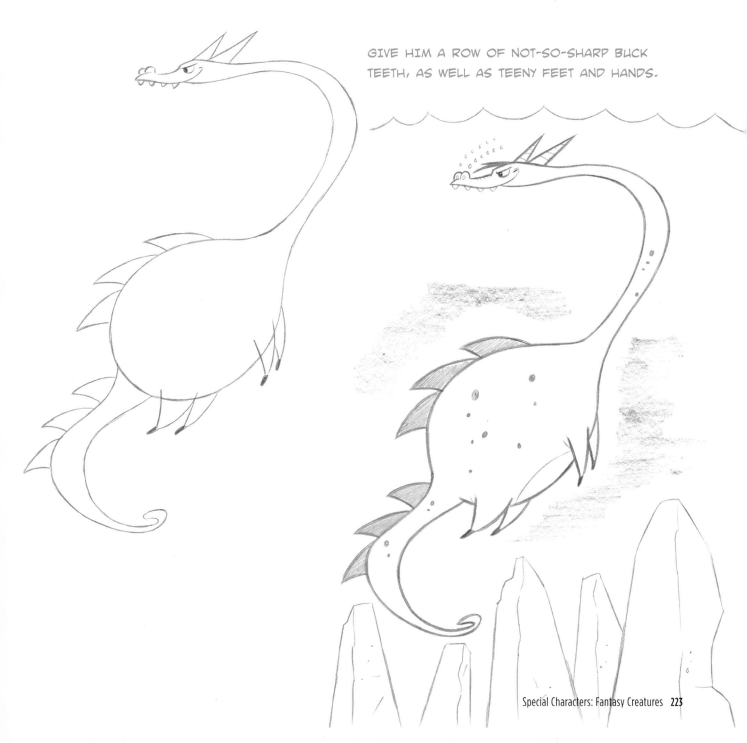

GIVE HIM A ROW OF NOT-SO-SHARP BUCK TEETH, AS WELL AS TEENY FEET AND HANDS.

INDEX